VELÁZQUEZ

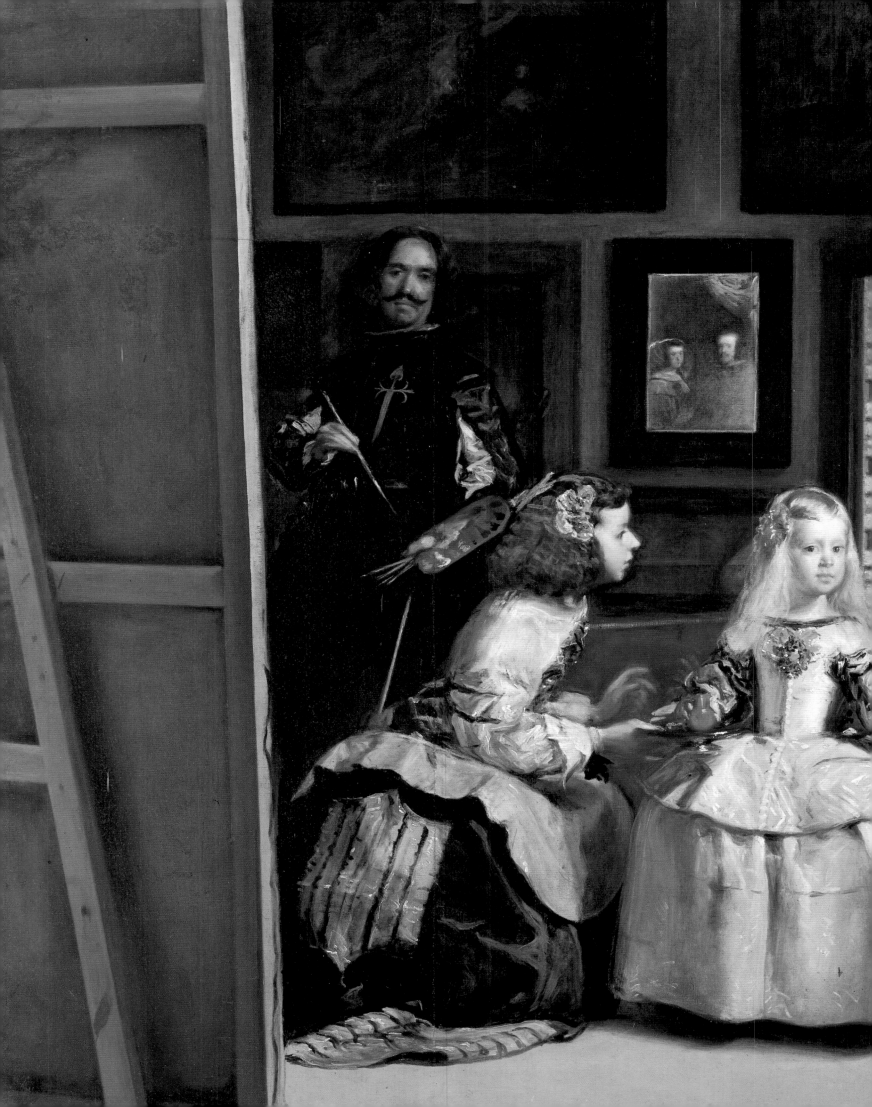

VELÁZQUEZ

Antonio Domínguez Ortiz

Alfonso E. Pérez Sánchez

Julián Gállego

THE METROPOLITAN MUSEUM OF ART

DISTRIBUTED BY HARRY N. ABRAMS, INC.

This publication is issued in connection with the exhibition *Velázquez*, held at The Metropolitan Museum of Art from October 3, 1989, to January 7, 1990.

The exhibition is made possible by Banco Hispano Americano.

Transportation assistance has been provided by Iberia Airlines of Spain.

This exhibition has been organized by The Metropolitan Museum of Art with the special collaboration of the Museo del Prado. An indemnity has been granted by the Federal Council on the Arts and the Humanities.

Published by The Metropolitan Museum of Art, New York
John P. O'Neill, Editor in Chief
Kathleen Howard, Editor
Gerald Pryor, Designer
Gwen Roginsky, Production Manager

Type set in Ehrhardt by U.S. Lithograph, typographers, New York
Printed on Mediaprint 150 gsm
Color separations by Cromoarte, Barcelona
Printed by Julio Soto Impresor, S.A., Madrid
Bound by Encuadernación Ramos, S.A., Madrid

Catalogue translated from the Spanish by Margaret Sayers Peden ("Velázquez and His Art" and nos. 6, 7, 8, 9, 11, 12, 19, 21, 23, 24, 26, 29, 32, 33, 34, 36, 39, and 40); Ernst von Hagen, Bertrand Languages, Inc. (nos. 1, 2, 3, 4, 5, 10, 13, 14, 15, 16, 17, 18, 20, 22, 25, 27, 28, 30, 31, 35, 37, and 38); and Everett Rice ("Velázquez and His Time").

Library of Congress Cataloging-in-Publication Data

Pérez Sánchez, Alfonso E.
 Velázquez / by Alfonso E. Pérez Sánchez,
 Antonio Domínguez Ortiz, Julián Gállego.
 p. cm.
 Catalog of an exhibition.
 Bibliography. p.
 Includes index.
 ISBN 0–87099–554–5. —ISBN 0–87099–554–5
 (pbk.). —ISBN 0–8109–3906–1 (Abrams)
 1. Velázquez, Diego, 1599–1660—Exhibitions. I. Domínguez
Ortiz, Antonio. II. Gállego, Julián. III. Metropolitan Museum
of Art (New York, N.Y.) IV. Title.
ND813.V4A4 1989 89–12670
759.6—dc20 CIP

FRONTISPIECE: Velázquez. Detail of *Las Meninas.* Museo del Prado, Madrid.

COVER: Velázquez. Detail of *Prince Baltasar Carlos as a Hunter* (pl. 22). Museo del Prado, Madrid.

To John M. Brealey

With affection and esteem
The Metropolitan Museum of Art and the Museo del Prado
dedicate this catalogue and the exhibition it documents

LIST OF LENDERS

AUSTRIA

Kunsthistorisches Museum, Vienna

GREAT BRITAIN

National Gallery of Scotland, Edinburgh
National Gallery, London
Wellington Museum, London
His Grace the Duke of Westminster

SPAIN

Monastery of San Lorenzo el Real de El Escorial
Museo del Prado, Madrid

UNITED STATES

Museum of Fine Arts, Boston
Cleveland Museum of Art
Dallas Museum of Art
Meadows Museum, Southern Methodist University, Dallas
Kimbell Art Museum, Fort Worth
The Metropolitan Museum of Art, New York
Private collection, New York
John and Mable Ringling Museum of Art, Sarasota
National Gallery of Art, Washington, D.C.

CONTENTS

CORPORATE STATEMENT

Founded in 1901, Banco Hispano Americano has long been involved in the world of culture. Most of its artistic activities have centered on the exhibition of the bank's own outstanding collection, whose treasures include works by El Greco, Rubens, Van Dyck, Zurbarán, Alonso Cano, Joaquín Sorolla, Picasso, Joan Miró, and Antoni Tàpies. Given our corporate history and our position as one of Spain's largest banks, we are especially proud of our collaboration with The Metropolitan Museum of Art in the presentation of this magnificent exhibition of works by Velázquez, the preeminent painter of the Spanish Golden Age.

Assembling this exhibition from the holdings of the Museo del Prado, Madrid, and of European and American collections involved remarkable cooperation between the Prado, the Metropolitan Museum, the Spanish Ministry of Culture, and the other lenders. This is the first exhibition outside Spain devoted to the master from Seville, and given the importance and fragility of his works, it is unlikely that such an extensive showing will ever be repeated. This event is therefore a unique and happy occasion, and we are pleased to have played a part in giving the American public an unprecedented view of one of the greatest of artists.

Claudio Boada
Chairman
Banco Hispano Americano

FOREWORD

"The very notion of a Velázquez exhibition is one that most of us have dismissed as belonging to the realm of unrealizable dreams, so great and rare a painter is he. Almost half of his paintings are in the Prado, and in the few other collections where they appear, they are so highly valued that their loan is seldom seriously envisaged." These are words I spoke to the press last spring in an élan of enthusiasm.

While this may seem an unconventional way to open the preface of a major institution's scholarly catalogue for a serious exhibition, I believe the special place of Velázquez in the pantheon of painters makes this little indulgence acceptable. Velázquez is considered one of the greatest painters of all time—indeed a few years ago I was fascinated to see that he came out first in a *London Sunday Times* poll of some fifty museum curators, critics, and artists—and museums feel an extremely proprietary attitude toward any of his works they are fortunate enough to have. This protectiveness arises not only from the intrinsic value of Velázquez's paintings but also from their great rarity— his oeuvre numbers little more than one hundred paintings, many of which are preserved at the Museo del Prado in Madrid.

For these reasons, perhaps, no major exhibition of Velázquez's work has ever been held outside Spain, and, as such, it is with immense pride and pleasure that we acknowledge those individuals and institutions who made both the exhibition and its catalogue possible.

First and foremost, The Metropolitan Museum of Art wishes to record its profound gratitude to the Museo del Prado and to the Spanish Ministry of Culture. In particular, we thank Javier Solana, Minister of Education, who, as Minister of Culture in 1987, supported this project when it was little more than a happy idea. We are indebted as well to his eminent successor, Jorge Semprún, for his continued assistance and wholehearted endorsement of the exhibition. Miguel Satrustegui Gil Delgado, former Undersecretary in the Ministry of Culture, ably guided this undertaking from the initial stages to its successful completion, solving all problems graciously and making our every encounter with the ministry pleasurable and rewarding.

Above all, this unprecedented exhibition owes its being to the unfailing cooperation and expertise of Alfonso E. Pérez Sánchez, Director of the Museo del Prado. As a result of his remarkable and courageous initiative, John M. Brealey, Sherman Fairchild Chairman of Paintings Conservation at the Metropolitan Museum, undertook in 1987 a special consultancy at the Prado, where he was entrusted with the task of overseeing and restructuring its conservation program. Many of the paintings in this exhibition were cleaned under Mr. Brealey's supervision by the Prado's team of restorers and conservators, to whom we offer our sincere thanks for their fine work. Mr. Brealey's challenging task, and our own negotiations with the Prado, benefited from the constant help of Manuela B. Mena Marqués, Deputy Director of the Prado, who handled a wide variety of logistic problems with exemplary resourcefulness and goodwill. We are grateful to the Real Patronato del Museo del Prado for its support of this important project. Special mention must also be made of the Patrimonio Nacional of Spain and the kind cooperation of its Chairman, Manuel Gómez de Pablos, who agreed to lend, at relatively short notice, *Joseph's Bloody Coat Brought to Jacob* from the Patrimonio's collection at El Escorial.

Other friends and colleagues in Spain have also offered help at critical points. The Banco Hispano Americano was a ready and gracious sponsor, and we acknowledge with special pleasure the key role played by its General Manager, Alvaro Fernandez-Villaverde, the Duke of San Carlos. We are grateful to Mr. Pérez Sánchez and to Antonio Domínguez Ortiz, Real Academia de la Historia, Madrid, for their elegant introductory essays and to Julián Gállego, Real Academia de Bellas Artes de San Fernando, Madrid, for his scholarly discussions of the individual paintings. A loyal friend to the Metropolitan in many ways, Santiago Saavedra assisted the Museum's Editorial Department in the production of the catalogue. Finally, to Plácido Arango, whose friendship and encouragement we value so highly, we extend thanks and a warm welcome to the Metropolitan as a member of the Visiting Committee of the Department of Paintings Conservation and of the Chairman's Council.

We are also grateful to Mrs. Renata Propper for her kind assistance with an important loan and to William Jordan for his sage counsel.

Following the wise advice of Mr. Pérez Sánchez, we augmented the works from the Prado with other Velázquez paintings from European and American collections, and we were greatly heartened by the extraordinary generosity of museum colleagues on both sides of the Atlantic. Velázquez's youthful years are documented by works graciously lent by the National Gallery of Scotland and the Wellington Museum. Almost every accepted painting by Velázquez in American collections has been lent; the notable exceptions are the works in the Hispanic Society of America and the Frick Collection —the charters of these institutions prohibit loans—but since both museums are in Manhattan, our visitors will be able to see these paintings.

At the Metropolitan Museum, Everett Fahy, John Pope-Hennessy Chairman, Department of European Paintings, shaped the exhibition as it expanded to include key loans from museums outside Spain and oversaw all aspects of its presentation. He worked closely with David Harvey, Designer, and was ably assisted especially by Patrick Lenaghan, a promising student at the Institute of Fine Arts. John P. O'Neill, Editor in Chief, directed the making of this catalogue, which was astutely shaped and edited by Kathleen Howard, Senior Editor, and was produced on an exacting schedule by Gwen Roginsky, Production Manager. The Department of Paintings Conservation—in particular, Gisela Helmkampf and Lucy Belloli —deserves the Museum's special gratitude, not only for enduring the absence of Mr. Brealey while he worked in Madrid but also for help with this exhibition. Zahira Veliz spent many months at the Prado assisting Mr. Brealey, and we are greatly indebted to her. Other individuals whose efforts have been essential to the success of this exhibition are Emily K. Rafferty, Vice President for Development, Linda Sylling, Assistant Manager for Operations, and Lita Semerad, Executive Assistant, Operations. Martha Deese, Assistant for Exhibitions, maintained numerous organizational details in exemplary order. Mahrukh Tarapor, Assistant Director, was the project's mainstay; her diplomatic skills assured the smooth implementation and ultimate success of this complex and important exhibition.

Philippe de Montebello
Director
The Metropolitan Museum of Art

VELÁZQUEZ

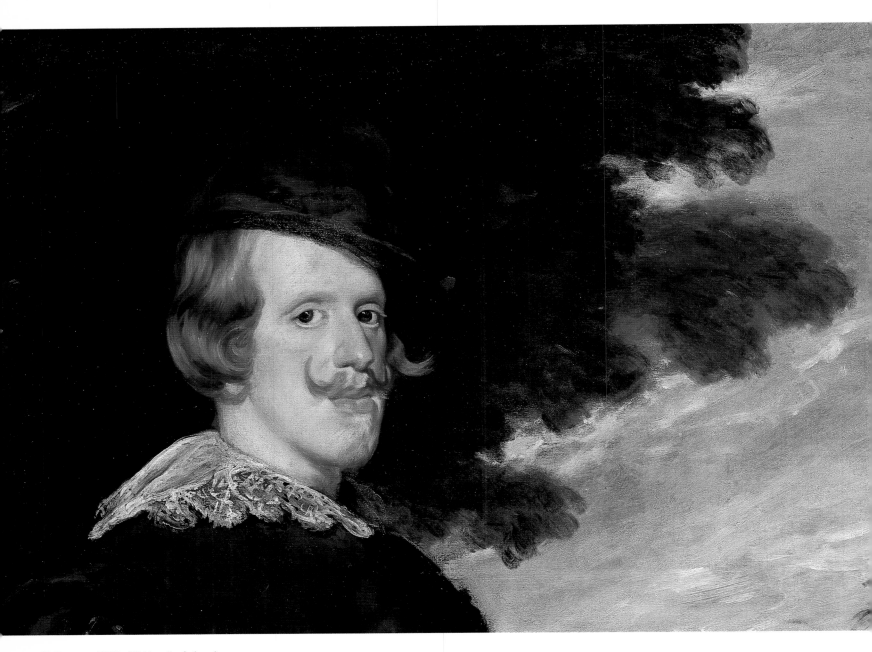

Velázquez. *Philip IV* (detail of pl. 20).

VELÁZQUEZ AND HIS TIME

Antonio Domínguez Ortiz

THE LIFETIME OF DON DIEGO DE SILVA VELÁZQUEZ coincides with a well-defined period in the history of Spain. He was born in 1599, a year after the death of Philip II. Although symptoms of decline were apparent in the Spanish empire, Spain was still by far the greatest and most formidable European power. Velázquez died in 1660, a year after the Treaty of the Pyrenees had confirmed the transference of European hegemony to the France of Louis XIV. During these sixty-one years all Europe was beset by upheavals, sinister in the main, which caused the seventeenth century to be called *El Siglo de Hierro,* the Age of Iron. There were disastrous wars, bloody revolts, massacres that horrified contemporaries, and an event that produced astonishment and dismay in a society imbued with an almost religious respect for the monarchy: the death of a king—Charles I of England—on the scaffold.

Europe at that time had imprecise boundaries. The northernmost reaches were almost terra incognita. The Mediterranean was to a large extent in the hands of Turks and Berbers, and the coasts of the Christian nations were under the constant threat of pirates. The greatest uncertainties lay to the East. The Ottoman empire, which reached the gates of Vienna, and Russia, immense, backward, and remote, formed a world apart. In short, "Europe" was much smaller than it is today; however, to the West, like a promise, stretched America, then being colonized.

This "smaller" Europe was divided by political and religious discord; the old unified monarchies (Spain, France, England) competed for predominance over the small Italian and German states that had not yet achieved unity. These political rivalries were compounded by religious ones, which seemed to be dying down at the beginning of the seventeenth century but which soon burst out with immense fury. The combination of the political and the religious produced strange alliances, as could be seen in the Thirty Years' War (1618–48), which from its religious origins drifted more and more toward political conflict and ended with a Protestant victory, thanks to the intervention of France, a Catholic power. It is astounding that a Europe so beset by all kinds of disasters could generate such great creative energy —the age of Velázquez is also that of Rembrandt, Bernini, Pascal, Galileo, Monteverdi, and many other giants of science, art, and literature.

Spanish culture during this period had, however, significant asymmetry. At Velázquez's death, despite deep internal crisis, the visual arts were established at a very high level; but Spanish literature, which had been marked by brilliant works in the first half of the century,

was in serious decline. The principal weakness of Spanish culture, however, was its failure to participate in the rise of modern science. At a time when economics and the art of war were beginning a process of rationalization that would require a rapid increase in scientific literacy, this deficiency exacerbated the effect of other negative factors present in the Spanish Monarchy, whether they were material ones, such as the low density of the population, or spiritual ones, such as religious intolerance, an exaggerated sense of honor, and a contempt for manual labor. These factors were not exclusive to Spain, but there they had special significance.

Much of the blame for Spain's failure to keep pace with the leading European powers has been placed on its isolation, which is rather paradoxical since Spain, the center of a far-flung empire, maintained extensive international relations. Its connections with France were especially close, both on an official level and on popular and literary ones. Isabella of Valois, Philip II's third wife, was a princess of the royal house of France. At the beginning of the seventeenth century, when the Bourbons had supplanted the Valois, a double marriage was arranged between the future Louis XIII and Anne of Austria, the sister of Philip III of Spain, and between the latter's son (the future Philip IV) and Isabella of Bourbon. Nevertheless, these family ties did not keep relations between the two monarchies from suffering steady deterioration until they finally reached open confrontation.

Frequent wars between France and Spain did not, however, impede the development of a feeling of mutual respect or the cultivation of the Castilian language in France—*"Ni hombre ni mujer deja de aprenderla* [Neither man nor woman fails to learn it]," wrote Cervan-

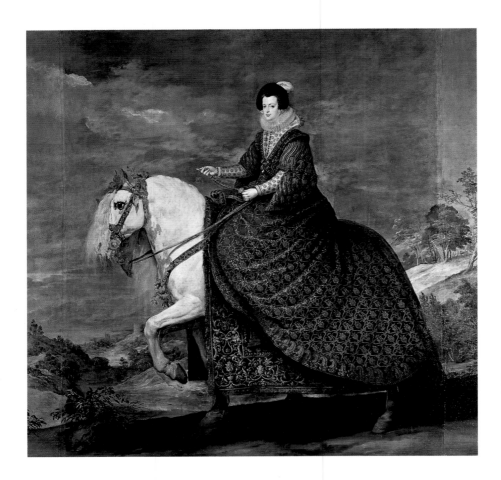

Velázquez. *Queen Isabella of Bourbon* (first wife of Philip IV). Museo del Prado, Madrid.

tes with notorious exaggeration in *Pérsiles y Sigismunda* (1616). Great writers of the Spanish Golden Age such as Guevara, Fray Luis de Granada, Cervantes, and Lope de Vega had many French readers. In 1635, in a Paris threatened by Spanish troops, the public filled the theater where Corneille's *Le Cid*, a play about a Castilian hero, was being performed. The complex love-hate relationship of the Spanish and the French was also reflected in economic life. Considerable numbers of Frenchmen immigrated to Spain; most came from the poorest regions, attracted by the high wages that were being offered in order to fill the gap left by the expulsion of the Moriscos. Many of them took up the humblest of trades; in fact, the model for one of Velázquez's earlier works, *The Waterseller* (pl. 5), was probably a Frenchman who had emigrated from Auvergne or the Pyrenees. French merchants also came to Spain, where they became involved in trade with the Indies or worked in domestic commerce. Some Madrid bookshops had French proprietors, an unsurprising circumstance given that a great number of Spanish books were printed in Paris and Lyons. For these men every new outbreak of hostilities between Spain and France was as much a threat to their businesses as to their persons.

Relations between Spain and the northern countries were less intense, but a number of Flemish artists and craftsmen worked in Spain, and there was a persistent Spanish demand for art objects from the Low Countries. In spite of prolonged hostilities, the Dutch maintained commercial relations and acted as intermediaries for many of the products that Spain needed: among them, grain from Poland and fish, wood, and copper from Sweden. The Hanseatic cities of Germany also had representatives in the ports of Spain. The Anglo-

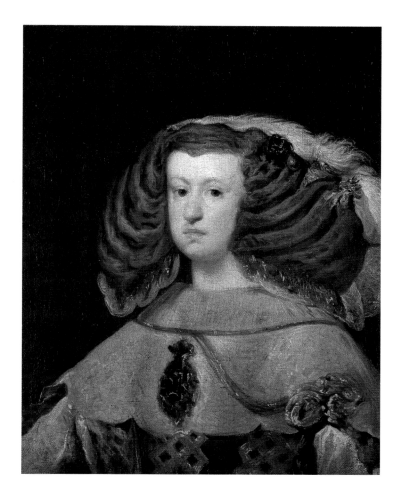

Attributed to Velázquez.
Queen Mariana of Austria
(second wife of Philip IV).
Real Academia de Bellas Artes
de San Fernando, Madrid.

Spanish Peace of 1604 stipulated that English traders were not to be harassed by the Inquisition, and the Dutch and the Germans later obtained the same privilege.

Relations with Austria were facilitated by a commonality of religion, political interests, and dynasty; the Habsburgs of Madrid and those of Vienna supported one another on the international chessboard. In time, the Viennese court adopted the black costume of the Spanish Habsburgs as well as the rigorous etiquette of the Madrid court. In Vienna the Spanish ambassador was second in importance only to the emperor.

With these widespread international contacts, with Spanish soldiers stationed throughout Europe, with an extensive network of confidential agents and spies, and with openness to foreign cultures, how can it be said that Spain was isolated? This estrangement did exist, however, even though it was more spiritual than physical. Contacts with the non-Spanish world were maintained only by a narrow stratum of society. The masses did not trust foreigners, in part because of religious animosity. The decrees promulgated by Philip II prohibiting study at foreign universities and confirming the Inquisition's trials of heretics and prohibition of heterodox literature helped create a climate that was not propitious for intellectual communication. Spain was permeable to literary and artistic influences from abroad, but in the field of science it became more and more isolated. It moved from a relative equality with the other European powers in the sixteenth century to a clearly disadvantaged position in the seventeenth.

There were also political and economic reasons for this decline. The struggle of the Spanish Monarchy against the Protestants of England, the Low Countries, and Germany led to a growing alienation. And the domestic life of seventeenth-century Spain was marked by progressive deterioration. In 1600 Spain had a population of slightly less than eight million inhabitants; this was more than England's but smaller than Italy's and scarcely half France's. This population could not sustain broad international involvements, especially since it also provided emigrants for the colonies in America. The imbalance between Spain's needs and its demographic realities became more noticeable as the seventeenth century progressed. At the beginning of the century a widespread and persistent epidemic took half a million lives. Shortly afterward, during 1609 and 1610, three hundred thousand Moriscos were expelled. This measure caused a great upheaval in the kingdom of Valencia and lesser, though considerable disruptions in Aragon, Murcia, and some regions of Castile. It was widely condemned within Spain and left a deep scar on the collective memory. It was also the subject of a painting, now lost, which Velázquez hoped would be presented at the court of Philip IV (reigned 1621–65), the recently crowned king, who did not approve of the cruel measure adopted by his predecessor.

Catastrophic plagues continued to devastate Spain; an especially severe one, which lasted from 1648 to 1653, caused great loss of life throughout the Mediterranean region, especially in Andalusia. Velázquez's birthplace, Seville, was one of the cities most affected. There was still another protracted and widespread incursion of bubonic plague, in addition to other, more localized epidemics. Each left behind a trail of mourning and desolation that was visible in the art of the period; many paintings, especially those of the Sevillian master

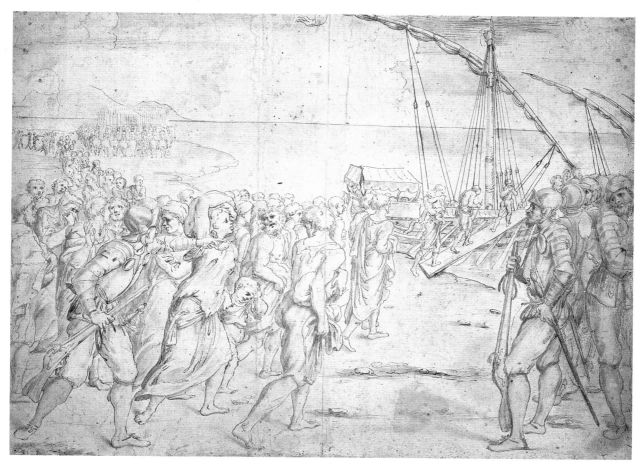

Vicente Carducho. *The Expulsion of the Moriscos.*
Museo del Prado, Madrid.

Valdés Leal, reflect the constant presence of death and the melancholy awareness that worldly goods and pleasures are fragile and transitory. Military losses and emigration to the Indies aggravated the demographic imbalance. The economic crisis impeded or delayed marriages, and births were not sufficient to replace the population lost to death and emigration.

Shifts in population changed the face of Spain. The central regions were drained by immigration to the Mediterranean coastal area, most affected by plague. Many people immigrated to the north as well. In Galicia, Asturias, and the Basque provinces the cultivation of corn had recently been introduced from America. The high yield of this crop made it possible to maintain a more numerous population in those areas. At the end of the seventeenth century the northern regions were the only ones that had experienced a growth in population; the rest of the peninsula remained stagnant, and some parts experienced declines. Castile lost its former predominance in favor of the peripheral regions. Only Madrid grew, at the expense of Toledo, Ávila, Burgos, Segovia, Valladolid, and other cities whose splendid monuments testified to their earlier periods of prosperity.

The decay of the old Castilian cities was caused in part by the departure of noble families, who abandoned their provincial residences and uncomfortable castles for the court. But it was also brought about, in large measure, by the economic crisis that Spain experi-

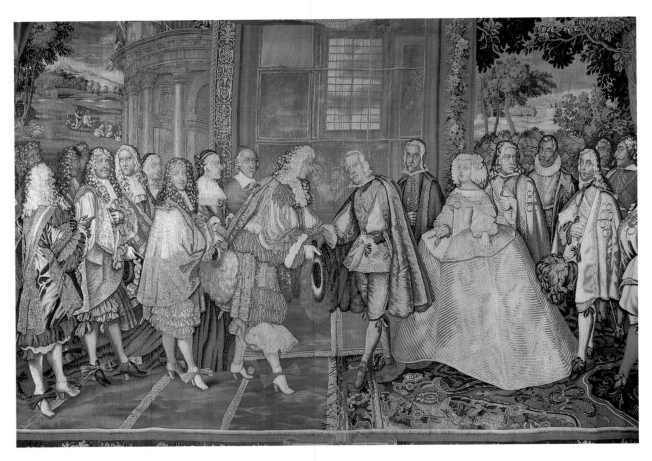

Meeting of Philip IV and Louis XIV at the Isle of Pheasants.
Tapestry designed by Charles Lebrun.
French Embassy, Madrid.

enced in the seventeenth century. This plight has been attributed to various causes. One of the most obvious was industrial competition from foreign nations that were not so shackled by guilds which rigidly regulated private initiative. Richer in capital and technology, other countries were able, especially in the textile industry, to follow the whims of changing fashion. Foreign products were also cheaper because wages and the cost of living were relatively high in Spain. Nor should we overlook the chivalrous mentality of the Spaniards, which led them to disdain mercenary activities and manual labor. Commerce with America fell more and more into the hands of foreigners, and much of the wealth from the New World rapidly disappeared to pay for imports and to meet the expenses of the bellicose foreign policy of the Spanish Habsburgs. A sizable portion of the gold and silver from America was hoarded in the form of jewelry, household furnishings, and liturgical objects; great amounts of silver were stored in Spanish monasteries, convents, palaces, and churches. At the same time, there was a lack of capital for the nation's economic development.

Until 1627 the situation was not especially grave, but then poor harvests, monetary devaluation, inflation, and scarcity caused rapid decay. Developments in international politics caused domestic difficulties. The interminable strife with the Dutch continued, breaking into armed conflict in 1635. Louis XIII and Richelieu found allies among the Protestant powers and even within the Iberian Peninsula itself. In 1640 the Catalans and the Portu-

guese, angered by the burdens imposed by war and the limited respect of the central government for their age-old rights and freedoms, refused obedience to Philip IV and joined forces with his enemies.

Increased efforts to finance multiple wars brought about higher taxes and short-sighted expedients such as the sale of public offices. The state lowered interest on the public debt by fifty percent, causing the ruin of many small investors and a general loss of confidence—no one was willing to lend money to a state that paid little or nothing at all. The Peace of Westphalia (1648), in which Spain recognized the independence of the United Provinces, was the first sign that the Spanish empire no longer held European hegemony. The next step down the slope was the Peace of the Pyrenees (1659). France did not abuse its military advantage but was content with some frontier territories, primarily because the queen mother wanted her son, Louis XIV, to marry María Teresa, daughter of Philip IV (this union took place in 1660). This was not, however, the end of war for exhausted Castile; there remained the recovery of Portugal, for which Philip IV strove in vain until his death.

The political crisis and its economic consequences affected every level of Spanish society, although in different ways. As in all periods of crisis, there were some who profited, especially in the higher bureaucracy and among members of the municipal oligarchies. But far more suffered. Both the nobility and the clergy saw their incomes fall (and thus artistic and literary patronage was reduced). Even so, the number of nobles and clergymen increased —because of the crisis, many people sought to escape its effects by taking refuge in the privileges of the *hidalguía* or the Church. After the war few new monastic institutions were founded, but the existing ones gained new members from the ranks of the bankrupt, those disenchanted with the world, and those avoiding conscription. Numbers increased and quality declined. The same was true of the noble estate, which, having lost its ancient military vocation, had become idle and sedentary. In the first years of the seventeenth century there were still many younger sons of the nobility who enlisted in the renowned *tercios hidalgos* (gentlemen's regiments). (Velázquez left enduring likenesses of these men in *The Surrender of Breda*.) But later there were far fewer volunteers, and it was necessary to resort to forced recruitment. The famed Spanish infantry decreased in numbers and in quality, for want of men and money.

By mid-century dissatisfaction with growing impoverishment was manifested throughout Europe in uprisings that ranged from small food riots to political revolutions of considerable importance. In the Spanish Monarchy itself there were two revolts of consequence—in Catalonia and in Portugal—as well as a long series of lesser conflicts. Both the Catalans and the Portuguese refused obedience to Philip IV, the former temporarily and the latter permanently. In most cases, when the people rioted they acclaimed the king and placed all blame on his ministers. *Viva el rey y muera el mal gobierno* (Long life to the king and death to bad government) was the usual cry. The reason for this attitude lay in a deep-rooted loyalty to the crown which not even sufferings or political disasters could destroy. In the people's eyes the king was the representative of God, and it therefore was forbidden to rebel against him. The king's power was regarded as absolute, but not as tyrannical or des-

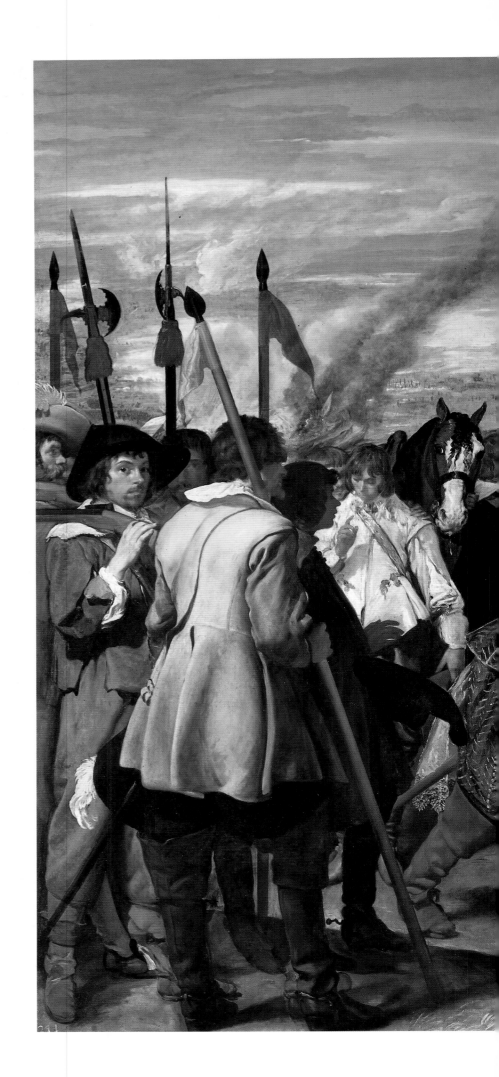

Velázquez. *The Surrender of Breda*.
Museo del Prado, Madrid.

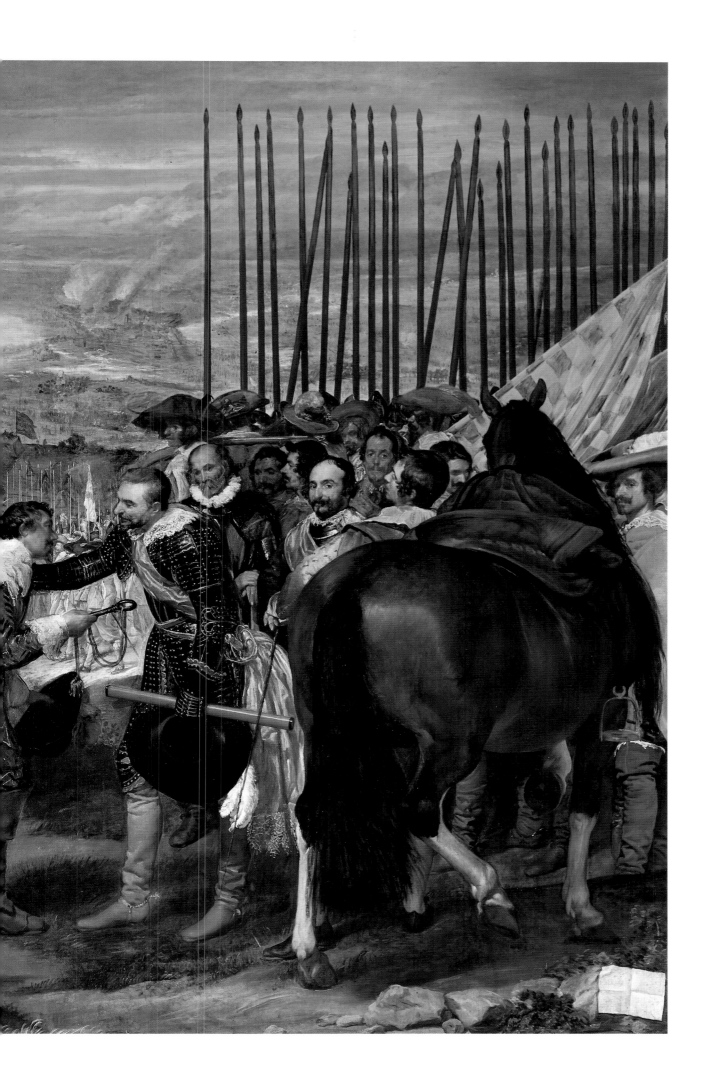

potic. "Absolute" meant that the monarch was not subject to ordinary laws but rather to the law of Nature, to moral law, and to the contract that existed between the sovereign and the nation. For this reason, he could not impose new taxes without the consent of the kingdom, which was represented in the Cortes.

A monarch of such power and authority was expected to lead an existence that differed greatly from that of his subjects. He had to surpass even the highest of them in magnificence. The royal court had to embody the sovereign's majesty, and it was directed by a series of regulations and customs whose purpose was to establish the hierarchies of the king's service and to separate the person of the king from his vassals by means of a complicated ceremonial called *Etiquetas de Palacio*.

Compared to the monarchies of France and England, that of Spain was relatively late in establishing a fixed place of residence. Only in 1561 did Philip II decide to settle permanently in Madrid. Until that time the monarchs of Castile continually roamed their domain, lodging now in old castles or alcazars (Seville, Granada, Toledo, Valladolid) and now in monasteries or convents which had adjoining royal residences (Guadalupe, Poblet, Las Huelgas). The essential members of the central administration moved about with the sovereign. The growth of state bureaucracy made it increasingly inconvenient to have officials, servants, and records forever on the road, traveling continuously. This was, undoubtedly, one of the reasons that prompted Philip II to settle his court. The royal residence was Madrid's Moorish Alcázar, which stood on a hill on the western edge of the city overlooking the Manzanares River. Philip II, who poured so much treasure into building El Escorial, paid scant attention to this citadel. It was left for Philip III and Philip IV to enlarge it and decorate it, but they failed to achieve the grandeur appropriate to the dwelling of the Sovereign of Two Worlds. Its ambience remained gloomy and austere. And, since the administrative offices that attracted a great number of applicants were located in the Alcázar, it lacked space for the royal household. The continuous coming and going of palace servants, bureaucrats, military men, and civilians in search of jobs gave noisy life to the plaza in front of the Alcázar's main entrance.

Eager to please Philip IV, the count-duke of Olivares moved to create another residence: the Buen Retiro Palace, on the eastern side of Madrid. Constructed during the 1630s, it had what the Alcázar lacked: ample space, gardens, fountains, ornamental lakes, cheerful rooms with paintings by noted artists (Velázquez among them), and a theater where plays by the great dramatists of the day were performed. On certain occasions the public was allowed to enter, and the king was freed from elaborate court ceremonial. He also found greater freedom of movement during his stays at the other royal residences which were oriented toward the hunt and which were more pleasant and less sumptuous than his palaces in Madrid. In the course of time an annual routine was established—the king and his intimates alternated his residence in Madrid with stays in El Escorial, Aranjuez, Valsaín, La Zarzuela, and El Pardo. Surrounding all of these royal palaces, there were vast areas of unspoiled forest land set aside for the king's favorite amusement: the chase. (In fact, because they were used for hunting, the Casa de Campo and El Pardo were saved from severe

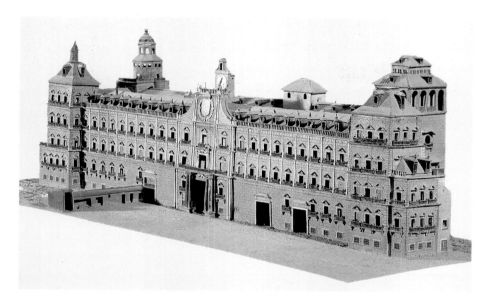

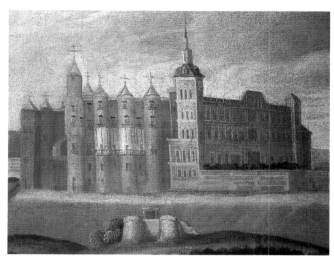

Model of the Alcázar, Madrid.
Museo Municipal, Madrid.

View of the Alcázar, Madrid
(detail of *View of Madrid from the Segovia Bridge*).
Museo Municipal, Madrid.

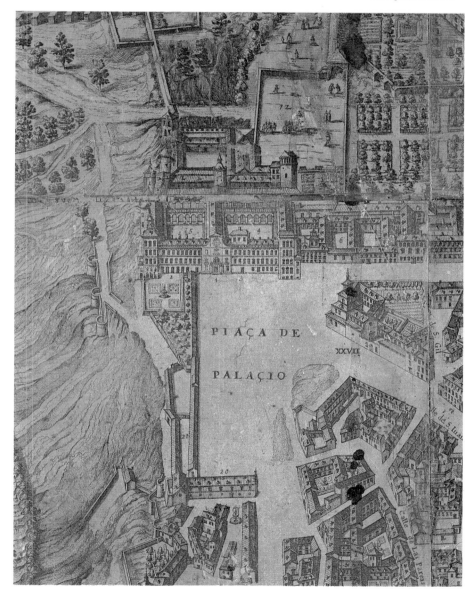

Pedro de Texeira. *Plaza del Alcázar*
(detail of map of Madrid).
Archivo de la Villa, Madrid.

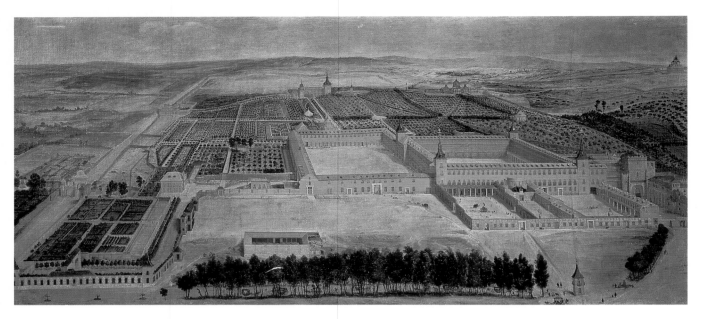

Jusepe Leonardo. *Palacio del Buen Retiro.*
Museo Municipal, Madrid.

deforestation and still display their seventeenth-century settings to the citizens of the Spanish capital.)

This collection of royal palaces required legions of servants and great sums of money for maintenance. These residences formed a royal patrimony, whose administration was separate from that of the state treasury. Inventories describe the countless riches they contained: jewels, furniture, relics, manuscripts, and art objects of incalculable worth. In royal wills mention is often made of unicorn horns which were thought to have marvelous powers.

The court of Madrid was a self-sufficient entity, a veritable city which had every facility and in which thousands of people lived. Here exquisite foodstuffs were prepared for the royal family and high dignitaries, along with more common fare for the multitude of servants. For religious services there was a royal confessor (a most influential cleric) and a royal almoner as well as the chaplains, preachers, and musicians of the royal chapel. Eminent physicians, surgeons, and apothecaries cared for the residents of the court. Transport consisted of carriages, litters, and beasts of burden. Horses and dogs for the royal hunt were under the watchful eye of the master of the king's horse, while the captains of the royal guard concerned themselves with the armed corps, a group that was more decorative than efficient. Just as in the houses of the nobility, at the royal palace there were *hombres de placer*—jesters, dwarfs, and simpletons—whose deformities heightened the splendor of those who were healthy, beautiful, and rich. At the other end of the spectrum there were learned men, eminent literary figures, and distinguished artists. A place of violent contrasts, the court contained humanity in all its forms.

During the reign of the *reyes católicos* Isabella and Ferdinand, the greater nobility had shown a distant, even hostile attitude toward the court, but under the Habsburgs they changed their tactics and approached the sovereigns, offering their services and hoping to receive *mercedes* (rewards), *encomiendas* (land grants), or viceroyalties or other lucrative posts in exchange. Posts as gentlemen-in-waiting were solicited as a great honor. Aristocrats of

the noblest birth aspired to be stewards, equerries, or chamberlains or to attain other high court offices. Charles V had introduced the very rigid etiquette of the Burgundian court. This did not replace Castilian protocol but was superimposed on it, causing much duplication of function and thus great additional expense. In the seventeenth century the expenditure for the royal household amounted to a million ducats annually, in a state budget of less than ten million.

From the outset of Philip IV's reign in 1621, an effort was made to reduce this tremendous outlay. In this matter, as in so many others, the king was guided by Don Gaspar de Guzmán, count of Olivares and later duke of Sanlúcar, who had gained royal favor and was to direct the course of the monarchy until his fall from power in 1643. The phenomenon of the *privado* (royal favorite) was not peculiar to Spain. James I and Charles I of England and Louis XIII and Louis XIV of France also had ministers who combined the authority exercised today by a head of government or prime minister with the privilege of intimate

Juan Martínez del Mazo. *The Gardens of the Palace of Aranjuez.* Museo del Prado, Madrid.

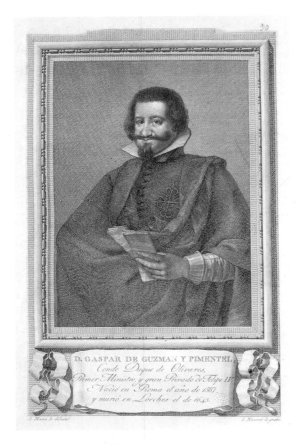

The Count-Duke of Olivares.
Ministro Felipe IV, Madrid.

Church of San Pedro, Seville, where Velázquez
was baptized.

personal friendship with the sovereign. In theory the king scrutinized everything and made all of the decisions; in practice, even with the help of counselors and royal secretaries, this was not possible. If the king wanted to enjoy a life of his own, a favorite behind the throne was indispensable. Such was the relationship between Philip IV and Olivares. The king was a man of great culture who spoke several languages fluently and had exquisite taste, especially in painting. He was never unmindful of the government of the nation, but beneath an impassive appearance, he concealed a passionate nature. He was devoted to his wife, the beautiful Isabella of Bourbon, but he also had numerous mistresses and several bastard children. Olivares lightened the king's labors and allowed him to devote himself to various pleasures, both sensual and artistic, much to the annoyance of his subjects. They blamed his surrender of responsibilities for the ills that plagued the kingdom. The king himself had fits of remorse and feared divine punishment.

Velázquez's biography is, in large part, the story of his artistic activity. Except for his two journeys to Italy, he passed his days in his studio, first in Seville and later in the Alcázar of Madrid. His life was not marked by drama and conflict. Both as an artist and a man, Velázquez fit perfectly into the environment of his time, and he reflects the circumstances in which he lived.

Velázquez was born in Seville, a cradle of artists and a city whose fame and wealth attracted many others. Seville was the port of entry for galleons carrying great treasures from the Indies. With nearly 150,000 inhabitants, it was the most important city in Spain, the residence of noblemen, clerics, and wealthy merchants, many of whom were patrons of writers and artisans.

His father was a native of Portugal, and such mixed heritage was common during this period. The close relations between the two peninsular states had culminated in 1580 with the union of the two crowns. This gave rise to intense immigration among the Portuguese, who made their way in large numbers to the Lower Guadalquivir area. The majority of these people married and settled there. But after Spain's separation from Portugal, initiated in 1640 and accomplished in 1668, the Portuguese began to be looked upon with distrust. (This prejudice was one of the causes of the difficulties, discussed below, that the great artist had in becoming a member of the Order of Santiago.)

The prosperity of Seville began to wane at the outset of the seventeenth century, at the same time that Madrid was growing in importance. After a brief removal of the court to Valladolid (1601–1606), it became clear that the capital would not be changed again. Madrid's population grew until it exceeded that of Seville. Many aristocrats abandoned their provincial residences to build palaces in Madrid, which replaced Seville as a center of patronage of the arts and which thus attracted several great artists, among them Velázquez and Zurbarán. Velázquez's move to Madrid took place in the early years of the reign of Philip IV and was

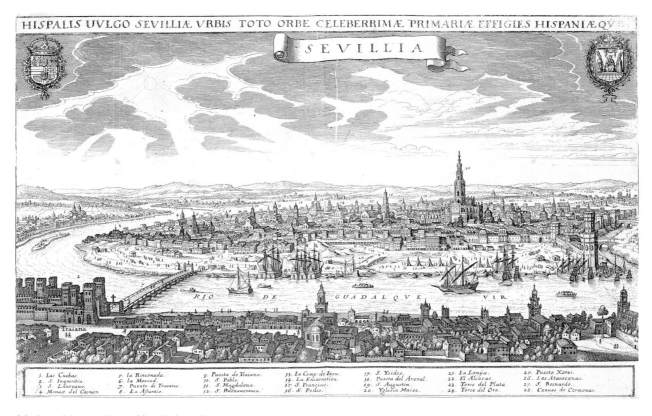

Mathäus Merian. *View of Seville from Triana.*
Biblioteca Nacional, Madrid.

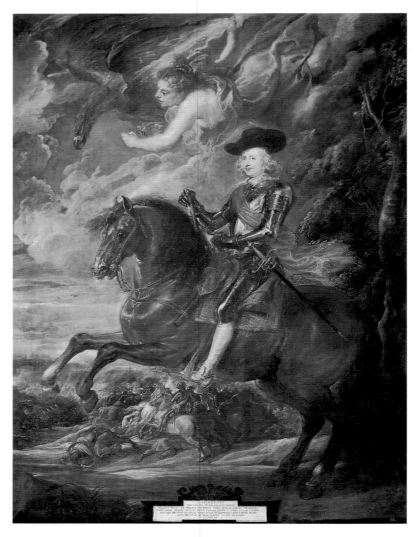

Peter Paul Rubens. *The Cardinal-Infante Ferdinand of Austria
at the Battle of Nördlingen.*
Museo del Prado, Madrid.

made with the support of the king's favorite, Don Gaspar de Guzmán. Although he was
born in Rome, Don Gaspar had always considered himself a Sevillian, just as his father and
his grandfather had been. In his youth in Seville Don Gaspar had frequented the circles in
which writers and artists gathered under the protection of noble patrons. Among the men he
met were Francisco Pacheco, Velázquez's father-in-law, and the lyric poets Juan de Jáuregui
and Francisco de Rioja (the latter was Guzmán's librarian and confidant). When Don Gaspar
de Guzmán achieved absolute power at court, he favored his friends from Seville. Without
such a powerful protector it would have been difficult for Velázquez to overcome the obsta-
cles against his appointment as painter to the king. His career was thus linked to the phe-
nomenon of the *privado*.

Spain's international ties are clearly reflected in Velázquez's artistic career. His only
two journeys abroad (the second one was rather prolonged) took him to Italy, specifically to
Rome, where so many of his compatriots lived and which continued to be an inexhaustible
source of inspiration for artists. His contacts with the Low Countries, the other great center
of culture, were indirect but important; in Seville he had studied Northern paintings from

Flanders and had met a number of Flemish artists. (In 1628, in Madrid, he became a friend of Peter Paul Rubens.) There is less to say about his connections with France, obstructed as they were by almost continuous war. But there are some signs that these relations existed; he was painter to Queen Isabella, and later, as chamberlain of the palace, he worked hard at organizing the journey of the royal family to Fuenterrabía. In fact, the fatigue and worry caused by this journey may have hastened his death. His connection with the court in Vienna, where some of his work may still be seen, had its roots in Habsburg dynastic ties.

Velázquez was typical of his time in his ambition to obtain a public declaration of his noble lineage, probably to refute two widespread prejudices, one concerned with his ancestry and the other with his profession. The Portuguese living in Spain were suspected of being *marranos* (persons of Jewish origin). At the time Velázquez sought the habit of the Order of Santiago, it could not be affirmed or denied that Velázquez's father was a member of this group because war impeded the necessary inquiries. The difficulty relating to his profession was also great. The distinction between artists and craftsmen, which was clear in Italy in the sixteenth century, was recognized much later in Spain, where the studios of even the most eminent artists were still regulated by the rules of the guilds. El Greco had gained a triumph by keeping the paintings he executed for the Hospital of Illescas off the tax rolls. But this was an isolated episode. Throughout the seventeenth century painters continued to struggle for painting to be considered a liberal art and not a manual trade.

Yet another obstacle was the abiding objection of the military establishment to awarding the Spanish military orders, created to reward services in war, to courtiers and bureaucrats. All of these factors explain why, in spite of Philip IV's determination to please a man he admired as an artist and regarded as a friend, the concession of the habit of Santiago to Velázquez was so difficult. It was necessary to ask for dispensation from the Holy See, because the military orders continued, at least in theory, to be religious orders, and Velázquez had to declare that he painted to please and honor the king, and not as a means of earning a living, before he was named a member of the Order of Santiago in November 1659.

Although we know little of Velázquez's thought, his determination to achieve the credentials of nobility and to certify his *limpieza de sangre* (purity of blood) shows the extent to which he shared the mentality of the Spaniards of his day. In a modern drama the distinguished playwright Buero Vallejo has sketched a portrait of a nonconformist Velázquez who is rather like a precursor of Goya—a rebel spirit condemned to live in a society that does not satisfy or understand him. There is nothing, however, to warrant such a depiction. Through his life and work, however, we can surmise that Velázquez's character was far removed from the cruelty, fanaticism, and superstition so rife in that era as well as many others. But at no time did he reject the fundamental values of a society in which he felt totally integrated.

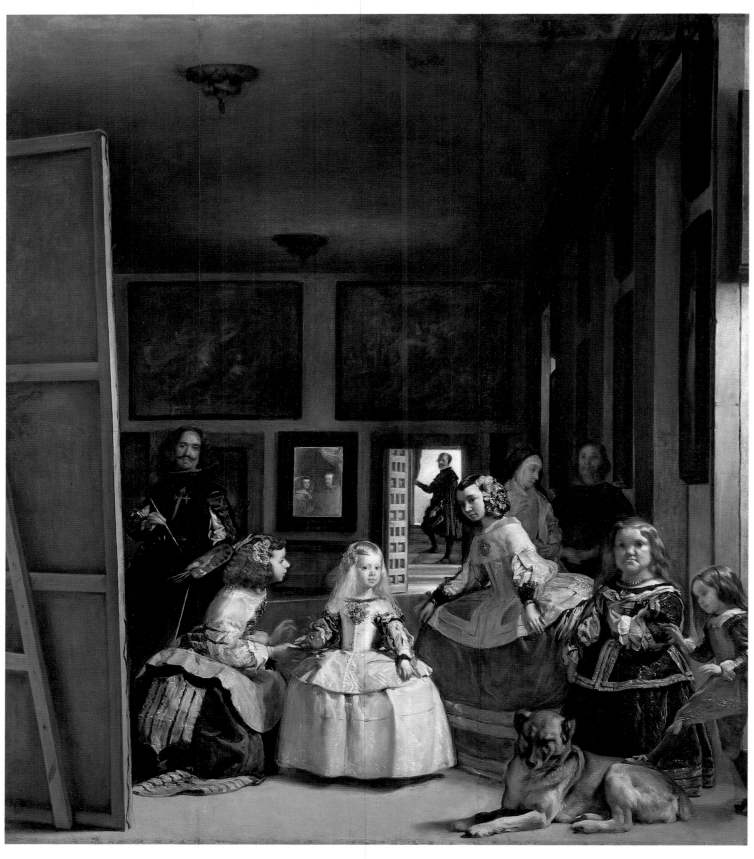

Velázquez. *Las Meninas.*
Museo del Prado, Madrid.

VELÁZQUEZ AND HIS ART

Alfonso E. Pérez Sánchez

VELÁZQUEZ may be, may be forever, the most perfect example of the pure painter, that is, one who besides being gifted with a phenomenal eye also possesses the unerring hand that can freeze reality, suspending it within an instant of radiant life. The poet Rafael Alberti, in a poem describing the temperament of the master from Seville, writes:

> *En tu mano un cincel*
> *pincel se hubiera vuelto,*
> *pincel, sólo pincel,*
> *pájaro suelto.*

> In your hand a chisel
> would have become a brush;
> a brush, an ordinary brush,
> a bird on the wing.

Luca Giordano called Velázquez's *Las Meninas* a "Theology of Painting." Velázquez's biographer Antonio Palomino, repeating the expression, adds: "Meaning that just as Theology is the highest of the Sciences, so that canvas represents the apogee of Painting." Similar praise, coming from the most diverse historical perspectives and most contradictory artistic attitudes, has been repeated through the centuries for this and others of Velázquez's works.

Along with Goya and Picasso, Velázquez is the heart and soul of Spanish painting. And it is his status as a pure painter that is always emphasized. In the eighteenth century, Anton Raphael Mengs, the philosopher-painter and theoretician, father of the most rigorous neoclassicism, said of *Las Meninas* that "it seems as if the hand played no part in its execution, but that it was painted by will alone."

A marvelous, and almost magical, facility that allows paint to flow across the canvas not only with rigorous precision but also with surprising freedom constitutes the major fascination of an artist who offers the viewer no flamboyant flourishes, no images fraught with expressive resonances easily connected with the world we live in, as is the case with Goya. A portraitist above all, with a profound insight into man and man's suffering, Velázquez penetrates to the core of his models and "salvages," as Enrique Lafuente Ferrari so aptly

put it, what is most profoundly personal about them. His manner of confronting kings and plebeians, infantes and buffoons, with identical serenity is paired with his prodigious ability to capture both living things and the faintest palpitation of the landscape.

As has been repeatedly pointed out, Velázquez reveals in all his works an exceptional love for the world and its beings. Carrying the resources of aerial perspective to extremes never before achieved, he had a singular aptitude for bringing reality to life in the two dimensions of the canvas, translated not in terms of tactile objectivity, as the old tradition of Renaissance perspectivism had striven to accomplish, but as pure visual entities. The process of his artistic evolution leads from his beginnings in Seville, impregnated with the tradition of tenebrist naturalism, to the works in which dematerialization is the dominant note; there, nonetheless, the eye perceives what is represented as "truth, not painting"—as Palomino so perceptively noted.

In a parallel trajectory Velázquez developed a full personal career that led from his origins as a hidalgo of modest family to important posts in the palace hierarchy and service to the king—the most honorable occupation to which a Spaniard of his time might aspire—culminating with the cloak of nobility upon being named knight of the Order of Santiago, the most important chivalric order of Spain. As other commentators have noted, performing the dual role of artist and courtier profoundly affected Velázquez's life history; it also marked his artistic production, which was blessedly free of the conditions, limitations, even burdens, that Spanish artists of the time were forced to suffer—inevitably dependent, as they were, upon the patronage of the Church and captive to the pressures of a severely limiting society. As a result of his position in the court, Velázquez is conspicuous in the narrow world of seventeenth-century Spain; he was a cultured man, a reader of the classics, an inquiring traveler who prolonged his sojourns in Italy until the king—half annoyed, half indulgent—was forced to demand his return.

In a Spain where painters had barely risen above the status of craftsmen and where artists of obvious technical ability were illiterate, Velázquez emerges as a figure of surprising independence. To underline the peculiar nature of his situation and his temperament, we need point out only one anomaly: the minimal attention given to religion in his oeuvre, especially during his mature years. In the inventory of his fine library one finds very few books of devotion in comparison to what was usual among people of good breeding and social position. There were, however, numerous books on mathematics, architecture, history, and Spanish and Italian poetry. If one excepts the years of Velázquez's youth in Seville, when as merely one more of the artists of his generation, he had to work for ecclesiastical patrons, religious themes occupy an insignificant position in his works and are always the response (*Christ on the Cross, The Coronation of the Virgin, Saint Anthony Abbot and Saint Paul the Hermit* [pl. 17]) to specific royal assignments. Of course we cannot think of Velázquez as a religious skeptic (an attitude inconceivable and obviously unconfessable in the Spain of the time). In contrast to his contemporaries, however, he distanced himself from conventional religiosity; this absence of the religious is nevertheless accompanied by a dignified and serious tone of mercy toward all creatures, by a "modern" and lay humanism, that makes him unique.

Velázquez is—and this distinguishes him even more in the Spanish world—a painter of mythological subjects, the preferred genre of European high culture. It is significant that one of his most famous creations, *The Weavers*, which through the eighteenth and nineteenth centuries was considered a "realist" painting, a simple representation of a woman tapestry-maker, was in fact a complex fable based on the myth of Pallas and Arachne, a beautiful tale from Ovid, which undoubtedly veiled a severe admonition to any who dared defy authority and power. But in this extremely beautiful painting, as in others in which Velázquez interprets classical myths, his sensitive and transcendent love for the ordinary caused him to clothe the gods and heroes in an immediate reality. Just as the art of the Catholic Counter-Reformation, in representing sacred figures with very human appearances, had restored a kind of quotidian intimacy to these subjects that made them more accessible to the veneration and affection of the faithful, so too Velázquez humanized the ancient gods and brought them closer to ordinary comprehension, expressly and consciously renouncing sentiment, along with the heroic and Olympian.

Velázquez is clearly an artist of the immediate. He can seem to be easy and direct. But his apparent realism is quite different from that of the nineteenth-century naturalist movements to which he has on occasion been considered a predecessor and through whose system of optics he has frequently been judged.

As the son of his time, the great century of the baroque, Velázquez created an art that, in its seeming immediacy and clarity, admits numerous enigmas. The multiple, complex, and at times cabalistic interpretations which in recent years have been offered for some of his more famous works—*Las Meninas, The Weavers*, even some of his youthful *bodegones*—reveal richness, complexity, and a multiplicity of possible readings. Like the *conceptista* poets who were his contemporaries, Velázquez plays with ideas and refines them in conceits of apparent transparency. This artist is above all an eye that observes with amazing intensity and a hand that records with astonishing sureness and precision. But both are at the service of an intelligence whose silent reserve and meditative objectivity create an aura of mystery.

Diego Rodríguez de Silva y Velázquez was born in Seville in 1599. Although many years later he would try, without notable success, to establish the nobility of his family line, it seems certain that both on the Portuguese paternal side (the Silvas) and the Sevillian maternal side (the Velázquez), his ancestors were indeed hidalgos, although members of the lesser nobility without significant wealth or social position. It is possible, as has recently been proposed, that he may have had distant Jewish ties, like many of the Portuguese families that settled in Seville at the end of the sixteenth century.

In 1599 Seville was the richest and most populous city in Spain; it was inarguably the most open, complex, and cosmopolitan city in the entire empire. By royal decree it enjoyed a monopoly on commerce with America, and this privilege attracted to it a rich colony of Flemish and Italian (especially Genoese) merchants who lent the city an air of animation, vitality, and unparalleled wealth. But alongside an ancient cultured nobility, the humanist ambience of the first half of the century, and the commercial bourgeoisie created

by the gold of America, there also thrived a motley underculture of adventurers, picaros, and shady characters living on the fringe of organized society, who frequented the brothels, filled the hospitals, and lined up every day for the gruel the convents provided to the poor. The prison of Seville was infamous; its picaresque world appears with remarkable verisimilitude in some of Cervantes's *Novelas ejemplares* (*Exemplary Novels*), and the city itself sometimes served as the colorful setting of plays by such dramatists of the Spanish Golden Age as Lope de Vega and Tirso de Molina.

It was within this varied and lively urban life that the young Velázquez, artistically gifted from childhood, began his training. Sometime in 1609, when barely ten, he spent some months in the workshop of Herrera the Elder, a prestigious and innovative painter no less renowned for his irascible character. Velázquez, it seems, could not abide him, and in 1610 he signed a contract as apprentice to the painter Francisco Pacheco, a man of character and temperament quite different from that of Herrera the Elder.

Pacheco (1564–1644) has passed into the history of Spanish art more as a writer and as a teacher of Velázquez than as a painter. The nephew of a respected canon of the cathedral of Seville, who protected him and bore the cost of his studies, Pacheco is a singular example of the literate, erudite artist well-acquainted with classical literature, one who— independent of his art, which was slightly old-fashioned and trivialized by a mediocre talent— played a very important role in the artistic life of Seville. He enjoyed considerable prestige in Church circles and participated in a very influential way in Sevillian literary groups; these *tertulias* were often modeled on the Italian academies, bringing together members of the local nobility, cultured clergymen, and artists of pen or brush. Well-versed in theology but also imbued with the brilliant humanism of Seville, Pacheco was the supreme embodiment of a type common during the Spanish Counter-Reformation: a faithful servant of a Church defending itself against Protestant reform with closed and intransigent dogmatism, but also a person who, with a bow to moral allegory, demonstrated an evident familiarity with classical tradition and the gods and goddesses of pagan Olympus.

A man of inquisitive mind, preoccupied with the dignity of the art of painting—which in Spain was still considered a humble profession—Pacheco was the author of an important treatise (*Arte de la pintura*), published posthumously in 1649, that is still the basic source for information on the contemporary artistic life of Seville and to a lesser extent of Spain. His book records theory, in which he is revealed as a faithful follower of the idealist tradition of the sixteenth century, a bit behind the times in respect to Italian and Flemish advances in naturalist painting. He also discusses practice and provides an extraordinary richness of detail regarding everyday activities in artists' studios and the daily influence of religion in the professional life of artists.

As a painter, Pacheco was a modest man, faithful to the Flemish tradition of Sevillian painting and to the models of Raphael and Michelangelo, which he interpreted with a certain dryness and hardness. Nevertheless, his love for the concrete shines in excellent portraits in red and black chalk, executed in preparation for a book of "true portraits" of Sevillian personalities, some of which have been preserved. And Pacheco knew how to direct his disciples

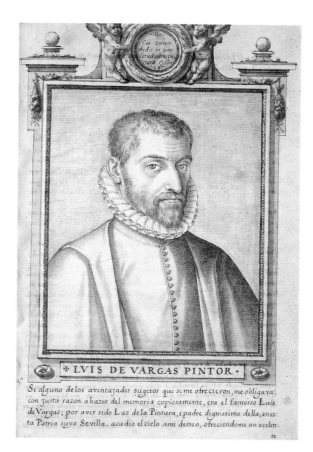

Francisco Pacheco. Title page,
Arte de la pintura.
Instituto Valencia de Don Juan, Madrid.

Francisco Pacheco. *Luis de Vargas,*
from *Libro de verdaderos retratos.*
Museo Lázaro Galdiano, Madrid.

toward the new ideas of emerging naturalism without forcing or limiting their abilities.

Pacheco's workshop was a center for social gatherings of cultured clergymen, noble patrons, musicians, poets, and people of varying conditions and intellectual preoccupations. This is the ambience in which the adolescent Velázquez must have moved during the six years in which, according to the terms of the carefully drawn contract, he was bound to his master, serving him "in everything that he said and ordered that was seemly and possible to do," while Pacheco taught him art "well and fully, according to all he knew of it, without concealing any part thereof." In 1617, upon fulfilling the terms of his contract, Velázquez was examined before the artists' guild of the city of Seville; registered as a member, he was empowered to exercise his trade freely and to open a shop and receive officials and apprentices according to the Spanish custom.

One year later, in April 1618, before he had reached the age of twenty, Velázquez married the daughter of his master Pacheco. Pacheco had seen in the youth, as he expressly stated, "virtue, integrity, and talent, and expectations for his innate and impressive skill" and had wanted—following the tradition of Sevillian workshops, knit together by bonds of kinship that created a tight web of interests guaranteeing work and commissions—to bind him conclusively to his house and trade. The young artist would then continue the tradition of his father-in-law's workshop, entirely dependent, like other painters of the time, on the

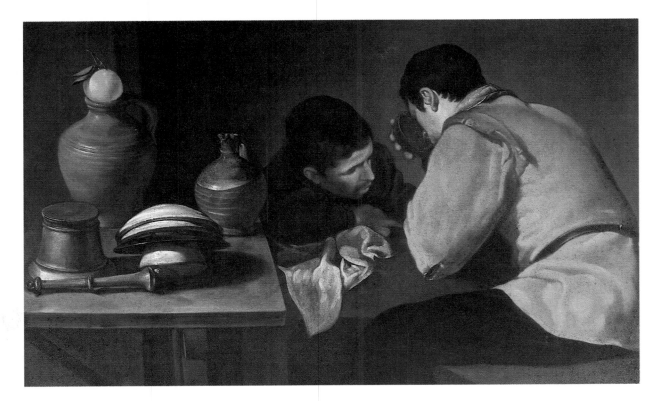

Velázquez. *Two Men at Table.*
Wellington Museum, London.

demands of an almost exclusively ecclesiastical patronage. The professional horizons that lay before the twenty-year-old Velázquez, the possibilities for work that awaited him, were no different from those his father-in-law had known or from those open to Zurbarán, his contemporary: religious painting, devotional canvases, monastic cycles and portraits, and an occasional ruggedly intense portrait or rigidly arranged still life.

The idealist atmosphere of the late Renaissance in which the elder Pacheco had been formed was giving way to the study from life. A naturalist mode was being shaped that the Church would wisely employ to make religion more accessible and, through the direct image filled with ordinary emotion, to combat the intellectual abstraction of the Protestant reform. The young Velázquez was interested in the most immediate aspects of reality and had an exceptional ability to reproduce them. His father-in-law and master tells us how "being a lad, he had bribed a peasant apprentice to serve him as model in divers attitudes and postures, now weeping, now laughing, indifferent to any difficulty." We can easily identify this young peasant in some of Velázquez's youthful canvases, where his rustic but tender childish face soon becomes familiar to us.

During those initial years, still in Pacheco's studio or newly graduated from it, Velázquez attempted—and achieved with extraordinary rapidity and control—to master the study from life, the formulaic "relief" and "qualities," employing the novel artifice of tenebrism, the strongly focused light that accentuated volumes and almost magically dramatized the most ordinary objects by drawing them into a foreground of light and importance. This genre

painting or *bodegón*—Flemish in origin, with its lower class subjects and everyday objects—was an excellent testing ground, and some of the canvases painted by the young artist in those years were probably nothing more than exercises in virtuosity. Velázquez kept for himself the most important works of that first period (*The Waterseller* [pl. 5]; *Two Men at Table* [Wellington Museum, London]), and the fact that he may have carried them with him to Madrid as proof of his mastery seems to confirm this thesis.

But along with these genre paintings, in which recent critics have seen a rather veiled allegorical or moralizing intent, the young artist, as was logical, also turned his attention to religious subjects. In this vein Velázquez produced a series of works of pious nature, surprisingly conceived as genre paintings, in which the viewer first perceives a kitchen or tavern scene; in the background—in the distance or disguised with some ingenious compositional artifice—the viewer then sees a biblical or evangelical episode, situated in a lesser or secondary space and containing figures on a much smaller scale. Canvases such as these (*Christ in the House of Martha and Mary* [National Gallery, London]; *The Supper at Emmaus* [National Gallery of Ireland, Dublin]) were inspired directly by specific works of Flemish mannerism—by Pieter Aertsen and Joachim Beuckelaer, among others. The compositions are complicated by a conscious ambiguity that makes it unclear whether the vignette that appears in the

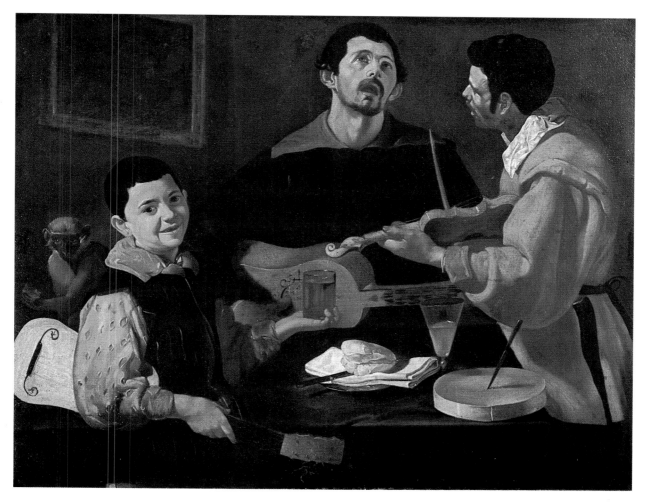

Velázquez. *Three Musicians.*
Gemäldegalerie, Berlin.

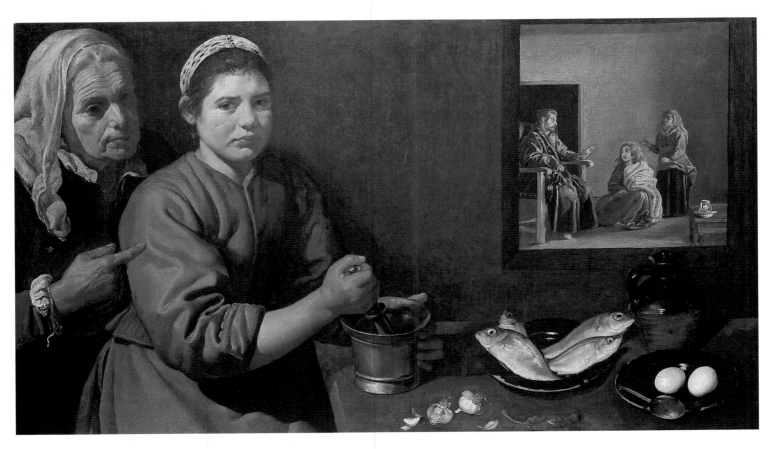

Velázquez. *Christ in the House of Martha and Mary.*
National Gallery, London.

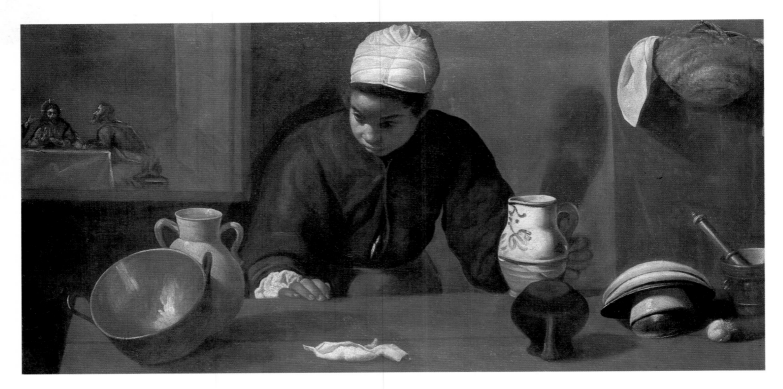

Velázquez. *The Supper at Emmaus.*
National Gallery of Ireland, Dublin.

background—and whose meaning is fundamental for understanding the work—is a real action taking place in a different room seen through an opening or a door, a scene in a painting hanging on the wall, or (as has been suggested recently, perhaps correctly) a reflection in a mirror of an event happening not behind the secondary characters but in front of them and therefore in the place where the viewer stands.

These canvases—as *Las Meninas* would later be—are a display of *conceptismo* (conceits in the mannerist tradition), to which Velázquez's virtuosity lends an atmosphere of truth; their baroque complexity made them suitable for hanging in the private gallery of some devout humanist or Sevillian aristocrat who valued the exceptional. But there are other works of more simple devotional character, like *The Immaculate Conception* and *The Vision of Saint John the Evangelist* (both in the National Gallery, London; originally in the Convent of the Carmelites in Seville). From the compositional point of view, both canvases are entirely conservative and are related to the style of Pacheco's drawings and paintings, but the rounded volumes, the intense chiaroscuro, the range of color, of warm, extremely personal tones with thickly daubed notes of gray-whites, and the vivid individualism of the faces place these paintings in the absolute vanguard of the naturalist style. Even more advanced, in spite of the traditional scheme, is *The Adoration of the Magi* (1619; pl. 2) and the remaining apostles of a dispersed group (*Saint Paul*, Museo de Arte, Barcelona; *Saint Thomas*, Musée des Beaux-Arts, Orléans). These paintings emphatically underscore Velázquez's exceptional skill in capturing a strong and expressive reality, while nonetheless realizing a religious intensity not very distant from that Zurbarán was achieving in these and later years. Because of this fascinating ability to capture the subject from life, to communicate perfectly what was most personal and characteristic of each being, Velázquez was supremely suited for the genre of the portrait, where he was soon to show an identical ability to transmit the internal life, the secret impulses, the raison d'être, of his sitter. His superb portrait of *Mother Jerónima de la Fuente* (1620; pl. 3), known in at least two versions of equal intensity, is a splendid example of his exceptional gift for suggesting the fierce, almost superhuman energy of the nun who at the age of sixty-six left Seville to undertake the adventure of founding a convent in the Philippines, clasping her crucifix almost as she would a weapon.

In all these early canvases, as Palomino pointed out, Velázquez uses a thick, modeling impasto that recalls the style of Luis Tristán. His drawing is precise and intricate; he carefully completes forms and pays close attention to detail. Color is predominantly earthy, thick clays and ochers, also in the style of Tristán, with intense patches of deep greens, dark yellows, and warm reds; shadow is heavy, with inky tones that exaggerate the already dark tenebrism. There is something in the roundness and precision of volumes in these early works, in the power and relief resulting from the sharply focused light, that suggests the effects of polychrome sculpture.

Beginnings of Velázquez's Career at Court

In 1621 Philip III died in Madrid, and the new monarch, the youthful Philip IV, granted favor to a Sevillian noble born in Rome, Don Gaspar de Guzmán, count of Olivares—soon

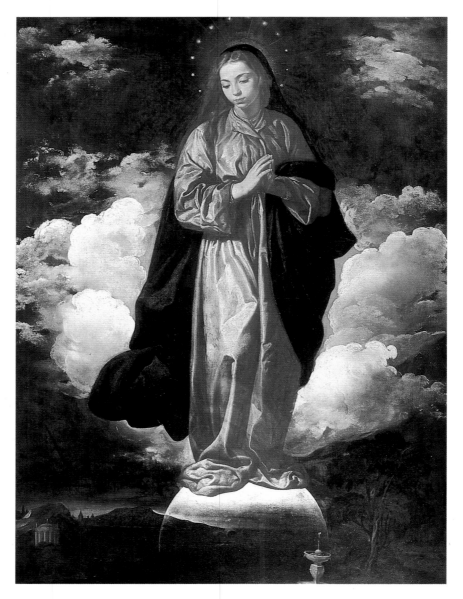

Velázquez. *The Immaculate Conception.*
National Gallery, London.

to be count-duke—who quickly became the king's all-powerful favorite. The presence of Olivares in such a high position caused uneasiness among the intellectuals and artists of Seville, but many saw in him the possibility of an entrée into court life.

Pacheco must immediately have grasped the possibilities, and he arranged for his disciple and son-in-law to test his fortune in Madrid, where he was sure Velázquez's extraordinary talents would not pass unnoticed. A first trip in 1622 does not seem to have produced the desired effect, but it did allow Velázquez to meet individuals of influence in palace society, to paint Luis de Góngora (pl. 4) at the behest of his father-in-law, and to see, perhaps for the first time, the royal collections that were to contribute so greatly to his definitive character and the transformation of his art.

In the summer of 1623, however, through the good offices of friends of Pacheco,

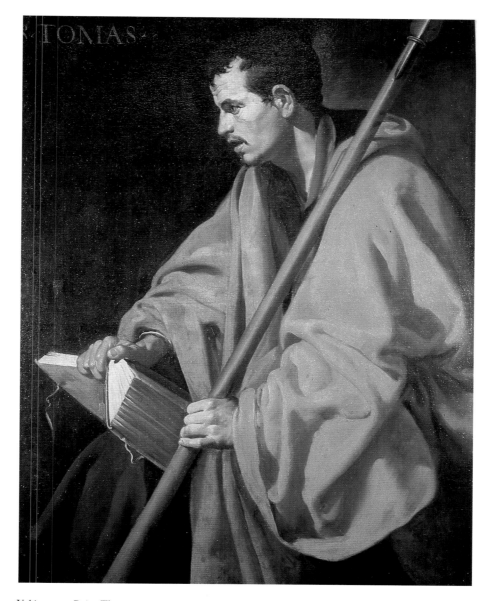

Velázquez. *Saint Thomas.*
Musée des Beaux-Arts, Orléans.

particularly Don Juan de Fonseca, the royal chaplain who had previously been canon of Seville, the count-duke summoned Velázquez to Madrid to paint the young king. The resulting equestrian portrait was considered brilliant by all who saw it. Thus began the transformation—both personal and artistic—of the painter from Seville.

In court society Velázquez was in daily contact with the high nobility surrounding the monarch, and he began to free himself from the social and economic bonds that had constrained him in Seville. This process of personal affirmation would lead him slowly but inexorably—thanks to the confidence and unquestioned affection he quickly gained from the king—to high posts in the world of palace life and to the ennoblement that was a necessary condition of appointment to the title of knight of the Order of Santiago, an honor reserved for the highest ranks of hereditary nobility.

Velázquez's situation in the palace was also exceptionally favorable to his development as an artist. Most important, it freed him from all patronage other than that of the sovereign. Commissions from private citizens all but disappeared, although soon after his arrival in Madrid he painted several portraits that were bought and paid for in the usual way of business transactions. Soon, however, he was painter to the king alone, trying to put behind him the "low and base" commercial activities that might hinder his ascent in society. It is highly significant that from the time of his arrival in Madrid the religious painting that would inevitably have been his principal activity in Seville virtually disappeared from his production. Even more significant was his daily exposure and his assiduous attention to the royal collections of Spain, which were of exceptional richness, especially in works by Venetian masters. That familiarity was to affect directly the evolution of his personal style, in transition from the dark naturalism of his Seville period to the luminous expression of his mature years and from a sober range of earth tones to silver grays and transparent blues. In addition, his privileged position allowed him occasionally to cultivate profane themes like history and mythology, subjects that artists dependent on monastic and clerical patronage for their financial support rarely had opportunity to paint. Similarly, Velázquez's service to the crown facilitated a privilege that was equally rare and difficult to obtain among Spanish painters: the voyage to Italy that provided direct acquaintance with the invigorating and fertile creativity of the country that was inarguably the crucible of artistic invention in Europe. There was unfortunately a negative side to the coin. Immersed in his responsibilities, concerned with his social improvement and with demonstrating on the practical level that great art was perfectly compatible with the dignity and nobility of intellectual activity, Velázquez was obliged to dedicate a great deal of time to administrative and bureaucratic arrangements that in turn limited his artistic activity—a fact lamented by his earliest biographers.

By 1623 Velázquez was definitively established in Madrid; by October he was painter to the king, replacing Rodrigo de Villandrando, who had died the previous year. In successive portraits of the king and the count-duke, one notes the progressive assimilation of all he was seeing and studying. His extraordinary capacity to capture and fix in time the individuality of his subjects was increasingly apparent in his techniques. Exposed to portraits by Alonso Sánchez Coello, who combined the precise, almost implacable, objectivity of Antonio Moro (Anthonis Mor) with the luminous lightness of Titian, Velázquez was testing his own formulas in the genre that was to be his most effective, one in which he would leave uncontestable masterpieces. His enemies—and he had them in abundance, if one is to believe contemporary sources—found this mastery a target for their hostility and scorn, saying "that all his skill can be reduced to knowing how to paint a head."

Because of this criticism, Velázquez found himself obliged to paint a number of works in order to prove his capacity for invention. Unfortunately they have not survived. The most important works painted by Velázquez in those first years in Madrid were lost in the 1734 fire at the Alcázar. Especially to be regretted is the loss of *The Expulsion of the Moriscos*, painted in 1627 in competition with the king's three other painters (the Italians Vicente Carducho and Angelo Nardi and the Spanish son of an Italian, Eugenio Caxes). Velázquez's effort was unanimously declared superior. We are assured by a contemporary writer that in it

Velázquez had succeeded in demonstrating that he knew how to paint more than "a head." *The Expulsion* was an elaborate painting combining historical account with allegory, in the style of certain complex Flemish compositions of the late mannerist tradition.

Of the surviving works from these years, the most significant is undoubtedly *The Feast of Bacchus* (*"Los Borrachos"*; Museo del Prado, no. 1170), a painting on a mythological theme in which the viewer is offered a very personal version of the classical theme of the Bacchanal or the Worshipers of Bacchus. Velázquez's direct, elemental, almost primitive approach could not have been further from the traditional heroic and sensual style in which his Flemish (Rubens) and French (Poussin) contemporaries represented this subject. In a manner analogous to the treatment of religious subjects during the Counter-Reformation, Velázquez interpreted the myth in a realistic manner. His painting presents a motley gathering of rough peasants and soldiers who in the adoration of Bacchus-Dionysus (a roguish youth) find the simple remedy to their worries and anguish. Wine-induced merriment, as it is in fact experienced by so many benighted worshipers of Bacchus, is communicated with forceful immediacy. The canvas also reveals the transformation Velázquez's technique was

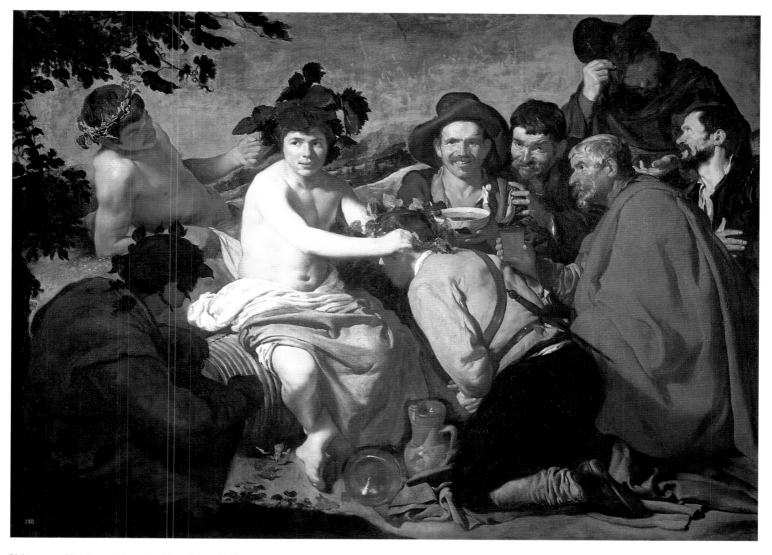

Velázquez. *The Feast of Bacchus* (*"Los Borrachos"*).
Museo del Prado, Madrid.

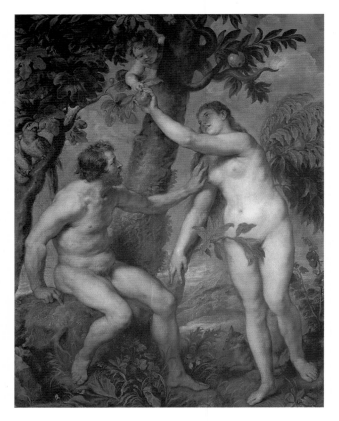

Peter Paul Rubens. *Adam and Eve.*
Museo del Prado, Madrid.

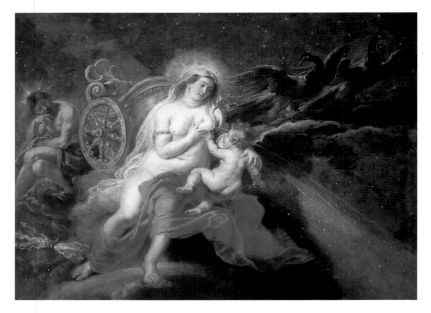

Peter Paul Rubens. *The Origin of the Milky Way.*
Museo del Prado, Madrid.

undergoing. There is still evidence of the style and color range that link him to his Sevillian period, but light is rendered in the manner of plein-air painting; in many details the technique is delicate uninhibited, the result of his exposure to Venetian painting.

In 1628 Velázquez met Rubens, who spent nearly a year in Madrid. He had come on a diplomatic mission but employed his time studying and copying the collections of the king of Spain. The great Flemish master was at the zenith of his creative energy and the height of his universal prestige. Velázquez accompanied him to El Escorial, and it is very likely that the numerous paintings Rubens executed during this time were done in the studio of the palace painters, that is, before the dazzled eyes of Velázquez. The Sevillian must have been strongly affected by the mastery of the Fleming—whose devotion to Titian he obviously shared—as well as by his status as a great lord welcomed at all levels of society. Even taking into account the chasm separating the sensibilities of the two men, it is probable that Velázquez found Rubens's visit to be one of the richest personal experiences of that period of his life, certainly the most valuable in identifying what must be done to complete his training and to achieve the much-desired goal of painter-gentleman.

First Voyage to Italy

In June 1629, soon after Rubens left Madrid—and probably as a consequence of his conversations with the Flemish master and his meditations on what he had seen—Velázquez

asked the king's permission to travel to Italy. The king and the count-duke agreed and facilitated the voyage by providing Velázquez with generous financial resources and letters of introduction to various Italian princes; their sponsorship could not help but have awakened certain suspicions, for the "secret missions" sometimes carried out by artists were well known. We are well informed about the journey, thanks to Pacheco's detailed account, a report later incorporated by Palomino. The trip was in fact an excuse to study painting. Velázquez sailed from Barcelona in the suite of Ambrogio Spinola, the marquis of Los Balbases. He arrived in Genoa and then traveled, via Milan, to Venice, which for him would be—as it had for Rubens and many other sixteenth-century masters—the ideal aesthetic environment and ever-present paradigm for his sensibility. The political moment in Venice was not propitious, for the Mantuan war of succession had roused Venetian hostility toward the Spanish. But with the protection of the Spanish ambassador, who provided him with a military escort, Velázquez toured galleries, palaces, and collections and completed his education in the work of the great Venetian masters to whom he would remain forever faithful. We know through Pacheco and Palomino that Velázquez made many sketches of what he saw; he even copied some of Tintoretto's works, among them a Communion of the Apostles, which must surely be the canvas now in the Academia de San Fernando, Madrid. From Venice he traveled to Ferrara, Cento (where he must have met Guercino), Bologna, and, as a concession to traditional devotion to the Virgin, to Loreto, and thence to Rome. His passage through Bologna was so hasty he did not even present the letters of introduction given to him in Madrid, and it is surprising he did not visit Florence. It seems clear that, after Venice, Rome was his true objective.

That the Rome of 1630 was a center of artistic interest is scarcely debatable. The polemic was alive there between naturalism—now nearly won by radical Caravaggism, but current in minor circles like those of the *bambocciati*, whose works Velázquez must have found interesting—and the classicism represented by the Roman-Bolognese line of Guido Reni and Guercino and enriched by the presence of Poussin and Claude. In these years there was, among the leading artists of Rome, a revived interest in Venice and a resurgence of attention to works of Titian and Veronese that only a few years later would be subsumed in the triumphant baroque of Pietro da Cortona. At the moment, however, their common neo-Venetian devotion permitted the harmonious coexistence of artists as disparate as Cortona, Poussin, and Andrea Sacchi.

This was the ambience Velázquez encountered, one which he must have found entirely to his taste, for he too, following his initial naturalist fervor, had recently discovered Venice. The elegant fusion of Venetian colorist sensuality with the rigor, balance, and reason of the Bolognese world can be identified in works painted during Velázquez's stay in Rome: *The Forge of Vulcan* (pl. 11) and *Joseph's Bloody Coat Brought to Jacob* (pl. 10).

These two works are perhaps—and he has been reproached for it—the most "academic" of any Velázquez painted. It is as if, after seeing and studying classical reliefs, compositions by the Renaissance masters, and works of his most famous contemporaries—especially Guercino—Velázquez had wanted to demonstrate his control of the serene,

sculptural nude and at the same time, as demanded by Roman-Bolognese example, to express "feelings," that is, expressions of the soul such as sorrow, surprise, hypocrisy, with intensity and absolute truth. These unique canvases are, in addition, magnificent exercises in spatial coherence, true displays of geometrical perspective and of Renaissance organization. They were undoubtedly preceded by careful studies, which unfortunately no longer exist. In these paintings, especially *The Forge*, the accessories, and something about the atmosphere, still evoke the naturalism, the almost *bodegón*-like tone, of Velázquez's earliest works; however, the brushwork is now lighter and freer, and color—in addition to the gleam of orange-yellows common in Poussin but not to be repeated in Velázquez—is characterized by the subtle grays, greens, and cold mauves which will be constant in his palette.

We know that during his Italian voyage Velázquez copied works by Raphael and Michelangelo; he even obtained special permission to enter the Vatican at will. We also know that by special authorization of the duke of Tuscany, he resided in the Villa Medici, where there was an important collection of classical marbles; there this phlegmatic and solitary artist—as described in contemporary accounts—could take pleasure in the contemplation of the beautiful panoramas of the most inspirational city in all Europe. We also know that at the end of 1630 Velázquez traveled to Naples to paint the portrait of Philip IV's sister Doña María, who was passing through on her way to Germany, where she was to be married to the king of Hungary, the future Holy Roman emperor. It is logical that on this voyage Velázquez would have met Ribera, who had lived in Naples for fifteen years and was the favorite painter of the Spanish viceroys.

The voyage to Italy would be the last stage in Velázquez's formation. He was thirty-two years old when he returned to Madrid in 1631. He was a mature man, and his art had advanced far beyond that of any possible rivals at court. His education had been the most complete that any Spanish artist could acquire. His reserved and secretive personality had been nourished by the richness of his experiences, and his technique had now reached a point of austere perfection.

Securing His Position at Court

When Velázquez returned to Madrid in January 1631, he immediately resumed his palace activities and was once more assured of the confidence and affection of Philip IV, who had been sufficiently astute to recognize the exceptional talents of the man who was now, and would for his lifetime be, his painter. During Velázquez's absence, a prince had been born, Baltasar Carlos, the long-desired heir to the crown. The king had not authorized any artist to paint him in order that Velázquez be the one to do it. The first portrait may not have survived, but the one in the Museum of Fine Arts, Boston, in which the prince is accompanied by a dwarf, is a composition of admirable intensity (pl. 21).

During the 1630s Velázquez's energies were greatly taxed by palace responsibilities. Through the initiative of the count-duke, a new palace, the Buen Retiro, was being constructed in Madrid; it was to have considerable importance in the history of Spanish art. To decorate it, large quantities of fine paintings were commissioned in Italy, and all the painters

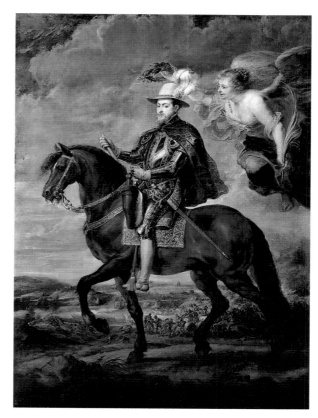

Titian. *Charles V at Mühlberg.*
Museo del Prado, Madrid.

Peter Paul Rubens. *Philip II on Horseback.*
Museo del Prado, Madrid.

of Madrid were expressly summoned, perhaps at Velázquez's instruction, to collaborate in this momentous undertaking: the royal painters Carducho and Caxes, along with their students Felix Castello and Jusepe Leonardo; Juan Bautista Mayno and Antonio Pereda; and even the Sevillian Zurbarán.

The palace was conceived as a tribute to the Spanish Monarchy and the sovereign. Velázquez's personal assignment was a series of superb equestrian portraits of Philip III and Philip IV, their respective wives, and the heir apparent, which would adorn the great Hall of the Realms; for the walls, a major series of canvases of battles was being painted, illustrating the triumphs of the monarchy. To this series Velázquez contributed *The Surrender of Breda*, the famous painting also known as *Las Lanzas* (*The Lances*).

These are masterpieces, paintings in which Velázquez had opportunity to demonstrate all he had learned in Italy. Some of the equestrian portraits (particularly those of Philip III and his wife Doña Margarita) seem to have been begun by a different hand, perhaps by Velázquez himself before traveling to Italy, but the other paintings—even those that were painted over or retouched by his brush—are worthy successors to the ideal series begun by Titian with his *Charles V at Mühlberg* and followed by the *Philip II* Rubens painted during his stay in 1628, surely before an attentive Velázquez. In all these paintings the landscape, with the easily identifiable mountains of the nearby Guadarrama range, is depicted in the plein air style, with extraordinary directness and verve. The atmosphere, particularly in the por-

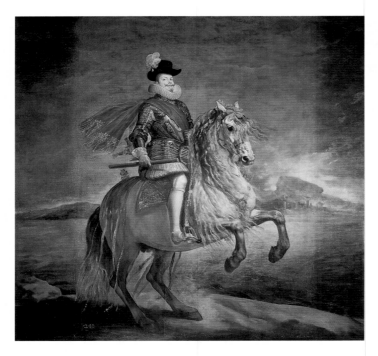

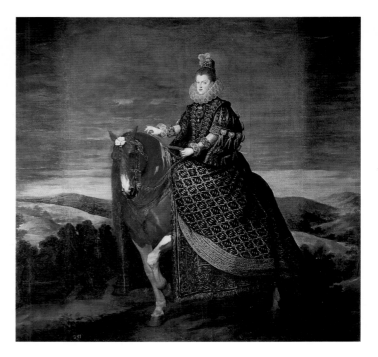

Velázquez. *Philip III on Horseback.*
Museo del Prado, Madrid.

Velázquez. *Margarita of Austria on Horseback.*
Museo del Prado, Madrid.

trait of the young prince Baltasar Carlos on his favorite pony, is of unequaled transparency. It was conceived to be displayed above the door, that is, to be seen at a distance and from below, and today's viewer is surprised by the audacious foreshortening of the rearing horse that seems to lunge toward him from the canvas. The treatment of the boy's face, thinly painted with light brushstrokes, is nonetheless a flesh-and-blood embodiment of the young prince's spirited features.

In *The Surrender of Breda*, a work of absolute technical and conceptual maturity, Velázquez achieves a prodigious balance between narrative—focusing with serenity and sober elegance on the moment of the delivery of the keys, presenting conqueror and conquered on an equal plane of chivalrous dignity—and execution, in which pulses a new perception of light and a subtle counterposition of luminous colored planes. All memory of Caravaggio's treatment of lighted volumes has disappeared. Matter has become impalpable, seeming to soak in light and at the same time radiate it, achieving a sensation of palpitation, of true life, created not through tactile techniques—outlines are no longer sharply defined—but rather through exclusively visual means. Velázquez's technique had become fluid in the extreme, and occasionally the pigments do not completely cover the canvas; areas of primer are visible, like the paper of a watercolor.

Along with paintings for the Buen Retiro, Velázquez was also working on the project for the Torre de la Parada, a hunting seat near the Pardo, where Philip IV had gathered a large collection of Flemish works—by Rubens and his workshop illustrating motifs from Ovid's *Metamorphoses*—and an exceptional series of hunting scenes and still lifes. To decorate the Torre, Velázquez, in a more direct and simple mode than that of the court portraits and with a marvelous individuality, painted members of the royal family dressed in hunting

attire and accompanied by their favorite hunting dogs in outdoor settings of mountains and woods appropriate to hunting activities. In these portraits Velázquez has avoided any superficial signs of regality. One even sees in them, through the pentimenti revealed by time, a process of simplifying clothing and gesture, a movement toward a greater immediacy that was in vivid contrast with what Van Dyck was painting in the British court. In contrast to the artificial and affectedly elegant manner of the Flemish master in his renderings of the English sovereign, whom he posed in hunting regalia against a landscape as elaborate as a stage set, Velázquez once again placed his subject against the understated background of the Guadarrama range with its dusty green oak forest and snow-covered peaks.

It may have been for the Torre de la Parada that he painted a number of mythological

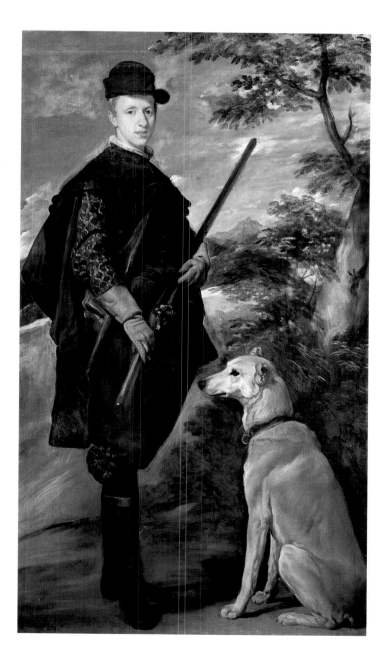

Velázquez. *The Head of a Stag.*
Museo del Prado, Madrid.

Velázquez. *The Cardinal-Infante Ferdinand as a Hunter.*
Museo del Prado, Madrid.

and literary figures some years later: *Mars* (pl. 28), *Menippus* (Museo del Prado, no. 1207), and *Aesop* (pl. 27). What is surprising is that they are so ordinary. Mars is a naked, weary soldier wearing an expression of fatigue and defeat. There is no trace of the solemn arrogance with which the god of war is usually represented; instead, in his melancholy and dissolute air, perhaps modeled after the Ludovisi Mars, he is less a burlesque of military life, a commonly held view, than a dramatic meditation on the fate of a Spain in obvious military decline. The two Greeks, philosopher and fabulist, recall the wretched vagabonds that Ribera often used to portray classic philosophers. We should no doubt derive a moral message, somewhere between stoic and cynical, from these figures and see in them the true wisdom of those who have learned to renounce worldly ties, commitments, and illusions.

During the 1630s Velázquez painted other, more complex canvases which in a certain way continue the style of the paintings for the Buen Retiro and the Torre de la Parada. *Prince Baltasar Carlos in the Riding School* (pl. 23) was intended to exalt the count-duke of Olivares, the prince's instructor and teacher, portrayed beneath the attentive gaze of the king and queen. The naturalness of a scene of daily life in the gardens of the Retiro undoubtedly incorporates symbolic elements accentuating the grace and assurance of the young heir and the loyal and instructive wisdom of the politician. Of analogous intent was the large equestrian portrait of the count-duke himself (pl. 18), executed, as Brown has acutely observed, with a certain triumphal flourish and a grandiloquence that contrasts with the calm simplicity of the royal portraits. This may be the one time that Velázquez lost his traditional serenity and balance and yielded to flattery. The subject's vanity, however, is manifest in very subtle ways, and the painter's mastery is apparent in the richness of the clothing and in the dazzling landscape of the battle, which alludes to the defense of Fuenterrabía, the only victorious military battle personally directed—from Madrid—by the count-duke and one from which he obtained extraordinary advantages and prestige.

Two unique religious works painted during those same years, both by royal command, are of a very different nature. *Christ on the Cross* (Museo del Prado, no. 1167), destined for the convent of San Plácido—as an ex voto if one may trust Madrid legend—is a superb testimony of the degree to which Velázquez had assimilated Italian classicism. The austere dignity of the beautiful male body, face veiled in the shadow of the hair, is a direct response to what he had learned in Rome. Although the composition—four nails and bowed head— was derived from his master Pacheco, the concept and technique with which it is translated are absolutely different. The amplitude of the nude body—serene as a classical statue but at the same time throbbing with life, after the Venetian example—makes this painting, as consecrated by the intuition of the Spanish public and explicitly stated by the philosopher-poet Unamuno, the perfect representation of Christ. Of similar classical reverberation, with a superb sense of elegance and balance, is *The Coronation of the Virgin* painted for the oratory of the queen in a range of violets and blues of rare perfection.

Painted for one of the hermitages, or oratories, of the gardens of the Buen Retiro, *Saint Anthony Abbot and Saint Paul the Hermit* (pl. 17) is a marvelous example of how, even when his painting was bound to the imperatives of the tradition of medieval iconography,

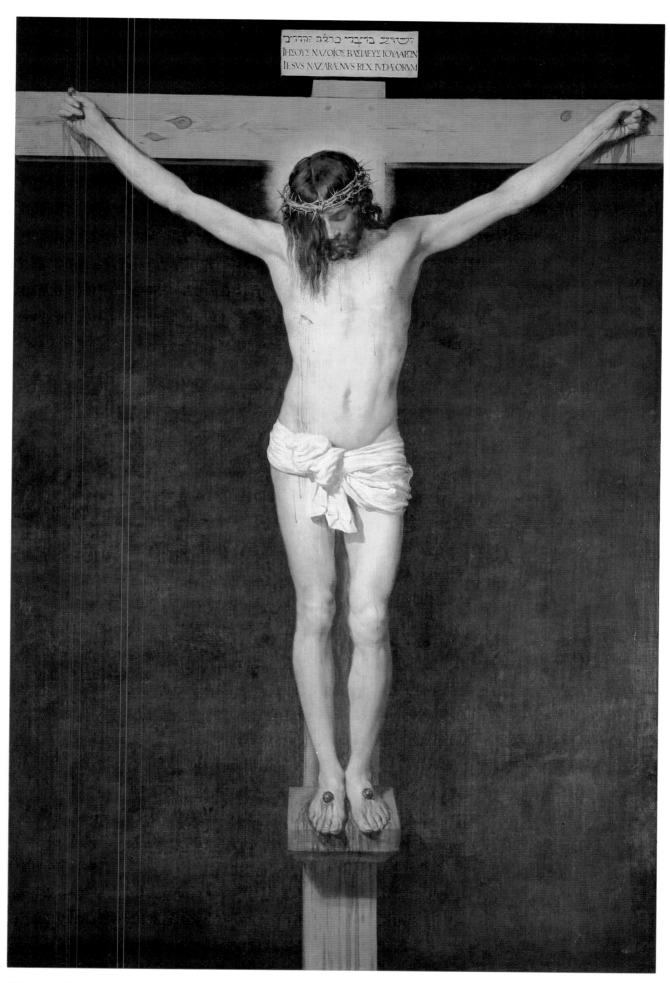

Velázquez. *Christ on the Cross.*
Museo del Prado, Madrid.

Velázquez. *The Coronation of the Virgin.*
Museo del Prado, Madrid.

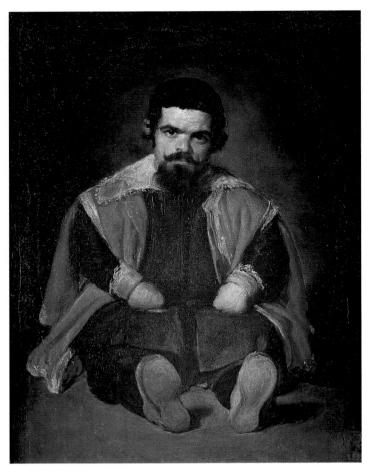

Velázquez. *Sebastián de Morra.*
Museo del Prado, Madrid.

Velázquez transforms narrative into something immediate, something vivid and imbued with the truth of reality. The expansive landscape, in which he placed episodes of the legend in a way very similar to that of the primitives, results in the same luminous authenticity as the backgrounds of the equestrian and hunting portraits.

To the 1630s and the early 1640s belongs a series of portraits that in their simplicity constitute one of the most famous groupings in all of Velázquez's production: the portraits of the dwarfs and buffoons so prominent in the court. These unique personalities were a heritage from other times; they entertained the king, and their comments on affairs of court were made with a familiarity and freedom that approached impertinence. For generations these *hombres de placer* had been painted, in Spain as well as Italy and Flanders, by the same artists who portrayed the sovereigns. Velázquez was thus continuing a tradition that included names as illustrious as those of Antonio Moro, Alonso Sánchez Coello, and Agostino Carracci. We shall never know whether the painter painted these pictures at his own initiative or at the monarch's request, but the latter is more likely. What is incontrovertible is that in these central years of his production, the portraits of these "palace vermin," as they were called, occupied a major portion of Velázquez's time. In them he has left us an impressive gallery of sorrowful

creatures scrutinized with an eye that would seem nearly merciless were the subjects not bathed in a subtle glow of grave melancholy and tender commiseration. These dwarfs, with their unforgettable expressions, include Don Juan de Calabazas (pl. 26), his absent gaze begging for affection; the profound, almost anguished questioning of the intelligent Sebastián de Morra (Museo del Prado, no. 1202); and the witless and absent expression of Francisco Lezcano (pl. 30). Alongside them are other figures of fools and buffoons, their broad grimaces communicating their doltishness, in which it seems that the painter wished to experiment with the boldest and most expressive possibilities of his brush. Thus, in the rudimentary scene of the raging naval battle in the background of the portrait of "Don Juan of Austria" (pl. 25), who in his martial obsession thought of himself as the victor in the Battle of Lepanto, Velázquez offers a perfect homage to Titian. In *Pablo de Valladolid* (Museo del Prado, no. 1198), the definition of physical space surrounding the subject is rendered with prodigious mastery, without any geometric referent, based only on light and shadow in a supremely knowing display of aerial perspective.

Many other important portraits belong to this period when Velázquez's role at court was being consolidated and he was gaining successive promotions in his official career. In 1634 he was named gentleman of the wardrobe, yielding his previous post as usher of the bedchamber to his son-in-law Juan Bautista del Mazo, who had married his daughter Francisca. In 1643 he was named gentleman of the royal bedchamber and in 1646 gentleman of the royal bedchamber, with official duties; with each advancement Velázquez penetrated further into the inner circle of the king, who continued to show the painter his confidence and esteem. The Spanish political situation could not help but influence the lives of those so close to the center of power. In 1640 there were uprisings in Portugal, which then seceded from the Spanish Monarchy, and in Catalonia—the latter with the support of French forces. The fall of the count-duke of Olivares, relieved from power in 1643 and exiled to Toro, stiffened the monarch's resolve to assume responsibility for governing and to direct the military campaign in Aragon. Between 1642 and 1646 he traveled there on five occasions, twice accompanied by Velázquez, who in June 1643 painted the monarch in battle dress in the Aragonese city of Fraga (Frick Collection). The king was devastated by a series of family tragedies. The severity of these blows—the deaths of the queen and the prince Baltasar Carlos—is reflected in the sovereign's correspondence.

Nevertheless, work on royal residences continued. The need to maintain a decorum appropriate to the stature of the empire—which may have been staggering, but which was still a great European power confronting an emerging France—led Philip IV to order that the old Alcázar be renovated in the fashionable Italian manner as an expression of wealth and power. The severe Herrerian interior of austere and unadorned vaulted ceilings was to be transformed into a modern palace with suites of salons and reception rooms decorated with frescoes. The arrangements for these alterations were entrusted to Velázquez in a series of royal orders that placed him in charge of all the works being carried out, especially the Octagonal Room the king wanted to resemble the Tribune in the Uffizi. In 1647 Velázquez was named *veedor y contador* of these renovations, that is, fully empowered

Rome. Doors immediately opened to Velázquez at the Academy of Saint Luke and the Virtuosi of the Pantheon.

In the view of many critics, Velázquez's portrait of the pope, painted immediately after that of Pareja, may be the greatest portrait ever painted in Rome. Without departing from the convention of the pontifical portrait, traditional since the time of Raphael, Velázquez, through his technique and his demanding harmony of reds, effects something dazzlingly new. The cruel, suspicious, and basically vulgar temperament of the pope is captured with such extraordinary precision that when he saw it, the pontiff himself exclaimed, "*Troppo vero* [too true]." The portrait, both admired and envied, exercised an intense and enduring influence on Roman artists from Giovanni Battista Bacciccio to Carlo Maratta. It dazzled every painter, Italian or foreign, who passed through Rome in the eighteenth century; Sir Joshua Reynolds, for example, judged it the finest painting he had ever seen.

Velázquez enjoyed enormous respect in Rome, although there were those who were apprehensive about his mission to acquire art for his king, for in some instances he relied on political influence to obtain, even force, an acquisition or a gift. Some of the strongest opposition came from Spanish nobles who considered such expenditures excessive in view of the economic crisis in Spain. Along with acquisition of works of art, Velázquez's second charge was to bring fresco painters back to Madrid to refurbish the Alcázar. His efforts to enlist Pietro da Cortona were unsuccessful, for that great master had no wish to leave Italy. Velázquez then undertook negotiations with the minor Bolognese artists Agostino Mitelli and Angelo Michele Colonna, who were more receptive; they accepted the invitation although they did not actually go to Spain until 1658. Velázquez must also have been actively painting portraits, of which a large number have been lost. Painting itself must have opened doors and facilitated his mission.

Rome was also the setting for an episode that has only recently come to light, one that adds a touch of human passion and adventure to Velázquez's life, which until this point seems to have been serene, sedate, and dispassionate. Documents found by Jennifer Montagu in the archives of Rome record the birth in 1652 of the painter's natural son; of the mother, we know nothing at all. An amorous interlude, then, was one of the reasons why Velázquez lingered in Italy, in spite of repeated demands for his return which were transmitted from the king through the Spanish ambassador. In one of these letters the king refers to the painter's "phlegm," with a tone of amiable tolerance that reflects the warmth between the two men. It was obviously this special relationship with the king that allowed Velázquez to enjoy in such leisurely fashion the freedom and beauty of Rome. A moving testimony to his appreciation of the ancient city is found in two small, exquisite landscapes of the Villa Medici, now in the Prado, which several indirect references establish as belonging to this period (pl. 13 [editor's note: see Julián Gállego's text for this plate for a discussion of the various dates given to the Villa Medici works]). During his first voyage Velázquez had lodged for some time in the villa, the property of the duke of Tuscany. Now, twenty years later, he returned to it and recaptured, with a melancholy-tinged lyricism, images that evoked his luminous youth. The dematerialized, nearly impressionistic, lightness of touch indicates an

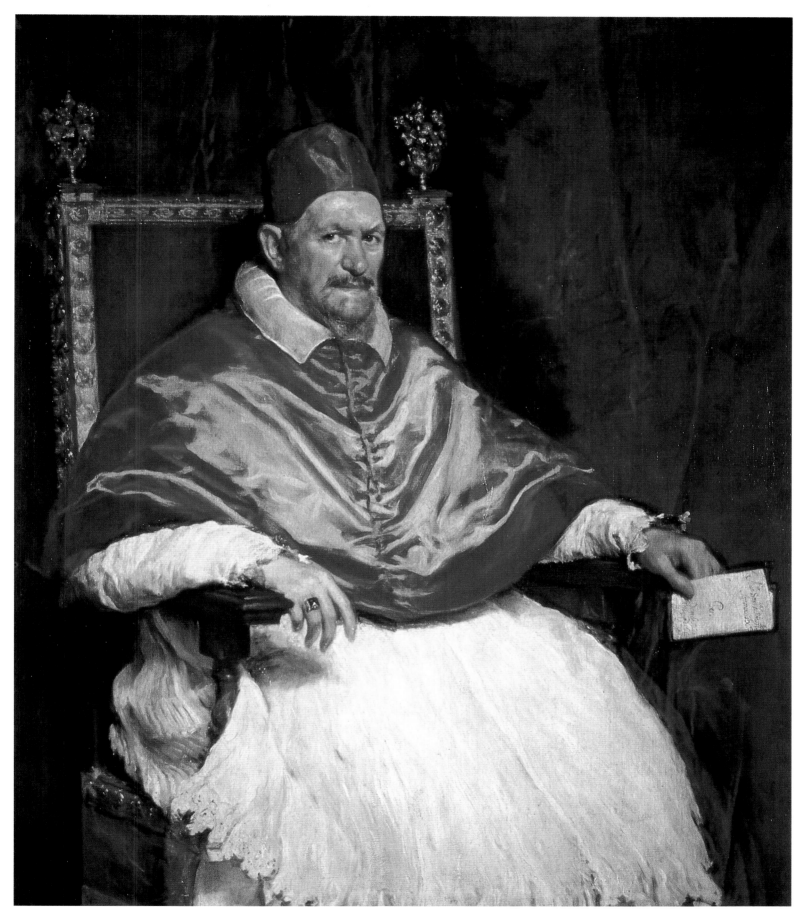

Velázquez. *Innocent X.*
Galleria Doria-Pamphili, Rome.

extreme modernity and freedom, and perhaps more than any finished work, these paintings offer us a glimpse into the "secret garden" of Velázquez's reserved temperament.

The Last Years

Velázquez returned to Madrid in June 1651, more than two years after his departure and more than a year after the first royal summons. Back at court, he resumed his labors on the renovation of the Alcázar, the primary reason for his journey. The paintings and sculptures he had brought with him delighted Philip IV. In 1652, placing him ahead of others who had been nominated by the royal council, the king named Velázquez chamberlain of the palace, a position of highest responsibility that tied him ever more closely to court life, while more severely limiting the time he could dedicate to painting. His duties were similar to those of a majordomo: to oversee the daily operations of the palace, to supervise all journeys and sojourns of the king and the court, and to attend to all lodging, clothing, and appurtenances. He was also responsible for decorations and ceremonial protocol involving the royal presence outside the palace—from the decoration of a church where the king and queen were to attend a religious ceremony, to the disposition of balconies or tribunals from which they were to observe a popular festival.

To adorn one of the halls of the Alcázar for which he was personally responsible,

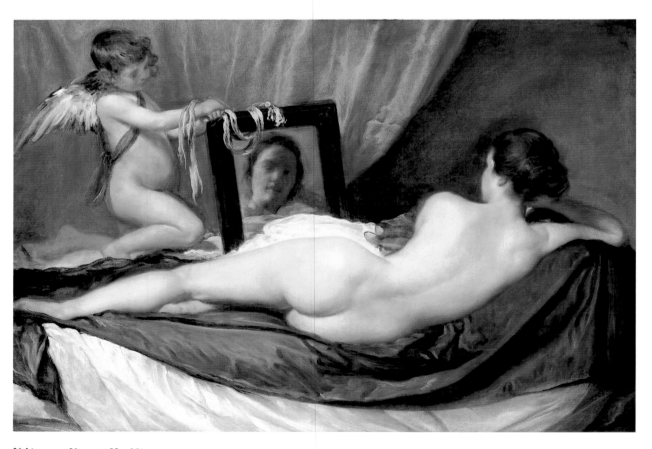

Velázquez. *Venus at Her Mirror.*
National Gallery, London.

Velázquez painted four mythological canvases, three of which (*Venus and Adonis, Psyche and Cupid, Apollo and Marsyas*) have been lost. The fourth, fortunately preserved, is the masterpiece *Mercury and Argus* (pl. 39), so remarkable for its airy brushwork and delicate gradation of grays and mauves. His stay in Italy had revived Velázquez's taste for the language of the classical fable, which reverberated there in every palace he entered. His figure of the shepherd presents a living person surprised in sleep with stunning realism; it is also a direct echo of the Dying Gaul, the classical sculpture that Velázquez must have seen in Rome.

The dates of these four paintings are uncertain and widely debated; many have argued that they belong to the period immediately preceding the second voyage to Italy. Probably related, however, are two major paintings which are the culmination of Velázquez's devotion to ancient fable and his very personal way of understanding and interpreting it. These are the *Venus at Her Mirror* (also known as *The Toilet of Venus* and *The Rokeby Venus*; National Gallery, London) and *The Weavers* (also known as *The Fable of Arachne* and *"Las Hilanderas"*; Museo del Prado, no. 1173). The former was painted for a powerful noble in royal favor, the marquis of Heliche, son of Don Luis de Haro, successor to the count-duke of Olivares. Velázquez's female nude, a subject always exceptional in Spanish art, has a pleasing corporeality. The example of Titian is, of course, decisive in the very concept of the painting, as is awareness of the Flemish world of Rubens. But for the classical roundness of the former and the warm sensuality of the latter, Velázquez substitutes a nervous vitality, a reverberant gracefulness, that is entirely new.

The Weavers was also painted for a private collector and entered the royal collections in the early eighteenth century. It may be the most completely achieved affirmation of Velázquez's attitude toward mythology. In the early paintings the religious theme was relegated to a secondary plane with conscious ambiguity, and the primary level was interpreted in the very concrete terms of genre painting or the *bodegón*. Here, too, the principal action (the moment when Minerva anathematizes the young Arachne, who has dared challenge her to a weaving contest, turning her into a spider before a tapestry representing the Rape of Europa) is shifted to the luminous but ambiguous background. In the foreground is a group of weavers and spinners depicted with all the immediacy and directness of everyday life: balls of yarn and winding frames, a whirling spinning wheel, even a cat, drowsing among the tufts of wool scattered about the floor. It is no surprise that for many years this masterpiece, regarded through a realist, positivist, bourgeois mentality, was interpreted as a genre painting, a simple "snapshot" of weaver women in the Royal Tapestry Factory of Santa Isabel. The painting is, however, one of Velázquez's most astute, complex, and enigmatic compositions. In the opposing attitudes of the two foreground figures, Angulo has felt the echo of Michelangelo's Sistine Chapel *ignudi*, which Velázquez studied carefully during his first trip to Italy. The tapestry in the background is a fervent homage to Titian, most especially to his *Rape of Europa* (Isabella Stewart Gardner Museum, Boston). The most personal and elusive expression of the artist's temperament is found in the luminous shimmer of this picture, in the silent, melancholy drama of the incident itself, in the subtle vibration of the air, where the golden dust of the wool seems almost to breathe.

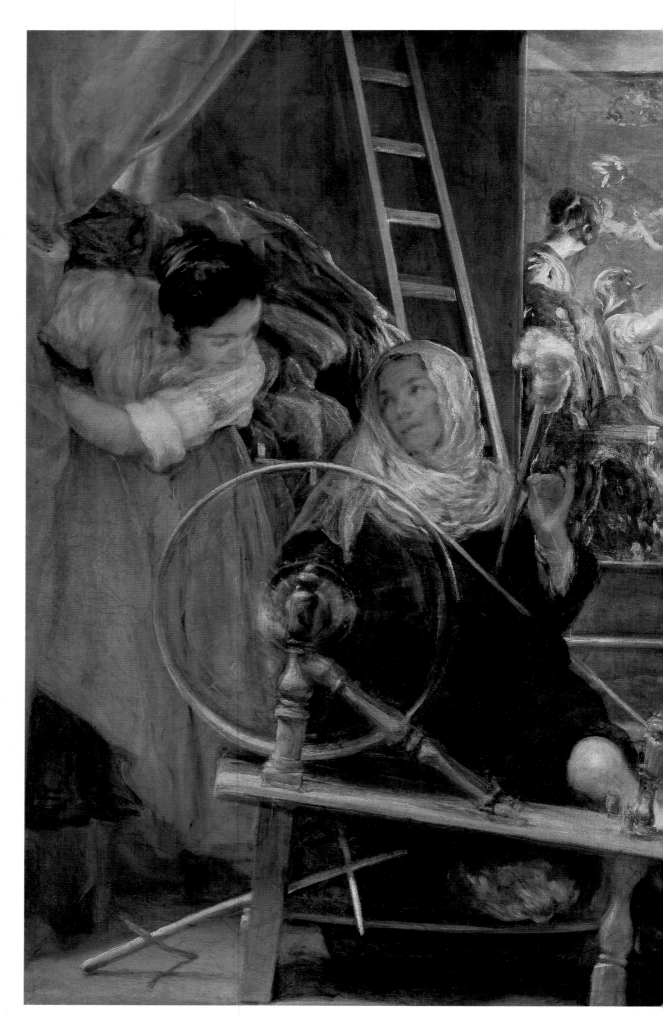

Velázquez. *The Weavers.*
Museo del Prado, Madrid.

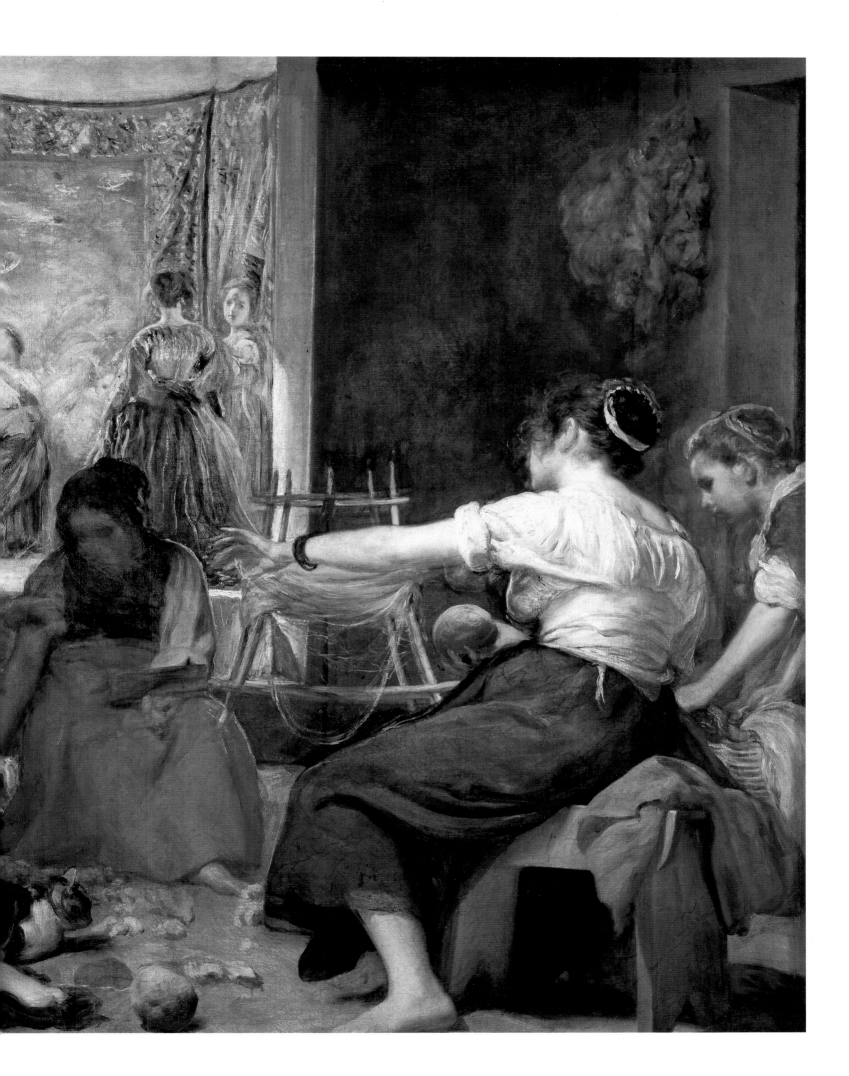

In 1656, as one of his palace duties, Velázquez was charged to install in El Escorial some of the paintings he had brought from Italy, as well as others purchased in the auction of the possessions of the beheaded Charles I of England. Velázquez proved to be an assiduous curator, even drafting a descriptive account, not extant, that scholars believe may have served as a basis for the subsequent *Descripciones de El Escorial*, written, beginning in 1657, by the convent's prior, Padre Francisco de los Santos.

In 1656 Velázquez also painted what the world recognizes as his masterpiece, perhaps the masterpiece of all painting: *Las Meninas*, as it has been called since the last century, or *The Royal Family*, as it was known in its time. This work represents the culmination of Velázquez's two principal characteristics: an immediate physical truth of vision and a complex intellectuality. Here a seemingly straightforward scene, which appears to have been happened on at a chance moment, is sustained by a complex mental underpinning, which makes it necessary, upon more careful examination, to regard the painting as an unsolved enigma. This renowned canvas depicts the infanta Margarita surrounded by her *meninas* (the young noblewomen who attended her), servants, and dwarfs and buffoons (the stunted Mari-Bárbola and young Pertusato, harrying the enormous dozing mastiff) in the austere setting of a palace salon. At the rear of the room a door opens onto a stairway where we see the back-lit figure of a gentleman whose name has survived along with the painting: Don José Nieto. Brush in hand, Velázquez himself stands before an enormous canvas of which only the back is visible; he seems to gaze questioningly at the spectator, as if it is the viewer he is painting. The key is found in a mirror with a heavy ebony frame hanging on the wall in the middle background. Reflected in its silvered surface are the blurred figures of the king and queen. It is they, certainly, whom Velázquez is painting with such a respectful attitude. It is they who are the true protagonists of the composition, they who give it meaning, for probably there is a symbolic intent to the painting: to present the infanta—at that moment heir to the crown, in the absence of a brother and because of the forced renunciation of her older sister, promised to the king of France—in a kind of reverent homage and anticipatory allegiance owed to the successor to the throne. All these things are insinuated in the silver penumbra, a resonant ambience rendered as never before. As Palomino noted, the floor— unlike that of the earlier *Joseph's Coat*, which is innocent of any linear reference to facilitate the effect of perspective—is so real it seems that one could walk on it; the highlighted steps and planes of light suggest space, distance, and physical boundaries with dazzling veracity.

Velázquez had succeeded in formulating what would perhaps be the absolute definition of pure painting: to replace reality with a reflection that would retain the spiritual quality and the physical properties of image and appearance and would be, in fact, more "real" than reality itself. In these last years of his life, burdened by palace duties, Velázquez substantially reduced his artistic production, entrusting to his son-in-law Mazo the copying of minor official portraits. He was nonetheless able to paint a number of portraits that rank among his greatest works.

Especially significant are the series of portraits of the royal children. Infanta Margarita (pl. 37), protagonist of *Las Meninas*, is presented in a number of images, and Felipe

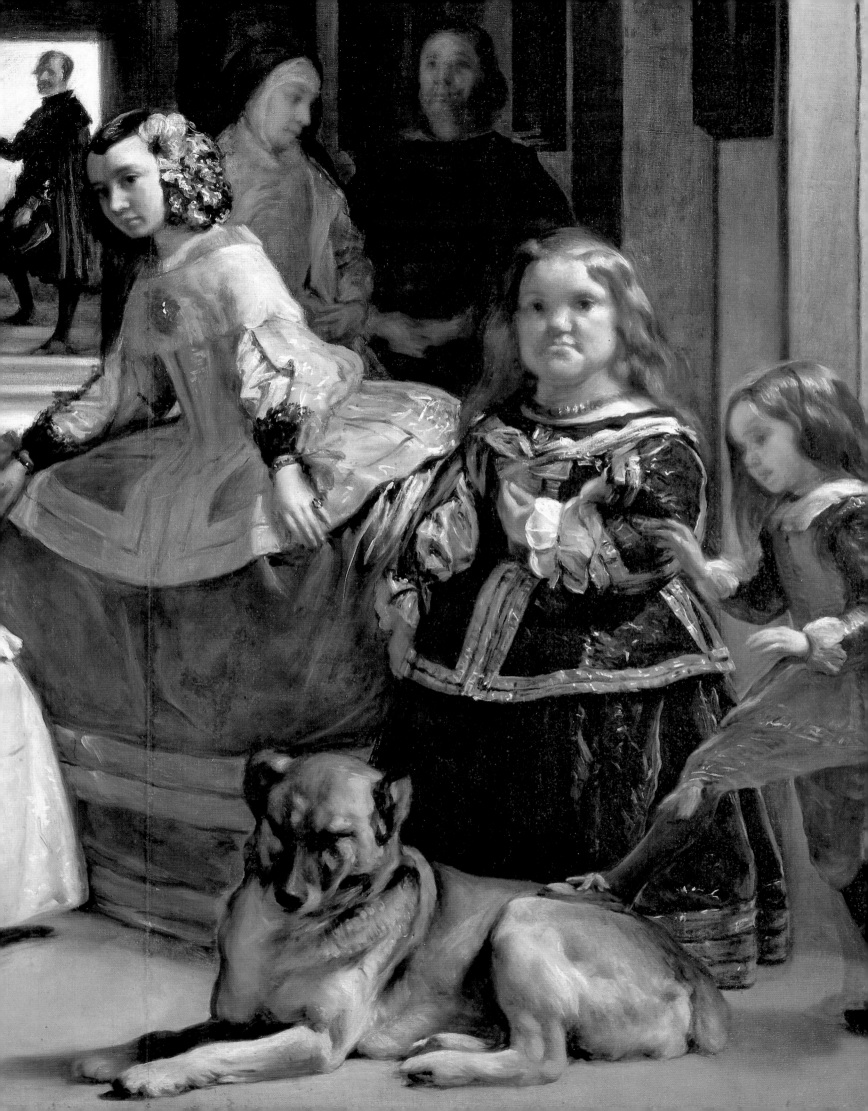

Próspero, the sickly infante, is shown accompanied by his little dog (pl. 40). Velázquez knew how to use the world of the court as the basis for his most intimate creations, which demonstrate his disdain for precision of outline and his delight in pure color, interpreted in subtle, exquisite, almost musical variations. Always the acute judge of the human condition, he succeeds in transmitting the melancholy gravity of these royal offspring, prematurely afflicted by rigorous etiquette, ill health, and the stress of their elevated station. They stand before us in the pathos of their profound human truth, transfigured by the artist's brush.

Along with those poignant childhood images, a marvel of refined color effects, Velázquez left other unforgettable images: the young queen Doña Mariana (pl. 35), posing with grave composure before heavy, gold-highlighted draperies, and the increasingly flaccid and anguished king (pl. 38). Velázquez portrayed a Philip bitterly disillusioned but always dignified in sober black barely relieved by the glitter of the golden chain holding the Golden Fleece, as he is seen in the moving portrait in London. A recently published letter, dated 1653, reveals with bitter melancholy the king's fear of the terrible evidence of the passing years. In a letter to Sor Luisa Magdalena de Jesús (who became a Carmelite in the convent of Malagón after abandoning life at court, where she had been countess of Paredes and governess of Infanta María Teresa), the king wrote: "It is nine years since any [portrait] has been made, and I am little inclined to subject myself to Velázquez's phlegm [a reference to his impassive temperament], nor thus find further reason to witness how I am growing older." The portraits then in which the monarch *was* subjected to the painter's phlegmatic pace, the slow recording of his aging, must have been painted after 1653, more likely around 1656.

The dejected monarch, however, through personal intervention and against the wishes of the Chapter of the Order of Santiago, which had not found that Velázquez's "nobility and qualities" had been sufficiently established, finally obtained for the artist the knighthood he had desired through the long years in the palace. Even on the occasion of his second voyage to Italy, Velázquez, through his contact with the Roman curia, had made known his desire to obtain a title or, at least, admission to a military-religious order. Finally, in 1659, not without substantial difficulty, the sovereign obtained a papal bull waiving the requirement of nobility, and Velázquez was named a knight of the Order of Santiago. This was the climax to his steady ascent in Spanish society, adding to his artistic mastery, now at its apogee, the realization of a desire that undoubtedly determined his behavior throughout his life, perhaps even explained attitudes otherwise difficult to comprehend.

Among the evidence introduced to establish the nobility of his family, we find the false testimony of artists who knew Velázquez well but who prevaricated in answering such questions as whether he had passed the examination of the painter's guild or whether he had ever had a workshop where he sold paintings—questions relating to his "low and base calling," which would have blocked admission to the nobility. Alonso Cano, Zurbarán, Carreño de Miranda, and other artists, as well as men who lived with him in the palace, testified on his behalf, with the obvious hope that by doing him this favor they might obtain some form of benefit for themselves.

It is odd that Velázquez, who was very conscious of his own worth, was so protective

of his position at court that he felt the need to avoid competition with less gifted artists. As vacancies occurred among the palace painters, he did nothing to fill them but instead strove to reign alone. Significantly, with the exception of the Italian Angelo Nardi, who outlived Velázquez and whose unassuming human and artistic temperament offered nothing to be feared, the only artist to obtain a position as court painter after the death of Caxes in 1635 and of Carducho in 1638 was Juan Bautista Martínez del Mazo. In 1633 Mazo had married Velázquez's daughter; he was faithful to the style of his father-in-law, remaining nothing but a shadow of the master.

Velázquez's role at court reached its culmination in his prominent participation in the ceremony to give Philip's daughter, Infanta María Teresa, to her betrothed, Louis XIV of France. The ceremony was celebrated on the Isle of Pheasants on the Bidassoa River in June 1660. With it was sealed the Treaty of the Pyrenees between France and Spain, putting an end to a long war. The ceremony, of exceptional political and symbolic importance, was organized and directed entirely by Velázquez in his role as chamberlain. As his early biographers rejoiced in describing, the painter attended in full regalia.

Soon after his return to Madrid, and after a relatively brief illness, Velázquez died. Seven days later, the wife who had accompanied him so inconspicuously throughout his life, also died. The inventory of Velázquez's possessions, recorded a few days following his death, gives detailed testimony to his way of life; he was certainly well-to-do, with luxuries unusual in the Spain of his time and even more exceptional for a painter. His library was well stocked with volumes on architectural theory, mathematics, astronomy and astrology, philosophy, and ancient history, along with books of poetry in Spanish, Italian, and Latin. Surprisingly, to repeat an earlier observation, there was a paucity of religious books. Because of an accusation by enemies—powerful and not few in number—Velázquez's goods were sequestered under the pretext that he had defrauded the crown in the execution of his office. A public investigation absolved him of any guilt. His biographer Palomino alluded to these accusations: "Even after death he was pursued by envy, being that certain men of evil intent had attempted to deprive him of his sovereign's grace through sinister calumny, it was necessary that Don Gaspar de Fuensalida, as a friend, as an executor, and in his office as greffier, answer these charges in a private audience with His Majesty, assuring him of Velázquez's loyalty and legitimacy and the rectitude of his behavior in all undertakings; to which His Majesty replied: 'I believe completely what you tell me of Velázquez.'"

Briefly stated, this was the personal and artistic peregrination of the great master. We note in him above all the phlegmatic character to which his contemporaries, drawing on the medieval theory of humors, so often referred. His calm restraint; his proud superiority, which lifted him above the bustle of everyday life; his profound knowledge of the human heart, of the vanity and meanness of court life—these qualities allowed him to satisfy his desire for social rank and to affirm the ethical value of his art. We know nothing, or almost nothing, about his private life; it remains remote, almost secret—except for the amorous episode we glimpsed in his second voyage to Italy and his preoccupation with the professional and social

career of his son-in-law, which led ultimately to his grandchildren's marriages to members of the nobility. But his devotion to Italy, his reluctance to return to Madrid, even in the face of his sovereign's command, the aforementioned *affaire de coeur*, the melancholy lyricism of the landscapes of the Villa Medici—all this shows a certain resistance to the strict discipline of Spanish life. Like Cervantes, who on one occasion praised "the free life of Italy," Velázquez saw and experienced in this longed-for Italy, a wider horizon filled with delightful artistic and personal possibilities. If in the full vigor of thirty he had found new paradigms and new artistic stimuli, at the serene maturity of fifty he experienced the evocation of a blissful past, the ardor of late fires, and the circumspect and seignorial savor of the beauty of the beings and objects his brush immortalized on canvas with, as Alberti so beautifully phrased it, "the fleeting trace of an enduring wing."

VELÁZQUEZ

An Old Woman Cooking Eggs

Oil on canvas
39 × 66½ in. (99 × 169 cm.)
National Gallery of Scotland, Edinburgh, no. 2180

The date of this painting, executed in Seville before Velázquez first visited Madrid in 1622, is put at 1618. According to Baxandall (1957, p. 156), whom Camón Aznar follows, the date became visible when the canvas was cleaned. The last two digits are blurred, but they can be read, and Bardi and López Rey accept 1618. Pantorba and Gudiol advance the date to 1620. Trapier (1948, p. 64) places it just before *The Waterseller of Seville* (pl. 5)—between *The Adoration of the Magi* of 1619 and the 1622 trip—and calls it "one of Velázquez's finest *bodegones*." Unknown to the early critics, the work was not mentioned by Cruzada Villaamil, Stirling-Maxwell, or Bürger. Curtis referred to it in 1883. The autograph is not open to dispute. The work is characteristic of the artist's Sevillian manner (Gállego 1974), and it, together with *The Waterseller*, represents the finest achievement of that period. Hence the date 1618 seems too early to some. Brown (1986, p. 12), who does accept this date, says this "is the first of the genre paintings which can be called a masterpiece."

With Justi and Beruete, Trapier takes *An Old Woman Cooking Eggs* to be one of the three *bodegones* cited by Palomino (1724, 106–1), "showing a plank used as a table with a brazier and a pot simmering on top." (Palomino, however, does not mention the old woman in his description.) Camón Aznar points out the resemblance to the old woman in the supposed portrait of Pacheco and his wife, María del Páramo, identified by Longhi in a predella panel of a retable (Museo de Bellas Artes, Seville), which suggests that she may have been the model for this figure. In any case, the resemblance of this portrait to the old woman in *Christ in the House of Martha and Mary* (National Gallery, London) is undeniable. MacLaren (1952, p. 74) compares this latter old woman (whom he identifies, I think mistakenly, with Martha) with the old woman cooking, saying they are "probably the same." If this observation is correct, it would confirm Velázquez's habit at that time of taking people whom he knew as models, in this case his mother-in-law. As for the boy, he may be the one Pacheco referred to (*Arte* III, chapter 8): Velázquez "had hired a village apprentice as a model." The same model may have served for the young cook (Martha, as I think) in *Christ in the House of Martha and Mary*.

This picture belongs to the class of genre paintings known as *bodegones* (cookshops) or *cocinas* (kitchens), regarded as the lowest form of the painter's art and much despised in Vicente Carducho's *Diálogos de la pintura* (1633, part 7, fol. 112). Probably with Velázquez in mind, he criticized "workmen of scant knowledge or reflection, who debase the noble art to vulgar notions, as we see today, in so many pictures of *bodegones* with base and villainous

Velázquez. Detail of *Christ in the House of Martha and Mary*. National Gallery, London.

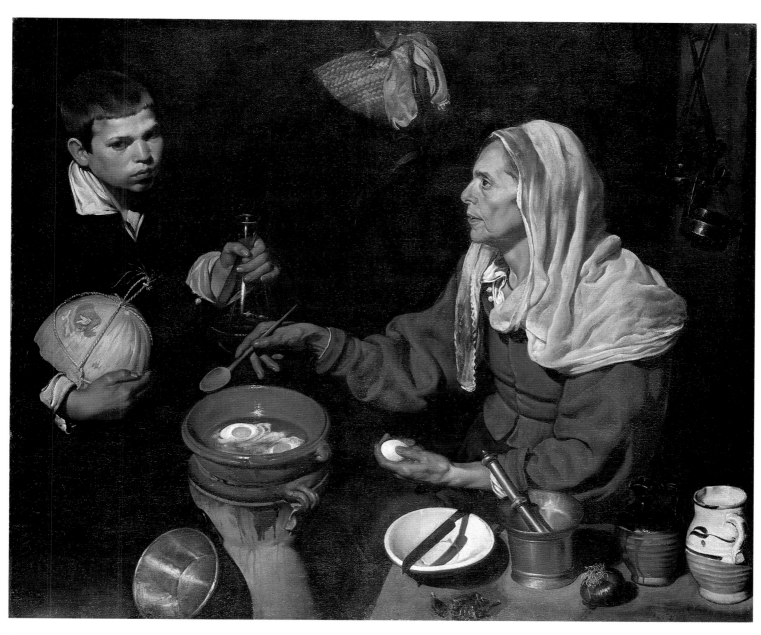

I

concepts. . . ." Pacheco vigorously replied: "*Bodegones* not to be esteemed? Of course they are, if painted as my son-in-law paints them, elevating them beyond all comparison, and they deserve very high praise indeed; for in these beginnings and the portraits . . . he found the true imitation of nature." Pacheco confesses that he himself painted "a little canvas with two figures from life, flowers and fruits and other playthings" in 1625, when in Madrid, "to oblige a friend." In this as in all else, Velázquez would breach frontiers, painting *bodegones "a lo divino"* (such as *Christ in the House of Martha and Mary*) —representing sacred subjects in the vocabulary of a little-regarded genre.

All this does not tell us for whom in Seville these *cocinas* may have been intended, since there is no record of the buyers, and he cannot have done them all "to oblige a friend." In his first successes he seemed destined to earn his bread in the religious sphere (*The Adoration of the Magi*, *Saint John the Evangelist*, and *The Immaculate Conception*), in which Pacheco, his master and father-in-law, was so influential.

That is not to say that Velázquez, schooled as he was in the Platonic theory of the embodiment of ideas in images (Gállego 1968, part 2, chapter 2), had no intention of symbolically ennobling these apparently rude themes; that would have suited his ironic temperament, his fondness for paradox. It has occurred to me that *An Old Woman Cooking Eggs* might represent the sense of taste (with *The Waterseller* illustrating thirst), but I do not find this interpretation convincing. Perhaps with time a better one may present itself (see pl. 5 for my remarks on *The Waterseller*).

The present picture shows an old woman cooking eggs on a brazier. The customary title is *The Old Woman Frying Eggs*, though Trapier prefers "cooking." Brown (1986, p. 12) speaks of eggs "being cooked in water or broth," which would preclude frying. Perhaps the eggs are being poached, but the identification of the dish as garlic soup with egg seems to me unlikely.

I have earlier stated (Gállego 1974) that this picture "represents an old woman in the act of frying some eggs; with her right hand she removes oil from the glazed earthenware bowl, using a wooden spoon so that the white will not stick; with the left, she prepares to break another egg on the edge of the vessel, which rests on a brazier. She lifts her gaze to, but does not fix it upon, a boy . . . bearing a bottle of wine and a large winter melon. This dynamic action Velázquez renders with disconcerting repose. Eyes do not meet, and the figures seem as immobile as the objects around them, as if surprised by the lens of a camera. A similar feeling of suspense may be found, not in Caravaggio, who is always dynamic, but in northern painters like Georges de La Tour or Louis Le Nain." Somewhat later (Gállego 1983, p. 40), after again remarking on this strange stasis—"the boy looks toward the viewer, while the old woman, with sightless expression, looks at no one"—I suggested that "the painter's attention, in converting them into objects, deprives them of life."

The composition is excellent: Before the woman's veiled eyes, in a helical curve, swirl a hanging basket, the boy's face, his hands with melon and bottle, the bowl and brazier, and a copper pot. The old woman's light man-

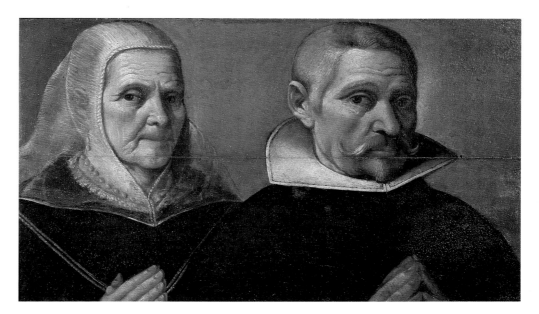

Francisco Pacheco. *Portrait of a Man and a Woman* (thought to be the artist and his wife). Museo de Bellas Artes, Seville.

LITERATURE

Mayer 111, Curtis 84, López Rey 108, Pantorba 16, Gudiol 8, Bardi 6

PROVENANCE

Woolett sale, Christie's, May 8, 1813, lot 45.

Smith, a dealer in Bond Street, London.

Private collection, Bradford (sale, 1863).

Sir J. C. Robinson, London.

Sir Francis Cook (by 1873), Richmond, Surrey.

National Gallery of Scotland, Edinburgh, by purchase (£57,000), since 1955.

tilla and the whiteness of the dish, the jug, and the egg in her left hand provide a counterpoint to the obscurity on the left. The small still life on the table (a mortar and pestle, an onion, another cruet, and the dish with a knife) is a pleasing composition in the mode of Chardin. The composition as a whole is oval. The colors are superb, based, as Gudiol notes, on close harmonies. Camón Aznar (1964, p. 203) notes that "in this canvas, Velázquez contrives to blend the crystal clarity of each thing, distinct in its hardness, with a prodigious feeling of unity."

2

The Adoration of the Magi

Oil on canvas
79⅝ × 49¼ in. (203 × 125 cm.)
Museo del Prado, no. 1166

The date of this canvas as indicated on the stone beneath the Virgin's foot seems to be 1619; this date is given in the Prado catalogue (1985, p. 726), and most authorities agree, with the exception of Camón Aznar (1964, pp. 216ff.), who reads 1617. It was probably painted for the Society of Jesus, with which the artist Francisco Pacheco, Velázquez's father-in-law and master, maintained cordial relations (portraits of Jesuits are frequent not only in his *Arte de la pintura* [Seville, 1649] but also in his *Libro de descripción de verdaderos retratos* [incomplete manuscript, Seville, 1599; Fundación Lázaro Galdiano, Madrid]). Curtis and Mayer note an unverified report that until 1775 the work was in the collection of Francisco de Bruna of Seville, where it was seen by the English traveler Richard Twiss; part of that collection derived from the Jesuits, who had been expelled from Spain by Charles III. Ainaud de Lasarte believes that the painting was intended for the Jesuit novitiate of San Luis in Seville, and Gudiol concurs.

In the opinion of López Rey the canvas must originally have been larger. Trapier (1948, p. 43) published a lithograph made after the painting in 1832 by Cayetano Palmaroli; this composition is wider on each side, with the result that the kings and their page on the left and Saint Joseph on the right are not cropped. López Rey thinks, however, that the lithographer may have made these additions in the spirit of the Velázquez composition. Some of the painter's canvases have been trimmed (e.g., *Prince Baltasar Carlos as a Hunter*; pl. 22) and others augmented (e.g., *The Weavers*), but considering Velázquez's zeal for compactness (especially notable in *The Weavers*, among others), it is plausible that the present dimensions may be original, particularly as the lateral extensions detract rather than improve. Furthermore, an altar painting would not have been so likely to suffer alterations as a palace composition intended to complement a wall decoration.

This is among the first dated works by Velázquez, who must have painted it at the age of twenty, a year after his marriage to Pacheco's daughter Juana on April 23, 1618. Their first daughter was baptized in May 1619. Since Velázquez, like Caravaggio, preferred real and familiar models, it might be supposed that this Epiphany is a family portrait with his wife, Juana, as the Virgin, his daughter Francisca as the Child Jesus, Pacheco as Melchior, Velázquez as Gaspar, and a brother of the painter's or a household servant or retainer as Balthazar, the black magus (Gállego 1974, pp. 127–28). There is, however, no evidence for this hypothesis. But while any critic may affirm or deny the likenesses, Velázquez undoubtedly did employ live models here, except perhaps for Saint Joseph, whose head is less successful. The page is

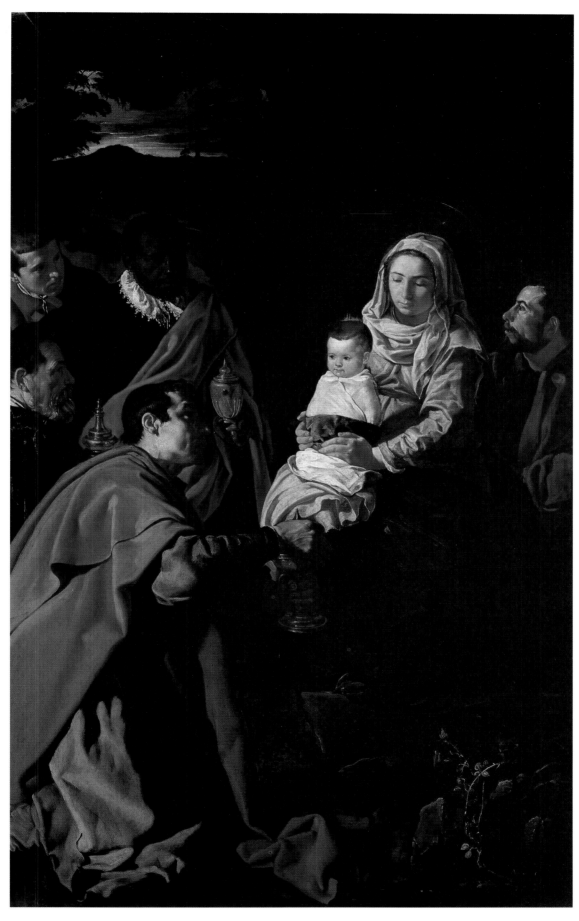

very like a boy who was "enlisted" for the purpose, according to Pacheco (*Arte* II, p. 146) who recommended working from life ("I rely on live figures for everything"; *Arte* II, p. 13). This practice coexisted with the Platonic idealism that, according to Menéndez Pelayo (1947), prevailed in Pacheco's coterie and was passed on to his pupil and son-in-law.

The naturalism of this Epiphany represents a new level of Caravaggism, which I believe reflects a development within Jesuit aesthetics. In his *Spiritual Exercises*, Saint Ignatius Loyola, the society's founder, counseled that religious and spiritual entities should be perceived with the five senses, as though they stood before us (Gállego 1968).

Nothing is idealized in this scene; there is nothing of the sumptuous about the royal magi, clad here in coarse woolens and plain robes, save for the golden vessels holding their gifts—gold, frankincense, and myrrh—and Balthazar's lace collar. This is a radical departure from the idealized depictions of the Epiphany, and even from the elegant costumes and coiffures of the rendition of this event by Juan Bautista Mayno (1611–13; Museo del Prado, no. 886), whose moderate Caravaggism later prompted him to side with Velázquez at the court. In the present painting the magi might be our neighbors. The Virgin provides the only focus for devout meditation, although Pantorba sees in her no "slightest trace of spirituality," for she is no more than "a fine girl of Seville, careful to hold the Child with hands...sturdy, strong, rather coarse." Justi finds that those hands "are powerful enough to handle the plough, and if necessary to seize the bull by the horns."

There has been comment on the Child's mummy-like body which contrasts with his bright, pleasant expression; but it should be recalled that in

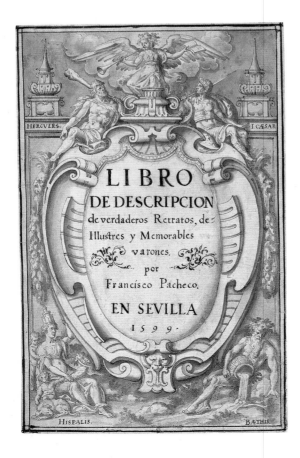

Francisco Pacheco. Title page,
Libro de descripción de verdaderos retratos
(Seville, 1599).

Detail of pl. 2.

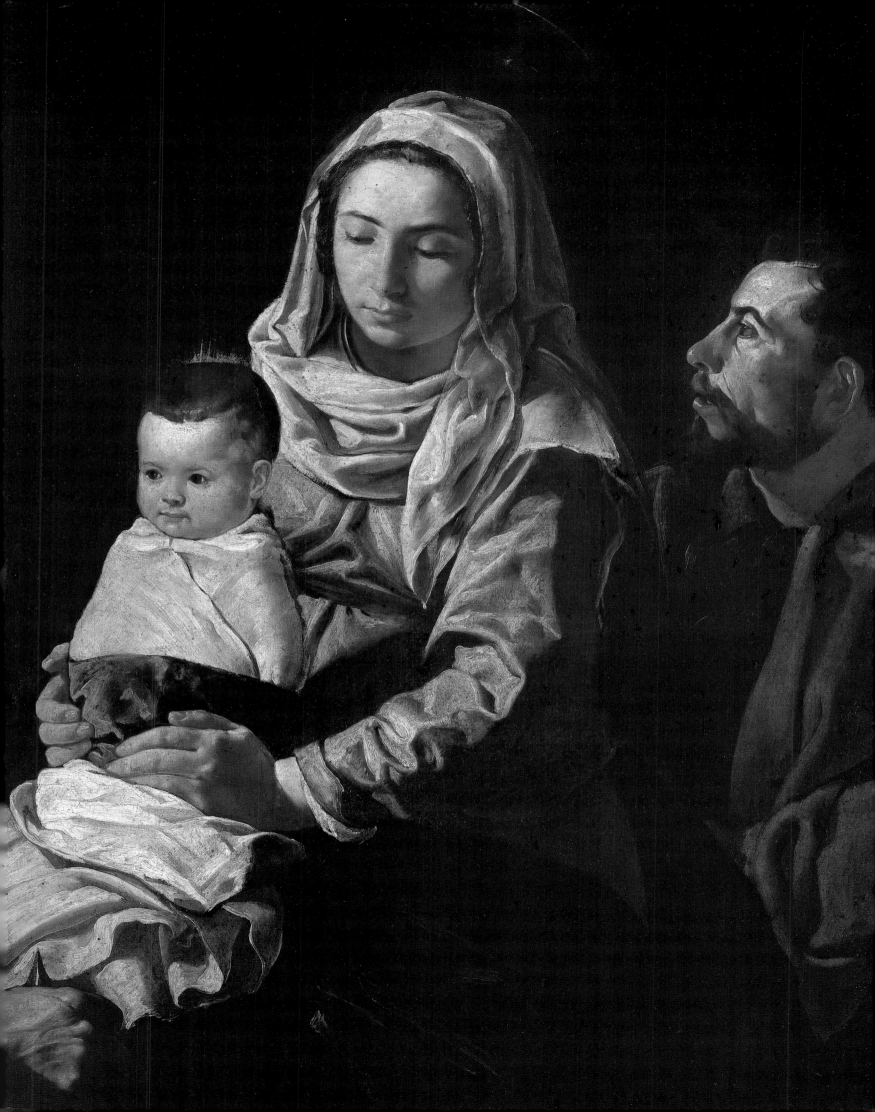

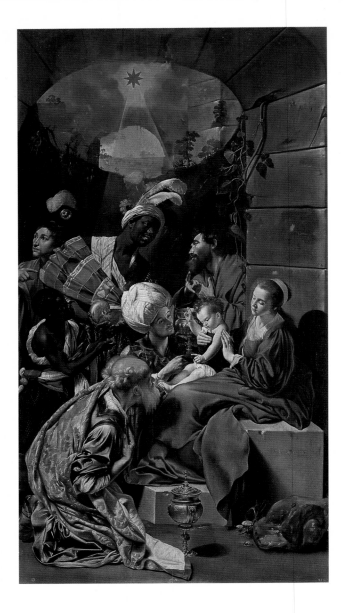

Juan Bautista Mayno. *The Adoration of the Magi*.
Museo del Prado, Madrid.

those times (and almost until our own century) infants were swaddled, and
thus this is another touch of Loyolan verisimilitude.

The color is somber and tenebrist, strongly lit from the upper left. De-
spite the wide range of the colors (the Virgin's pink dress and blue mantle,
Gaspar's green robe and brown mantle, Balthazar's red mantle, Saint
Joseph's violet robe and yellow mantle), a rather monochromatic modeling
predominates, akin to that of Herrera the Elder and Pacheco and later of
Zurbarán. There is a plasticity and a denseness in the fabrics, reminiscent of
carved figures. In discussing the reserved expression of the Virgin, Camón
recalls Martínez Montañés's figure of the Immaculate Conception in the
Seville Cathedral, known as *La Cieguecita* (the little blind girl). Sevillian sculp-
ture had matured earlier than Sevillian painting and powerfully influenced it,
notably in the strong and dark polychromy favored by painters, like Pacheco,
of the previous generation.

Attention is boldly directed to the Child, who occupies the center of the
very tight composition. Brown (1986, p. 21) criticizes the lack of space in the

LITERATURE

Mayer 7, Curtis 9, Pantorba 12,
López Rey 6, Gudiol 16, Bardi 9

PROVENANCE

Chapel of the Jesuit novitiate, Seville (?).

Collection of Francisco de Bruna, late in
the eighteenth century. Upon his death
(1804), his nephew Luis Meléndez pre-
sented the work to Ferdinand VII.

Monastery of El Escorial, according to
Pedro de Madrazo in his Prado catalogue
(with attribution to Zurbarán).

Museo del Prado since 1819.

magi group, stating that it gives a heaped-up wedding-cake effect. I, however, think it is difficult to judge an altarpiece with no knowledge of its architectural and spatial surroundings. This crowded treatment might be related to the contrasting bareness of a wall or the matching embellishment of a frame.

Velázquez does not follow Loyola's advice to locate the events surrounding the Nativity in a cave or grotto, and in any event the Epiphany took place some days after the Birth. There is a barely visible shaft of column and some masterly bits of verdure in the foreground, and the darkling horizon hints at Velázquez's future greatness as a landscape painter.

Juan Martínez Montañés. *The Immaculate Conception*
("*La Cieguecita*"). Cathedral, Seville.

3

Mother Jerónima de la Fuente

Oil on canvas
63 × 49¼ in. (160 × 125 cm.)
Museo del Prado, no. 2873

This impressive portrait was not catalogued until 1926 when an exhibition on the Order of Saint Francis was organized by the Sociedad Española de Amigos del Arte in Madrid to commemorate the seventh centennial of the death of the founder (1226). It was discovered in the vaults of the convent of Santa Isabel la Real in Toledo. This community had attributed it to Luis Tristán, but restoration revealed the signature "Diego Velázquez" and the date, 1620. Thus this is the earliest known work signed by the painter. Not long after this work was found, Jerónimo Seisdedos, the restorer at the Museo del Prado, discovered another painting at the same convent; it is almost identical to the present work (except for the crucifix in the subject's hand, which is seen from the back in one painting and from the side in the other). Also signed and dated by Velázquez, the second painting is now in the Collection Fernández de Araóz in Madrid.

In 1988 the two portraits were on view together at the Prado. The present version is usually taken to be the original, especially because the position of the crucifix, more plausible in the Araóz version, suggests a correction (in the judgment of Seisdedos and of Pantorba). Both had a scroll issuing from near the nun's mouth and reading: SATIABOR DVM GLORIFICATVS FVERIT (I shall be content as long as He has been glorified). This inscription was removed from the Prado version during restoration because it was thought to be an addition (although such inscriptions were common in paintings of the time; Pereda, Murillo, and Valdés Leal were still using them years later). The inscription at the top of the picture reads: BONVM EST PRESTOLARI CVM SILENTIO SALVTARE DEI (It is good to await in silence the salutation of God). At the bottom there is a long inscription:

> Este es verdadero Retrato de la Madre Doña Jerónima de la
> Fuente, Relixiosa del Convento de Santa Isabel de los Reyes de
> T. Fundadora y primera Abbadesa del Convento de Santa Clara
> de la Concepción de la primera regla de la Ciudad de Manila,
> en Filipinas. Salió a esta fundación de edad de 66 años martes
> veinte y ocho de Abril de 1620 años. Salieron de este convento
> en su compañía la madre Ana de Christo y la madre Leonor de
> Sanct Francisco Relixiosas y la hermana Juana de Sanct Antonio
> novicia. Todas personas de mucha importancia para tan alta obra.

> This is a true portrait of the lady Mother Jerónima de la Fuente,
> religious of the convent of Santa Isabel de los Reyes of Toledo;
> founder and first abbess of the convent of Santa Clara de la
> Concepción of the first rule of the city of Manila, in the

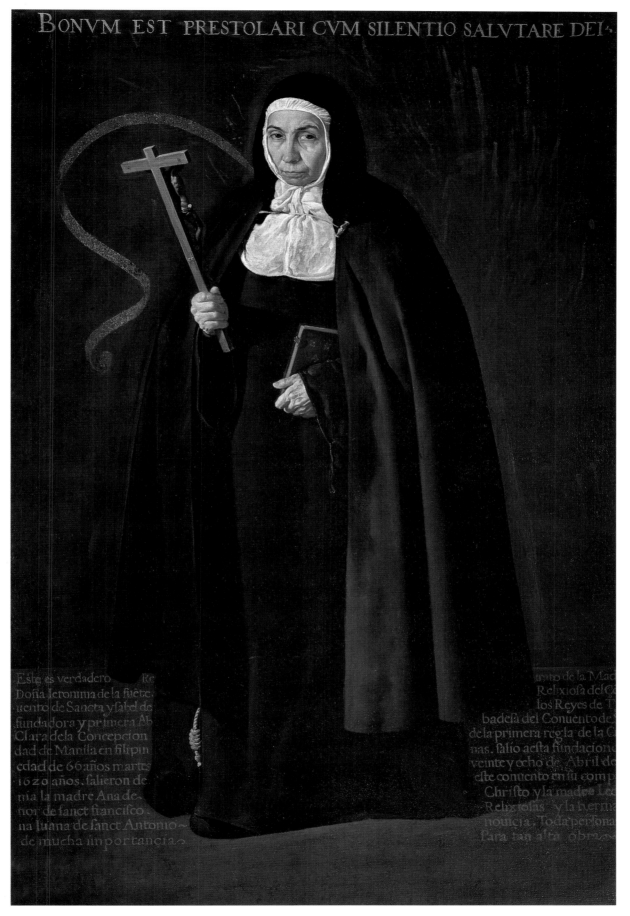

Este es verdadero Re
Doña Ieronima de la fuete.
uento de Sancta ysabel de
fundadora y primera Ab
Clara dela Concepcion
dad de Manila en filipin
edad de 66 años martes
1620 años. salieron de
nia la madre Ana de
nor de sanct francisco
na Iuana de sanct Antonio
de mucha importancia

nto de la Mad
Relixiosa del Co
los Reyes de
badesa del Conuento de
dela primera regla de la C
nas. salio aesta fundacione
veinte y ocho de Abril de
este conuento en su comp
Christo y la madre Lec
Relixiosas y la herm
nouicia. Toda perlona
Para tan alta obra

Velázquez. *Mother Jerónima de la Fuente.*
Collection Fernández de Araóz, Madrid.

Philippines. She departed this foundation at the age of 66 years, Tuesday the 28th of April 1620. Departing this convent in her company were Mother Ana de Christo and Mother Leonor de San Francisco, religious both, and Sister Juana de San Antonio, novice. All persons of great importance for so lofty a work.

The inscription is undoubtedly a later addition, since it refers to a foundation not yet established when the portrait was painted (between the first and the twentieth of June 1620, when the nun stayed in Seville, according to Camón Aznar [1964, p. 240]).

Pantorba (1955, p. 75) states that Mother Jerónima was from Toledo and was the daughter of Don Pedro García Yáñez and Doña Catalina de la Fuente. A contemporary wrote that "by her active mind and literary gifts, she was like a younger sister to Saint Teresa of Jesus." After the portrait was painted, she took ship at Cádiz, traveled to San Juan de Ulúa and thence

Detail of pl. 3

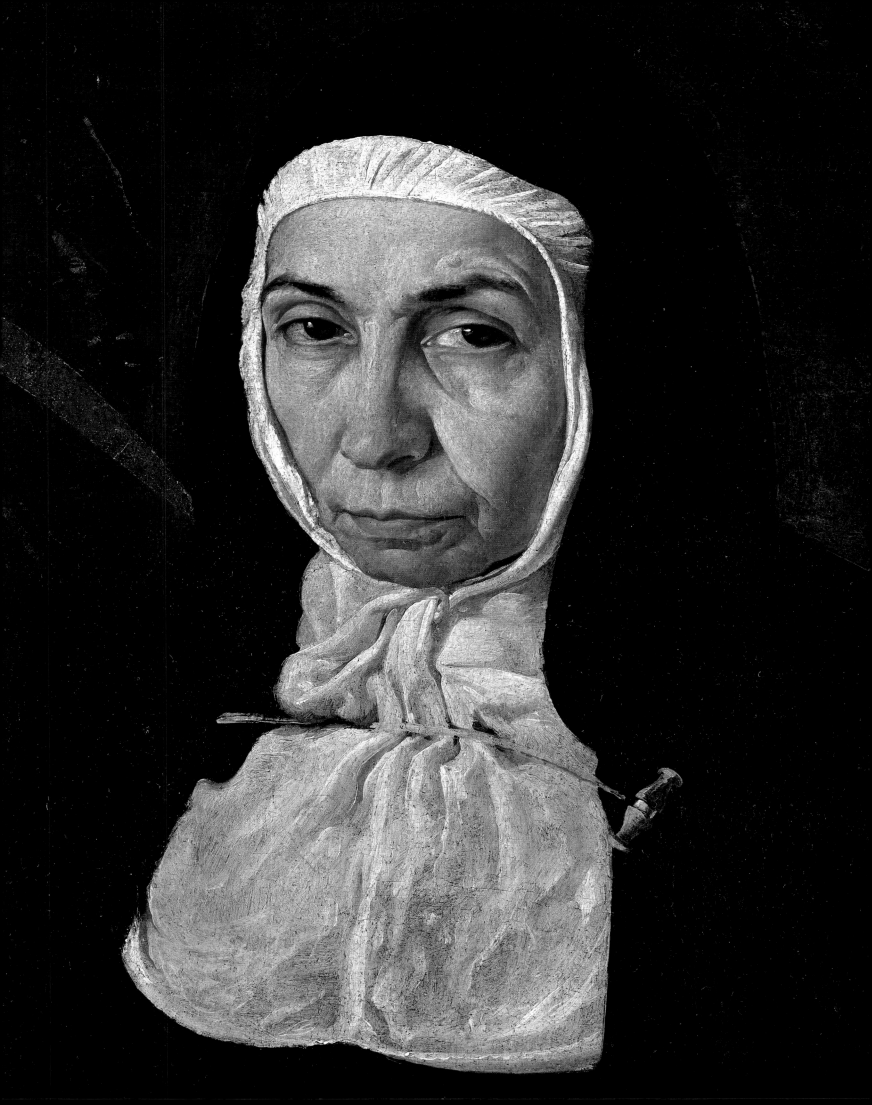

through Mexico, arriving as a missionary at Manila in August 1621. She died there in 1630.

Saint Teresa had reformed the Carmelites, and her community had had her portrait painted by Fray Juan de la Miseria. Following this example, the Poor Clares of Toledo wanted a portrait of Mother Jerónima de la Fuente. Perhaps at the suggestion of Pacheco, whose friends included many religious (his *Libro de retratos* portrays two Franciscans, Brother Luis de Rebolledo and Brother Juan de la Cruz), they engaged Velázquez, who was then accepting ecclesiastical commissions (*The Venerable Cristóbal Suárez de Ribera* and a number of renditions of religious themes).

The nun's physical and spiritual presence is impressive in these portraits. The face has something of Pacheco's stiffness, but here light is the deus ex machina of the composition, pouring over the rough-hewn features and strong hands of the community's founder as she holds the cross and the book with missionary firmness. The severe expression—the knitted brow, the faintly disdainful set of the lips, and the deep, sad look of eyes brightened by unshed tears—seems more emphasized in the Araóz version. The influence

Fray Juan de la Miseria. *Saint Teresa.*
Convent of the Carmelites, Seville.

Velázquez. Detail of *Christ in the House of Martha and Mary*. National Gallery, London.

LITERATURE

Mayer 546, López Rey 577, Pantorba 18, Bardi 17, Gudiol 17

PROVENANCE

Convent of Santa Isabel la Real, Toledo.

Purchased by the National Ministry of Education from the community in 1944, with the aid of the Patronato del Prado.

Museo del Prado since 1944.

of contemporary carvers is apparent in this almost tactile figure, whose most painterly touch is the finely pleated white wimple, haloing her face like a sign of sanctity and compelling the viewer to meet her gaze. Although these are early works, Velázquez's hand is evident in the absence of any concession to prettiness and of any imaginative excursion and in the solidity of the subject's body and stance. The changed placement of the crucifix is not arbitrary; in the Prado version Velázquez presents the penitent and in the Araóz version the missionary.

Brown (1986, p. 34) notes a certain "ambiguous definition of space," not unusual in the early works. When Velázquez paints a standing figure, "a type of pose which compels the artist to provide the illusion of a floor... he seems to tilt it upward" instead of following the rules of linear perspective. Thus one wonders if "Velázquez was unschooled in linear perspective"; however, considering Velázquez's independent bent, I am more inclined to think "that he knew the trick, but had decided not to use it."

The young artist could, in fact, render space in a conventional way; he followed the rules in the picture within the picture—Jesus preaching to Mary—in *Christ in the House of Martha and Mary* (National Gallery, London), which is of the same period as this portrait.

Here the feeling of verticality of the floor is due in large measure to the inscription that fills the area around the feet of the subject; in order to put his subject in a real space, the painter uses only the shadow she casts on the floor. He carried this device to its extreme in his 1632 portrait of Pablo de Valladolid; there the figure stands against a plain, pale ground, modeled only by the shadow of the legs.

Velázquez manifests an inability (or a refusal) to idealize what he paints. This virtuous and learned nun is a memento mori in Franciscan serge rather than a revered and beloved mother superior. Velázquez never painted a less appealing figure, and this portrait demonstrates his lack of sympathy for the conventions of sacred art, which he would have to have embraced had he continued to live in Seville.

4

The Poet Don Luis de Góngora y Argote

Oil on canvas
19¾ × 16 in. (50.3 × 40.5 cm.)
Museum of Fine Arts, Boston, no. 32.79

Through the painter Francisco Pacheco (*Arte* I, chapter 8), Velázquez's father-in-law, we know that the young artist "left Seville for Madrid about the month of April 1622.... At my instance, he did a portrait of Don Luis de Góngora, who was much celebrated in Madrid; at the time, there was no opportunity to portray Their Majesties, though the attempt was made." Since Pacheco indicates that his son-in-law returned to Seville immediately after this visit (Gállego 1983, pp. 45ff.), there is general agreement that this portrait should be dated to 1622.

It is believed that Pacheco's commission to his son-in-law would have been to acquaint the court with his abilities in portraiture and thereby advance his career. Such indeed was the result, beginning in the following year, 1623, when he was summoned by the count-duke of Olivares; by August 30 Velázquez was doing his first portrait of the king.

Pacheco also wanted a model for an engraving to be included in his *Libro de retratos* (Pacheco's drawing is, however, not included in the manuscript of this volume in the Fundación Lázaro Galdiano, Madrid). Velázquez had adorned Góngora's forehead with a laurel wreath (revealed when the Boston canvas was X-rayed); this element links this portrait with those by Pacheco of the poets Gutierre de Cetina, Fernando de Herrera, Rodrigo Caro, Francisco de Quevedo y Villegas, Baltasar del Alcázar, Cristóbal Moxquera, and others (Pacheco mentions that some of these drawings were done after paintings by other artists). This circumstance would seem to refute the argument of Jacinto Octavio Picón (1947, chapter 4) that, "given Pacheco's interest and Góngora's importance, his reputation being then at its zenith," and "this being moreover one of the first works undertaken by Velázquez to make himself known in Madrid, he would not have contented himself with painting only a head." Picón concludes therefore that the portrait in question must have been full-length or at least half-length, as in the later portrait of the sculptor Martínez Montañés.

Opinion is divided on the sequence of the three portraits of Góngora attributed to Velázquez, all of about the same size. On the other hand, "critics today, almost unanimously, acknowledge that the Velázquez original is the one that belonged to the marquis of La Vega Inclán and was shown in the spring of 1931 in an exhibition of Spanish masters held in London by the house of Tomás Harris Limited," from which it was acquired by the Museum of Fine Arts, Boston (Pantorba 1955, p. 80). The other two are in the Museo del Prado (no. 1223), among works from Velázquez's studio, and in the Museo Lázaro Galdiano, Madrid, of which José Camón Aznar was director. He held

this last version to be the original and far superior to that of Boston, which he took for a copy, "later, broader, impetuously baroque" (Camón Aznar 1964, p. 265). He criticizes the present painting as "a head treated in independent planes, as though faceted" (which is true enough, but a virtue in my judgment), and "of motley color." According to Pantorba, only Elías Tormo has shared Camón Aznar's opinion. Gudiol accepts all three versions as authentic (nos. 32, 33, and 34 of his catalogue) but gives precedence to the Boston one, "which must have been the prototype" (1973, p. 74). Mayer (1921) and Allende-Salazar (1925), as well as Borenius, Pantorba, Bardi, Trapier, Brown, and others, also say the Boston painting is the original.

We have seen in what circumstances it was executed by Velázquez, who was barely twenty-three, trying his fortunes at the court of a king who was only seventeen and who was dominated by the count-duke. The present painting is a careful work, in which he applied the rules of his master, Pacheco, a far better portraitist than a history painter. He can hardly yet have had the leisure to study the paintings at El Escorial, the object of his pilgrimage (according to Pacheco). Trapier recognizes this "manner of breaking up the planes of the face, of brushing in the eyebrows with broad strokes," in the later portrait of Olivares (1625; Hispanic Society of America, New York). By way of psychological insight, Brown (1986, p. 35) holds that "not until 1650, when Velázquez painted the portrait of Pope Innocent X . . . did he again turn

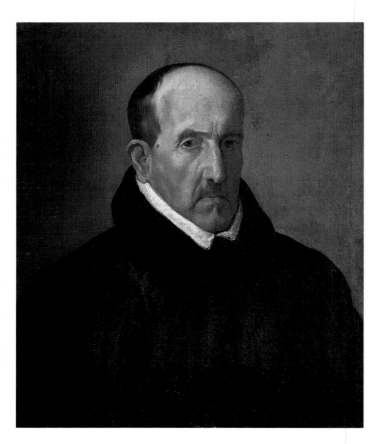

Velázquez. *The Poet Don Luis de Góngora y Argote.* Museo Lázaro Galdiano, Madrid.

Velázquez. *The Poet Don Luis de Góngora y Argote.* Museo del Prado, Madrid.

the full force of his merciless eye on another sitter." Here the poet holds the viewer in a fixed gaze, his expression a blend of obstinacy, pride, and disappointment.

Don Luis de Góngora y Argote was born in Córdoba, of a noble family, on July 11, 1561. He was thus sixty or sixty-one when Velázquez painted his portrait. As a youth, Góngora had begun the study of law at Salamanca, but he found this field uninteresting. Turning to the Church, he was named prebendary of the cathedral of Córdoba in 1585, when he was beginning to gain fame as a poet. In 1613 manuscript copies were circulated of his two long poems *Las Soledades* and *Polifemo*. Masterpieces of the difficult, complex style that came to be known as *gongorismo*, they were attacked by his literary adversaries, such as Lope de Vega, whom Góngora answered with aggressive firmness. Encouraged by enthusiastic admirers, in April 1617 he came to the court, where, though he was promptly named royal chaplain, he was harassed by quarrels with the envious and "consumed in courtly pretensions whereby he gained very little for himself and languished in continually straitened circumstances" (Millé y Giménez, 1932). It was at this time that Velázquez painted his likeness, a few years before an illness caused him to return to Córdoba, where he died on May 23, 1627. His genius was then belatedly recognized, and the first edition of his complete works (many previously unpublished) was published by López de Vicuña in Madrid in 1627.

Besides its merits as a painting, this portrait is of great iconographic value, which accounts for the numerous replicas or copies in existence. Among the most noteworthy, according to López Rey, are a workshop version (Mayer, no. 340; López Rey, no. 497) in the Museo Lázaro Galdiano, Madrid; a school version (López Rey, no. 498) in the Museo del Prado (no. 1223); and one in the Ramón Aras Jauregui collection in Bilbao (López Rey, no. 499); this last, formerly in the Gandarillas collection, had been purchased from Rojas Pavón of Córdoba, who had inherited it from the Argote family. Restored and trimmed in 1910, the Bilbao picture is noted by Pantorba (no. 133, with numerous references) as an independent work, possibly an original.

LITERATURE

Mayer 339, López Rey 496, Pantorba 22, Gudiol 32, Bardi 24

PROVENANCE

Owned by Francisco Pacheco and probably upon his death by Velázquez (a portrait of Góngora is listed as no. 179 in the inventory taken of his effects after his death in 1660).

Marquis of La Vega Inclán, Madrid, early in the twentieth century.

Tomás Harris Ltd., London, 1931.

Museum of Fine Arts, Boston, since 1932.

The Waterseller of Seville

Oil on canvas
42 × 31⅞ in. (106.7 × 81 cm.)
Wellington Museum, London, no. 1608

This work is arguably the masterpiece of Velázquez's Sevillian period, unless, as Brown (1986, p. 12) hints parenthetically, it was painted in Madrid after he moved there in 1623. This suggestion seems unlikely, however, since the model apparently was a Corsican, a type popular in Seville at the time, as noted by López Rey, Pantorba (p. 78), and Camón Aznar (1964, p. 208).

The work is undoubtedly authentic. It can be traced from 1623, when the artist gave or sold it to the canon Don Juan de Fonseca of Seville, who at Philip IV's new court held the post, both ecclesiastical and palatine, of *sumiller de cortina* (curtain chamberlain). Among his duties and privileges, woven into the intricate palace ceremonial, was that of attending the king and queen at chapel and drawing the curtain there against the courtiers at large. Fonseca, like many other Sevillians, was drawn to Madrid by Olivares, who, though born in Rome, was Andalusian by titles and connections. The count-duke was the patron of a number of other prominent Sevillians, among them the poet Francisco de Rioja and Velázquez himself, whom Olivares had Fonseca summon shortly after the disappointed painter returned home from his first visit to Madrid.

The painting remained in the Alcázar and then passed to the Buen Retiro, where it was seen by Palomino (1724), the first author to mention it. However, his description is as inaccurate as that he gives of *An Old Woman Cooking Eggs* (pl. 1). He speaks of "the painting they call the Waterseller, of an old man very ill-clad in a vile tattered cloak revealing his chest and belly, all warts and wens, and with him is a boy to whom he gives a drink." The man in the painting wears a brown smock with a vented or ripped sleeve over a shirt of dazzling whiteness—a costume of some dignity, as well as modesty—revealing only a fine head. For Camón Aznar (1964, p. 206) this portrait prefigures that of the magistrate Don Diego del Corral y Arellano (pl. 14) in the poise and dignity of the pose and in the quiet thoughtfulness of attitude. Palomino's mistake is not surprising; such lapses were not unusual in descriptions of works of art, especially before photography, when too much trust was placed in memory.

The painting was later moved to the Palacio Nuevo, where Ponz (1776) saw it. There it won praise (with reservations) from the neoclassicist Anton Raphael Mengs, and Goya made an etching of it. Pantorba states that "this painting drew much comment in the early literature." Carried off from Madrid by Napoleon's brother Joseph, the Bonaparte king of Spain, when he was compelled to flee the city, the picture was captured by the victor of the Battle of Vitoria (1813), Arthur Wellesley, later the duke of Wellington. Wellesley

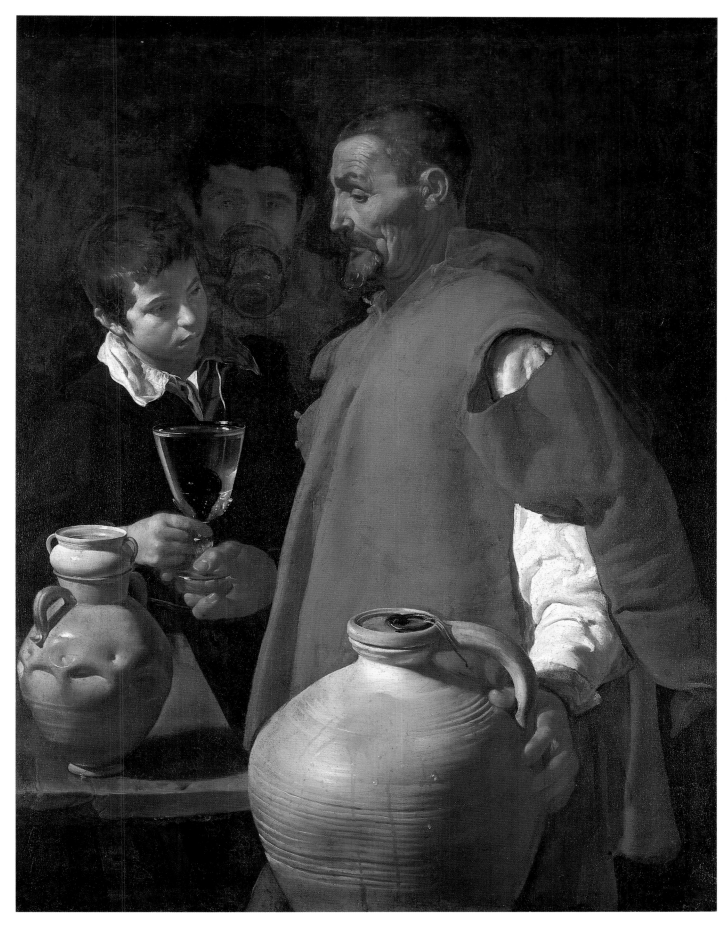

Velázquez (?). *The Waterseller of Seville.*
Collection Contini-Bonacossi, Florence.

brought it to London, along with other paintings, and asked the Spanish
government what he should do with them. Ferdinand VII, now restored to
the throne of Spain, promptly made him a present of them, and *The Watersel-
ler* is now in the Wellington Museum, London, with two other works ascribed
to Velázquez.

Several dates have been offered: López Rey, 1619–20; Bardi, 1620; Pan-
torba, 1621; and Gudiol, 1622. Gudiol (1960, p. 418) surmised that the replica
or copy in the Collection Contini-Bonacossi, Florence, unduly disdained
by Pantorba, might be Velázquez's first version of the theme; however, he
omitted it from his catalogue. In that painting, which has a drier, harder
execution, a cap or bonnet has been added, changes not to be expected from
a copyist. Two other replicas or copies are known, one at the Walters Art
Gallery, Baltimore. The Wellington painting is contemporaneous with *An
Old Woman Cooking Eggs*, or later by some months, according to Beruete,
who finds the latter less technically expert. *The Waterseller of Seville* is superior

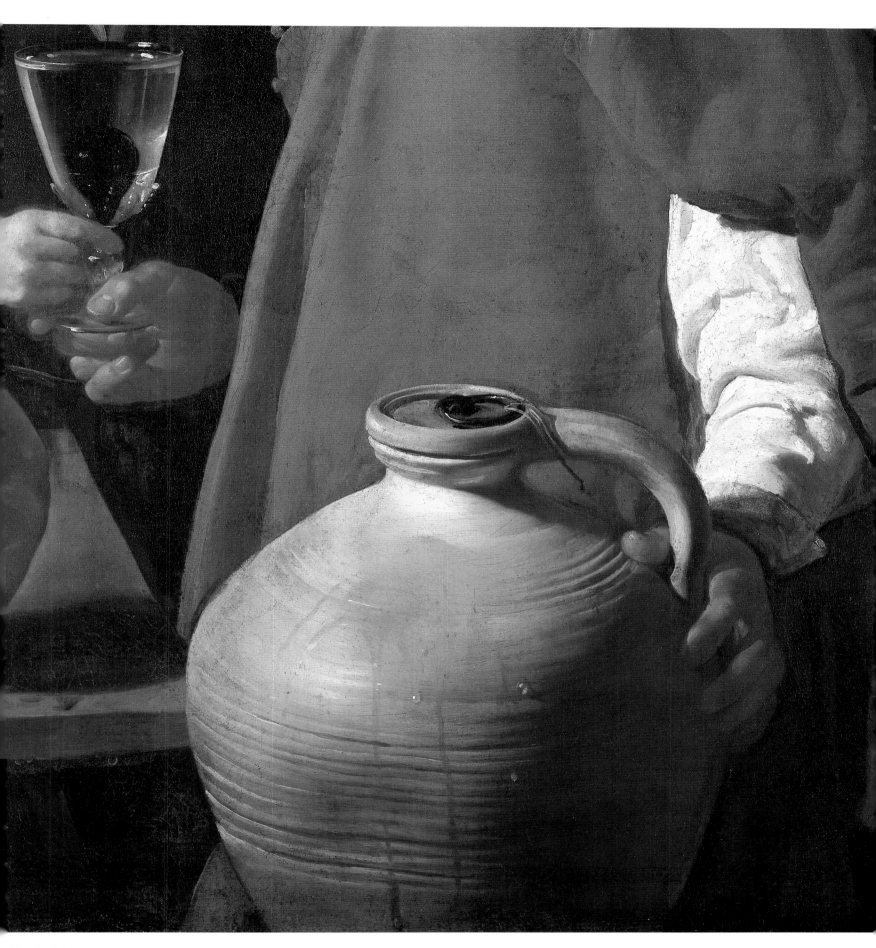

Detail of pl. 5.

in composition, describing a luminous spiral from the large jug in the fore-
ground (the artist has placed it in front of the picture plane, in the viewer's
space, like the floor in *Las Meninas* executed years later), through the smaller
jug (in turn surmounted by a paler cup) standing on a bench or table, to
the heads of the three people in order of age, the old waterseller last of all.

While his left hand "protrudes" from the picture plane, holding the
handle of the large jug (awe-inspiringly painted, with the modeling of the
best of Zurbarán but with unsurpassable details of staining and "sweating"),
with his right hand he offers a large-stemmed crystal goblet, full of clear
water, in which the outline of a fig is seen. According to some commentators
the fig is intended to perfume the water; to Camón Aznar it has "a salubri-

Velázquez. *Portrait of a Gentleman* (Juan de Fonseca?).
Detroit Institute of Arts.

LITERATURE

Mayer 118, Curtis 86, López Rey 124, Pantorba 21, Gudiol 11, Bardi 20

PROVENANCE

Juan de Fonseca, Madrid, 1623.

On the death of Fonseca in 1627 passed to Gaspar Bracamonte and later that year to the cardinal-infante Ferdinand of Austria in the Alcázar, Madrid.

Buen Retiro, inventories of 1700 and 1716.

In 1754 the Italian P. Caimo described the work in one of his *Lettere* as already in the Palacio Nuevo, where it appears in the inventories of 1772 and 1794. Ceán Bermúdez catalogued it in his *Diccionario histórico de bellas artes* (1800).

Taken from the Palacio Nuevo in 1813. Recovered by Wellington, who brought it to London. Ferdinand VII later gave it to him as a gift. At Apsley House, which afterward became the Wellington Museum.

ous virtue" but may have sexual connotations. A boy, head slightly inclined (similar but not identical to the one in *An Old Woman Cooking Eggs*), hastens to accept the cup; his dark dress and his collar seem to indicate that he is a person of some rank. Between the heads of these two, half in darkness, is interposed that of a young man drinking from a glass.

It has occurred to me that this composition may be an allegory of thirst, or, more persuasively, of the three ages of man: Old Age proffers the cup of knowledge (or perhaps of love) to Youth, who takes it with gravity; they look neither at each other nor at the cup. The coarser young man in the background drinks eagerly from his crude tumbler. As I have remarked (Gállego 1974, p. 132), "Age proffers the cup of knowledge to Boyhood, whom as yet it cannot serve, whereas Maturity drinks freely." The clear glass reveals the fruit and the water, previously hidden in the earthenware jug.

This scene has the same sense of arrested motion as *An Old Woman Cooking Eggs*. Drawing and modeling are brilliantly accurate. Velázquez never achieved more than this in the Sevillian manner. He breaks free of the picture plane; the great water jug, precursor of the still lifes of Cézanne and Juan Gris, stands in the viewer's space, its tactile perfection seemingly within reach of one's hand.

6

The Supper at Emmaus

Oil on canvas
48½ × 52¼ in. (123.2 × 132.7 cm.)
The Metropolitan Museum of Art, New York, Bequest of Benjamin Altman, 1913
(14.40.63)

Scholars agree that this is an autograph work. Camón Aznar once suggested that "this may be a canvas painted by Alonso Rodríguez, a Sicilian painter born in 1578, the son of a Spanish Captain Rodríguez, a native of León" (1964, p. 257); he cited thematic analogies to the present work (for example, Rodríguez's *The Supper at Emmaus*, Galleria Nazionale, Messina). At the end of this discussion, however, Camón Aznar concluded that "this possibility does not suppose a definitive exclusion of this extremely enigmatic canvas from the oeuvre of Velázquez, for the admirable technique, the splendor of the brushwork, and the total environment are superior to what was being done in Italy at the time. With these reservations and hesitations we believe we must continue to grant primacy of attribution to the name of Velázquez" (p. 260). Soria (1960, pp. 459–60) offers the opinion that "reminiscences from Tristán may be found in the brilliance and dramatic impact of the white draperies, in the deeply carved flux of other drapery folds, and in the sleeve of Christ's rose garment or in his blue mantle." Bardi (1969, p. 89) holds there are links with Zurbarán, Herrera the Elder, and Juan del Castillo, an opinion shared by Mayer and Pantorba. The latter (1955, p. 78) finds similarities between this head of Christ and several painted by Zurbarán, which raises the possibility that the artists may have shared a common model—a not unlikely occurrence in Seville. Beruete has perceived similarities between the standing Emmaus disciple and the head peering over the shoulder of the man holding the cup of wine in *The Feast of Bacchus* (Museo del Prado, no. 1170). Trapier (1948, pp. 136–37) says that Beruete's opinion is "hardly supported by a comparison of the techniques with which the two heads are painted." It is possible, in any case, that it is the same model and that he may also be the model for *The Waterseller of Seville* (pl. 5), as Pantorba believes.

This curious *Emmaus* provokes a seeming infinity of comparisons and stylistic kinships. The most striking is its similarity to a work on the same theme (Museo de Bellas Artes, Toledo) painted by Mateo Gilarte in Valencia, and undoubtedly inspired by the Velázquez painting. Gilarte added figures on the sides that disrupt the compact composition of the exemplar. Longhi, the first to cite the Alonso Rodríguez painting (1926, quoted by Trapier 1948), also alludes to Caracciolo and his Berlin painting *Saint Cosmas and Saint Damian*, in which one of the heads "appears—because of the distribution of the light—in exact relationship with *The Supper at Emmaus* by Velázquez." Finally, comparison is inevitable between the Velázquez painting and the

6

Velázquez. Detail of *The Feast of Bacchus* ("*Los Borrachos*").
Museo del Prado, Madrid.

Caravaggio painting on the same theme in the National Gallery, London. Faced with such a multiplicity of relationships, we can only admire all the more the indisputable originality of the Velázquez *Emmaus*, with its focused composition and almost aggressive color, so different from his contemporaneous works. Trapier accurately comments (1948, p. 135) that "the brilliant pink of the tunic worn by Christ is a surprising colour note in the artist's subdued palette of this period" and that "the other colours are in an entirely different chromatic scale, blue, yellow, and earthy brown."

This evangelical scene is painted in the same style (even the cloth is similar) as *The Three Men at Table* (Hermitage, Leningrad), usually assigned a date around 1620, but there are differences of opinion about the date. Lafuente Ferrari proposes 1619; Bardi and Pantorba, 1620; Soria, 1622; Gudiol, 1622 or 1623; Brown, after 1623; Wehle and Trapier, 1625–27; López Rey, 1628 or 1629, on the eve of Velázquez's first voyage to Italy. Before a decision about the date can be made, it must first be determined whether the painting predates Velázquez's first (1622) or second (1623) journey to Madrid or whether

it belongs to the first Madrid period (1623–29), when he was familiarizing himself with the paintings in the royal collections. One critic places the execution of the painting with *The Adoration of the Magi* (pl. 2), another critic with *The Feast of Bacchus*. This proves, once again, the uniqueness of this painting, which Gudiol believes is a contemporary of another, no less unusual work: *The Virgin Bestows a Chasuble on Saint Ildefonso* (Museo Provincial de Bellas Artes, Seville). This would place the present work in that brief Seville period between the trips to Madrid. This is admittedly a Caravaggesque painting, although not in the vigorous color or in the delicate grayish luminosity, which reveals Velázquez at his most original.

This work depicts an episode in the Gospel of Luke (24:13–35). After the Resurrection Jesus appeared to two disciples traveling to a village called Emmaus; they did not recognize him, but toward evening they pressed him to stay with them. "When he was at table with them, he took the bread and blessed, and broke it, and gave it to them. And their eyes were opened and they recognized him; and he vanished out of their sight." That moment of blessing and breaking the eucharistic bread has been represented in a multitude of paintings, with outstanding examples by such artists as Titian, Veronese, and Rubens, all much admired by Velázquez. Caravaggio's brilliant treatments of this episode (National Gallery, London, 1596–98; Pinacoteca Brera, Milan, 1606) present the same *aggiornamento* of the evangelical themes so dear to Velázquez and his generation (Gállego 1983). In the religious *bodegones* or *cocinas* (kitchen pieces) that the young Velázquez was so fond of painting (*Christ in the House of Martha and Mary*, National Gallery, London, and *The Supper at Emmaus*, National Gallery of Ireland, Dublin, in which the servant girl is sanctified by the scene of the supper in the background), themes scorned by such scholars as Carducho are ennobled by an inner religious or symbolic meaning.

A copy of the present painting was exhibited in 1838 in the Galerie Espagnole de Louis Philippe in the Louvre. When this collection was broken up, the painting was acquired in 1853 at a Christie's auction in London (no. 283) for £235 by the earl of Breadalbane, Plymouth.

LITERATURE

Mayer 15, Pantorba 20, López Rey 19, Gudiol 29, Bardi 21

PROVENANCE

Collection José Cañaveral, Seville, after 1850.

María del Valle González, Seville.

Manuel de Soto, Spanish consul, Zurich, in 1906.

Heinemann Gallery, Munich.

Wildenstein and Co., Paris.

Benjamin Altman, New York.

The Metropolitan Museum of Art since 1913.

Philip IV

Oil on canvas
78¾ × 40½ in. (200 × 103 cm.)
The Metropolitan Museum of Art,
Bequest of Benjamin Altman, 1913 (14.40.639)

The probable date of this painting is 1624. It remained for many years, virtu-
ally unknown, in Zarauz (Guipúzcoa), in the ancestral seat of the Corral
family, where it appeared in the 1688 inventory of the estate of Don Juan and
Don Cristóbal da Corral e Ipeñarrieta, sons of Don Diego del Corral (pl. 14)
and Doña Antonia de Ipeñarrieta (pl. 15). It was brought to Madrid in 1850,
along with the companion portrait of the count-duke of Olivares (Museu de
Arte, São Paulo).

There were questions about the identity of the subject. Beruete believed
the painting to be a portrait of Philip's brother, the cardinal-infante Ferdinand.
This opinion was shared by Mélida, who deemed it a copy of a lost original.
In the archives of the ducal palace of Granada de Ega in Zarauz, Mélida
found a receipt signed by Velázquez, in which he states that in Madrid on
December 4, 1624, he collected a bill in the amount of 800 reales for paint-
ings commissioned by Doña Antonia de Ipeñarrieta: "three portraits, one of
the king, one of the count of Olivares, and one of Señor Garciperes." There
could be no doubt that the painting was of Philip IV (Mélida 1906, p. 173).

Despite the document signed by Velázquez and despite general agree-
ment that this is an autograph work, Brown remains doubtful. In his view this
is a workshop copy of a lost original. Although "the version in The Metro-
politan Museum of Art was part of a documented commission of 1624 . . . and
has been accepted as an autograph work," he argues that "the dull, mechani-
cal execution, evident despite the loss of the impasto, suggests the hand of a
follower" (1986, p. 287 n. 32). But who might that Velázquez assistant have
been in 1624? Juan de Pareja (pl. 32) had not entered his service, and even
had he been apprenticed, he could never have been capable of this level of
painting. About Diego de Melgar we know scarcely anything, other than the
fact that he assisted Velázquez in Seville. As Velázquez had only recently
arrived at court, he had not as yet acquired a workshop where he and his
assistants could carry out commissions like that of Doña Antonia. The estab-
lishment of his workshop in 1651, by which time Mazo had assumed the style
of his master and father-in-law, was still years away. López Rey (1979, pp. 42,
73) accepts the hand of Velázquez, although he points out that there are
restorations and repainted areas in the face, eyes, and background; he adds
that it was unlikely the portrait was painted from life but rather was based on
earlier works.

Francisco Pacheco, Velázquez's teacher and father-in-law, relates that
Velázquez, living in Seville in 1623, was summoned to Madrid by the royal

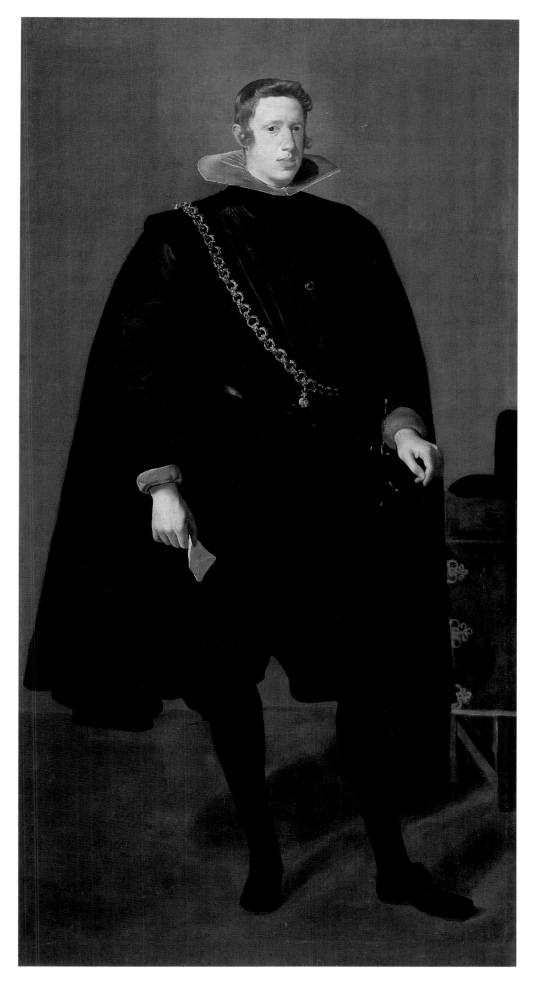

chaplain, Don Juan de Fonseca, at the order of Olivares. "He was given lodging in [Fonseca's] home . . . and painted his portrait" (Camón Aznar [1964, pp. 276–78] theorizes that this is the bust painting of an unknown subject now in the Detroit Institute of Arts). When this painting was removed to the palace, it was received with great acclaim, and as a result of that success, Velázquez painted his first portrait of the king on August 30, "to the pleasure of His Majesty and of the infantes and the count-duke, who affirmed that until that time [no one] had [truly] painted the king; and all the lords who saw it were of the same mind" (Pacheco, *Arte* I, chapter 8). Pantorba states that the Metropolitan portrait must be "considered a copy, painted by Velázquez, of his first portrait of the king . . . the original of which, logically, remained in the palace and which then would have been lost in the notorious fire. It is logical to believe that Doña Antonia de Ipeñarrieta, wishing to have a copy of the celebrated portrait of the monarch, would have commissioned the artist who was, or was immediately to be, author of her husband's portrait." López Rey (1963, no. 232) believes that Velázquez executed the portrait after the bust owned by Cardinal Ferrari.

Gudiol (1973, p. 81) praises this painting: "The young king is portrayed standing beside a table covered with red velvet, in a pose that shows self-

X ray of pl. 7.

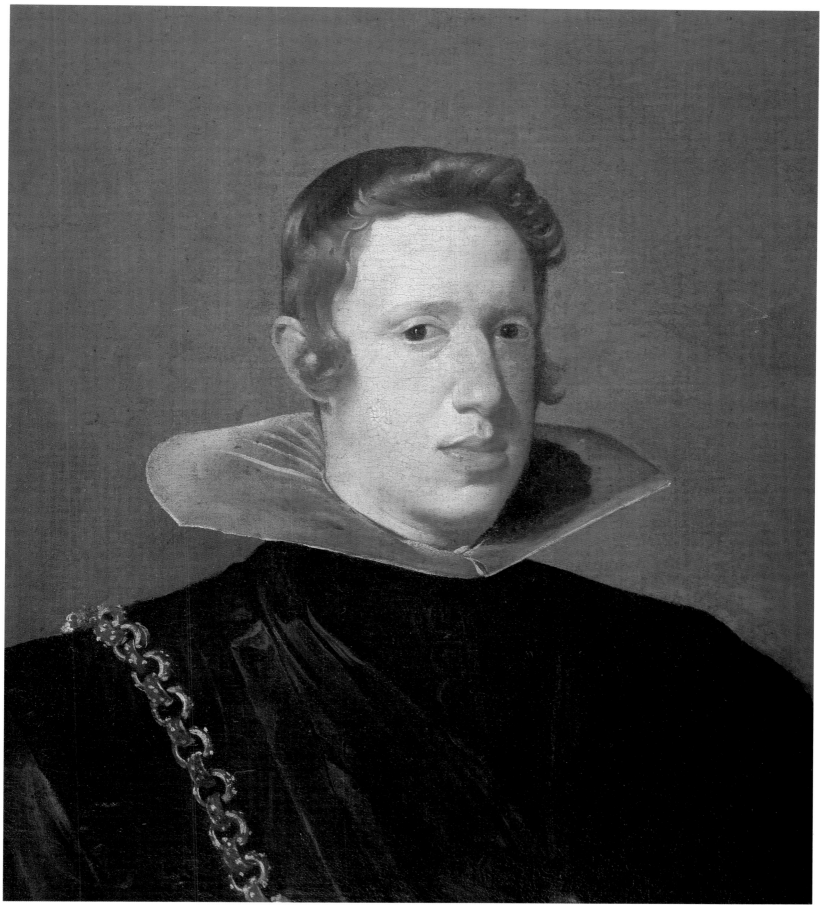

Detail of pl. 7.

Details of pl. 7.

8

Philip IV

Oil on canvas
80¾ × 46⅛ in. (205 × 117 cm.)
John and Mable Ringling Museum of Art, Sarasota, no. 336

This figure's pose resembles that in the Prado portrait of the black-clad king (no. 1182; pl. 9); the features are also so similar that they seem to come from a common source, which would also be the source for a second Prado portrait (no. 1183), a bust in which the king wears damascened armor and a general's red sash (the Prado catalogue suggests that the latter painting is a fragment of a larger, possibly equestrian, canvas). The Sarasota portrait differs, however, from the other two in its free and confident air and in the relaxed placement of the figure before a pillar on the left and, on the right, a table covered with a rich velvet cloth with gold frogs that fasten at the corners. Philip's hat rests on the table: It is not funereal black with a high cylindrical crown (the type worn in the austere court of his grandfather Philip II) but a handsome soft, broad-brimmed felt turned up on one side and trimmed with a luxurious plume held by a large pearl. Everything about the king's attire is opulent: the heavily embroidered suede gauntlets, long buckskin doublet revealing sleeves of rich iridescent silk, full breeches puffed at the thigh, fine riding boots, and wide crimson sash, trimmed with gold lace, which is knotted at the shoulder and floats free behind the back, as if lifted by a light breeze. The iconography of this portrait can be compared to the later *Philip IV in Brown and Silver* (National Gallery, London) and *Philip IV at Fraga* (Frick Collection, New York). These two paintings are more mature in technique, but the king lacks the arrogance and decisiveness he shows here, one hand grasping his baton and the other, the haft of his sword. The placement of the feet in the Sarasota work is more elegant than in most Velázquez portraits of the first period in Madrid, the years to which we must assign this handsome, if puzzling, canvas. The pose and the rising perspective of the floor add to the sovereign's stature, despite the fact that his head is farther from the frame than in contemporaneous images. He may possibly have posed on a dais, although it is not apparent in the painting.

For liveliness and grace, Justi considered this canvas one of the finest of its period. But these qualities, which in certain ways link the portrait to Rubens, and the amber tones and the luminosity of the floor have made a few critics doubt its legitimacy and argue that it is out of place among the somber "gray" portraits of the 1620s. Allende-Salazar believes that it is a copy of the Prado portrait (no. 1182; pl. 9) but with the subject in different attire. Mayer is doubtful that it is the work of Velázquez; López Rey (1974) is no more convinced. Pantorba and Bardi do not list this painting, even among questionable works. Gudiol and Díaz Padrón attribute the portrait to Velázquez (the latter in the catalogue for *"Splendeurs d'Espagne et des villes belges,"* the

8

Velázquez. *Philip IV*.
Museo del Prado, Madrid (no. 1183).

exhibition held in Brussels in 1985, where this canvas, little known until then, created a sensation). Passavant, Curtis, Suida, and Justi agree that the work is authentic. Justi and Gudiol lean toward a date of 1627 or 1628 for this exceptional work, a date in harmony with the age of the sitter, who was born in 1605 and who here appears to be in his early twenties.

In 1960 X-ray examination of the present painting revealed an earlier figure dressed in armor. This evidence appears to support a date in the late 1620s, since an order of September 3, 1628, requests that the necessary pieces of armor for portraits of the king be delivered to Velázquez. The Prado bust of the king in armor (no. 1183) may also be related to this order. The existence of this earlier figure also strengthens the hypothesis that Velázquez reworked the Sarasota painting after his meeting with Rubens and perhaps even after his first journey to Italy.

In the present painting pentimenti are visible around the king's leg and also the table (which was once larger, occupying nearly the entire background). In the background, behind the sumptuous hat, and in the foreground, extending from the table leg, are traces of other false starts, later painted over.

This combination of earlier and later elements can also be seen in other contemporary portraits by Velázquez—notably the equestrian portraits of Philip III, Margarita of Austria, and Isabella of Bourbon (Museo del Prado, nos. 1176, 1177, and 1179). (The first, with its windblown sash, broad-brimmed hat, and plume caught by a pear-shaped pearl, presents enigmatic similarities to the present portrait.) In discussing these equestrian portraits, the Prado catalogue, relying on documentary evidence, concludes: first, that Velázquez

LITERATURE

Mayer 207, Curtis 107, López Rey 243, Gudiol 45

left the framed portraits nearly complete when he went to Italy in 1629; second, that the canvases were finished by another artist as yet unidentified; and third, that after his return in 1631, Velázquez modified those parts in which his hand can be recognized. Although Beruete does not cite among these areas either the sash or the hat, I am inclined to believe that Velázquez may have added these and other elements to both the equestrian portrait of Philip III and the Sarasota portrait of Philip IV. The anomalies in the present canvas could thus be explained as the masterly retouching in 1631 (or later) of the portrait that was painted before 1629 following either the Prado model (no. 1182) or the first of this group of portraits (painted in 1624; Metropolitan Museum, pl. 7). The Rubenesque style of the accessories of the Sarasota canvas could be the result of the influence of Rubens himself, whom Velázquez knew in Madrid after their meeting in August 1628 and who seems to have supported the young Sevillian painter's plans to travel to Italy.

Philip IV

Oil on canvas
82¾ × 40⅛ in. (210 × 102 cm.)
Museo del Prado, no. 1182

Critics agree that this is an autograph work. Opinions about the date vary although experts concur in placing it during the years of the painter's first Madrid period, before his voyage to Italy. Gudiol suggests this could be the first portrait Velázquez painted of the young king in 1624. Cruzada Villaamil dates it 1623; Pantorba 1625; Camón Aznar believes it was retouched in 1627. The Prado catalogue (1985, p. 734) states that it was "painted before 1628, when the pose and clothing would have been modified"; it also points out that "the corrections, or pentimenti, are widely known; they prove that the pose in this portrait originally followed that of the 1624 painting in the Metropolitan Museum [pl. 7]."

Brown (1986, pp. 45, 47) observes that "throughout his career, Velázquez (like many portraitists) began a formal portrait commission by making a bust-length study of the sitter from life, which was taken back to the atelier to serve as a model for the finished work and for copies by members of the workshop." He believes that "the best candidate for the life study of the king [is] a bust-length portrait, now unfortunately much damaged," in the Meadows Museum, Southern Methodist University, Dallas. "Using this work, or one like it, Velázquez elaborated a full-length portrait, which some years later he extensively repainted." This full-length painting is the one we are examining here.

It was Velázquez's custom, after the execution of a portrait, to make substantial modifications. In this painting he suppressed the "baroque" elements in Philip's posture until he achieved a renunciation of contemporary style. It was this renunciation that displeased André Félibien des Avaux (1688, v, p. 9) when he lamented the absence of *"ce bel air que relève et fair paroistre avec grace"* the paintings by artists of other countries, especially Italy, in which one saw *"un certain gout tout particulier"* (it would have been more accurate to say *tout généralisé*), which animated the portraits of the Rubens school (surprisingly, this spirit is evident in the Sarasota portrait of Philip IV [pl. 8]). Following the severity of the school of the Spanish court, which was initiated with the works of Antonio Moro and continued by Rodrigo de Villandrando and Bartolomé González, Velázquez eschewed theatricality; he conveyed an extraordinary naturalness and achieved (in the eyes of today's Félibiens) the "lack of style" that is in fact a timeless manner that transcends ephemeral modes and lends to his images, despite their period clothing, a power of immediacy.

9

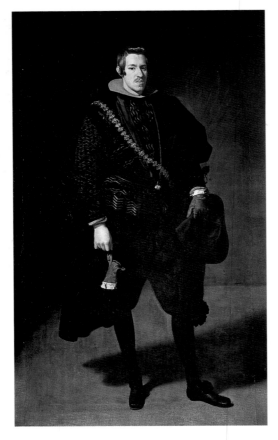

Velázquez. *Infante Don Carlos.*
Museo del Prado, Madrid.

In discussing the reworking of the present portrait, Brown (1986, p. 47) remarks that "the face ... now closely resembles the king's real-life appearance.... This change in the proportion of the head necessitated a corresponding change in the proportion of the body. Velázquez altered the pose by turning the body on a slight diagonal, reducing the width of the cape, and moving one leg behind the other. In this version of the portrait, Velázquez accomplishes two aims—greater accuracy of appearance and greater elegance of pose. These changes show a more mature understanding of Philip's taste in portraiture and established the format for royal portraits which was followed from then on."

In the present portrait the king is dressed in black. His starched *golilla* and short black cape follow the dictates of the pragmatic sanction of austerity which had just been issued and which forbade ostentatious clothing or a lavish display of jewels. Pantorba (1955, p. 90) observed: "The slender, blond youth, inexperienced and frivolous, who had already spent several years steadying the course of the Spanish monarchy, in this mournful portrait ... appears slimly austere and somber, with that aloof bearing of seignorial composure, and that expression of silent melancholy, that were his personal seal." In his hands he holds the two symbols of his mission as king. In his right hand is a sheet of paper, or a petition, symbolizing his administrative duties.

Rodrigo de Villandrando. *Prince Philip and Soplillo.* Museo del Prado, Madrid.

LITERATURE

Mayer 205, Curtis 105, López Rey 241, Pantorba 30, Gudiol 39, Bardi 38

PROVENANCE

This painting seems to have been moved from the Alcázar, Madrid, to the Buen Retiro.

The Buen Retiro inventory of 1701 lists a painting of Philip IV "in the manner of Velázquez," which, according to Pantorba, could be the present picture. Mentioned in inventories of 1716, 1789, and 1794.

Palacio Nuevo, 1791–1816.

Real Academia de Bellas Artes de San Fernando, Madrid, 1816–27.

Museo del Prado since 1827.

The left hand rests on the haft of an almost invisible sword, emblematic of his role as defender of the nation. On a simple table—the symbol of his office as chief justice of the realm—sits a black hat with a high crown and narrow brim, more similar to the high cylindrical hat that his grandfather Philip II wears in portraits by Pantoja and Sánchez Coello than to the flamboyant broad-brimmed hats of his father. Discussing this portrait and that of the king's brother the infante Don Carlos (Museo del Prado, no. 1188), Camón Aznar (1964, pp. 340ff.) observes that they are "the two most representative works of this period" and that "they offer us Velázquez's best theory on the genre. In their simplicity, they are the most regal. . . . Even their disdain, the nonchalance with which they have agreed to pose, their emotional distance, separates them, regally, from their viewers."

Joseph's Bloody Coat Brought to Jacob

Oil on canvas
87¾ × 98⅜ in. (223 × 250 cm.)
Monastery of San Lorenzo de El Escorial

The critics concur in placing this canvas and *The Forge of Vulcan* (pl. 11) in 1630. Both were painted in Rome during Velázquez's first journey; they have the same format, and sometimes are considered to be a pair. *The Forge* is now 15¾ in. (40 cm.) wider than *Joseph's Coat*, because two vertical strips were cut from the latter. Pantorba (1955, p. 98) states that old copies reveal that the figure of Jacob was not cut off at the elbow as it is now and that the youth at the left once held a staff, part of which can still be seen at the lower left.

Both pictures have the same number of figures, six in each, as if Velázquez wanted to emphasize the similarity of the disparate situations, thus uniting the whimsical and mythological *Forge* and the dramatic and biblical *Joseph's Coat*. Both were executed without the benefit of a royal commission, although they did later enter the Spanish royal collection. Palomino relates (1725, vol. 3, p. 106): "Velázquez brought these two paintings to Spain and offered them to His Majesty who, duly appreciating them, ordered them placed in the Buen Retiro, although the picture of Joseph was later moved to El Escorial and is in the chapter room." However, a receipt dated 1634, signed by the protonotary of Aragon, Don Jerónimo de Villanueva, indicates that he purchased them, along with other paintings brought from Italy by Velázquez, for the king at a price of more than one thousand ducats.

The scene depicted in *Joseph's Coat* is taken from the Old Testament, which tells the story of Joseph and his brethren, who, envious of his superiority, sold him to an Ishmaelite caravan. "Then they took Joseph's robe, and killed a goat, and dipped the robe in the blood...and brought it to their father [Jacob], and said, 'This have we found: see now whether it is your son's robe or not.' And he recognized it, and said: 'It is my son's robe; a wild beast has devoured him; Joseph is without doubt torn to pieces.' Then Jacob rent his garments..." (Genesis 37:31–34).

Velázquez has reduced the number of Joseph's brothers to five. Two of them (Ruben and Simeon?) show the bloodstained coat to Jacob, their father, who is seated on a small throne which rests on a carpet similar to that in *Prince Baltasar Carlos with a Dwarf* (pl. 21). The checkerboard floor is drawn according to rules of perspective, an exceptional circumstance in Velázquez. In the background two of the brothers, barely sketched, are outlined against an unadorned space that the artist had perhaps intended to be an extension of the finely executed landscape at the left. (This landscape passage demonstrates Velázquez's early proficiency in this genre.) A little dog, displaying the artist's skill at depicting these animals which will later appear in a number of

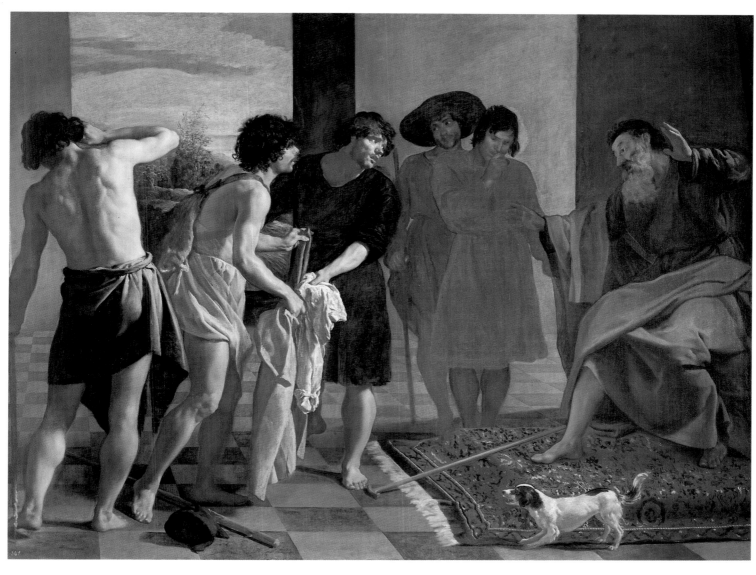

10

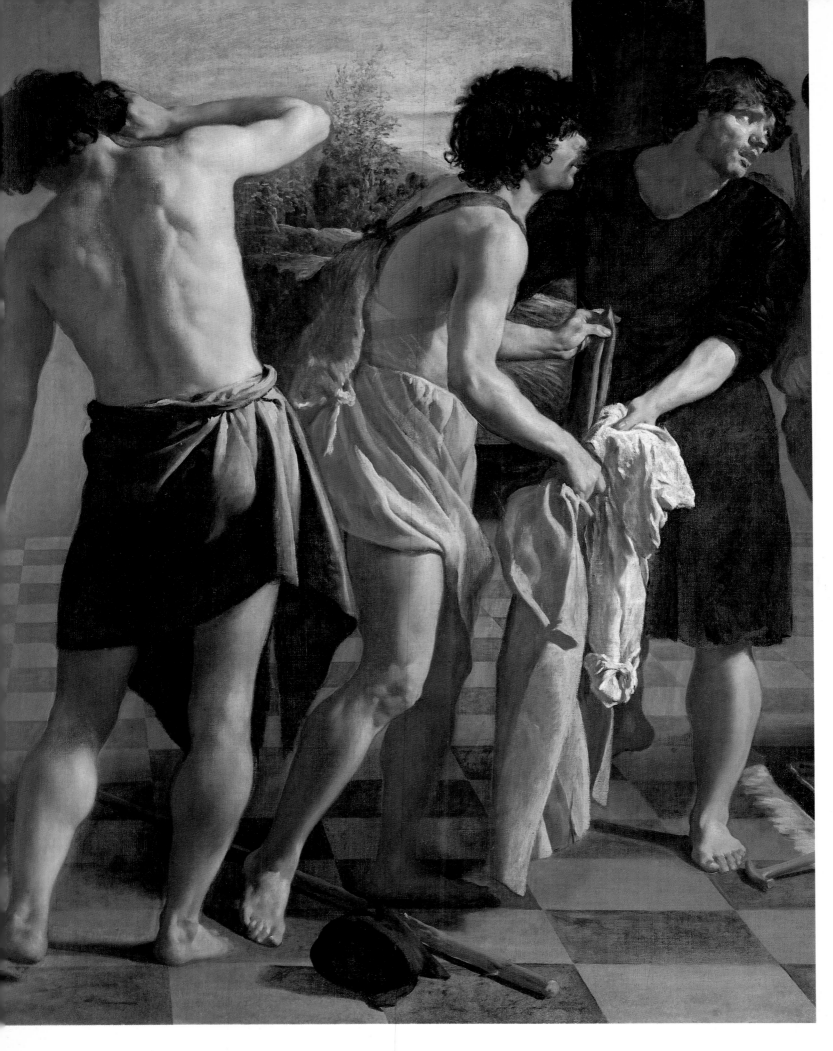

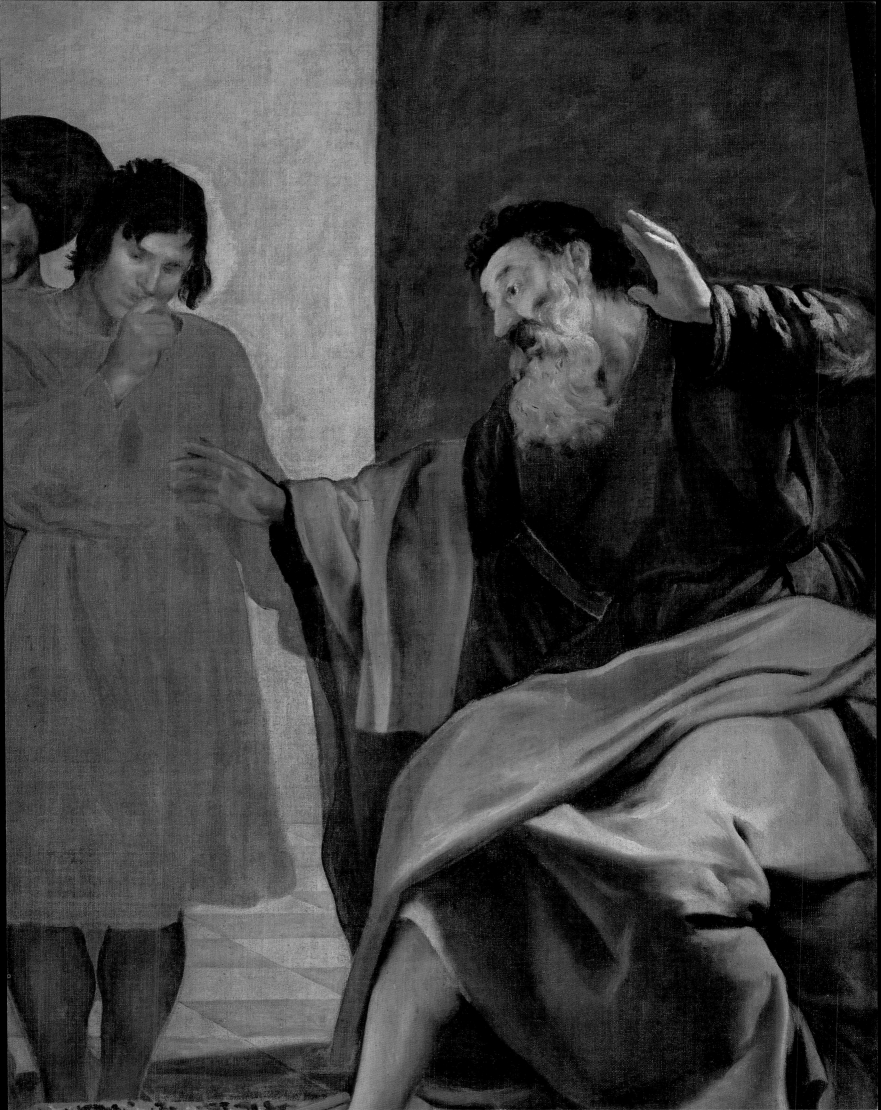

his portraits, barks at the treacherous brothers, as if scenting their betrayal.

This handsome canvas shows the influence of the Roman-Bolognese artists who were then in fashion in Rome (notably in the bare shoulders, resembling those of a blacksmith in *The Forge of Vulcan*). But if Guido Reni's example seems to pulsate in the cool and subtle *Forge*, in *Joseph's Coat* I believe I perceive something of Guercino's dramatic effects with chiaroscuro; Pacheco (*Arte* 1, chapter 8) states that Velázquez deliberately stopped in Cento, *paese* of that great painter who, in my opinion, influenced the Sevillian's career more than did Reni. The first mention of this picture appears in *Silva topográfica*, an indifferent poem of 1637 by the Portuguese poet Manuel Gállegos (Pantorba 1955, pp. 12–13 and 98). Fray Francisco de los Santos praises it in the second edition of his *Descripción de El Escorial* (1667), where the present painting was consigned in 1665.

Joseph's Coat and *The Forge* have been described as allegories of deception, calumny, or slander, but none of these elements are common to both scenes. I believe they are alike in manifesting the power of the word over human actions, an idea previously expressed in Andrea Alciati's *Emblemata* (CLXXX: "Eloquentia fortitudine praestantior" [Eloquence is more excellent than Fortitude], which shows Hercules holding men captive with the chains that issue from his mouth). That supports the notion, very typical of Pacheco and his Neoplatonic academy, of the superiority of ideas over material action; the lies of Jacob's sons will influence his actions and feelings. It is not to be forgotten, moreover, that Joseph's story prefigures that of the betrayal of Christ.

In 1845 a painting of the same subject was in the Madrazo collection in Madrid, where it was seen by Stirling, who reports that in that version the dog is asleep. The Madrazo gallery catalogue of 1856 hesitates to say whether it is a copy or an autograph painting. Mayer (no. 2) considered it a studio copy with variations. Since the death of its owner, Mariano Hernando, it has been in an unknown private collection. Pantorba cites other old copies of *Joseph's Coat*.

LITERATURE

Mayer 1, Curtis 3, López Rey 1, Pantorba 37, Gudiol 58, Bardi 40

PROVENANCE

Bought by Jerónimo de Villanueva from the artist for the royal collections in 1634.

Buen Retiro until 1665.

Monastery of San Lorenzo de El Escorial since 1665.

Detail of pl. 10.

The Forge of Vulcan

Oil on canvas
87¾ × 114⅛ in. (223 × 290 cm.)
Museo del Prado, Madrid, no. 1171

The Prado catalogue, critics, and historians agree on 1630 as the date of this canvas and of its companion piece *Joseph's Coat* (pl. 10). Both were painted by Velázquez during his first sojourn in Rome, and both were done without benefit of a royal commission, although a few years after his return to Spain they entered the royal collections. After they were purchased from the artist by the protonotary of Aragon, Don Jerónimo de Villanueva (López Rey 1963, pp. 47ff.), *Joseph's Coat* went to the monastery of San Lorenzo in the Escorial, and *The Forge* to the Buen Retiro. According to Brown and Elliott (1980, p. 136), both paintings first hung in the Buen Retiro. Pantorba (1955, pp. 98–101) proposes that both works were painted in the Roman home of the Spanish ambassador to the Papal States, Don Manuel de Fonseca, count of Monterrey, and that embassy servants were probably models. Pantorba believes that *Joseph's Coat* was painted before *The Forge*, which seems to him a more consummate work. *Joseph's Coat*, however, has blank sections of background that

Antonio Tempesta. *The Forge of Vulcan.*
From Ovid, *Metamorphoses* (Antwerp, 1606).
The Metropolitan Museum of Art, New York.

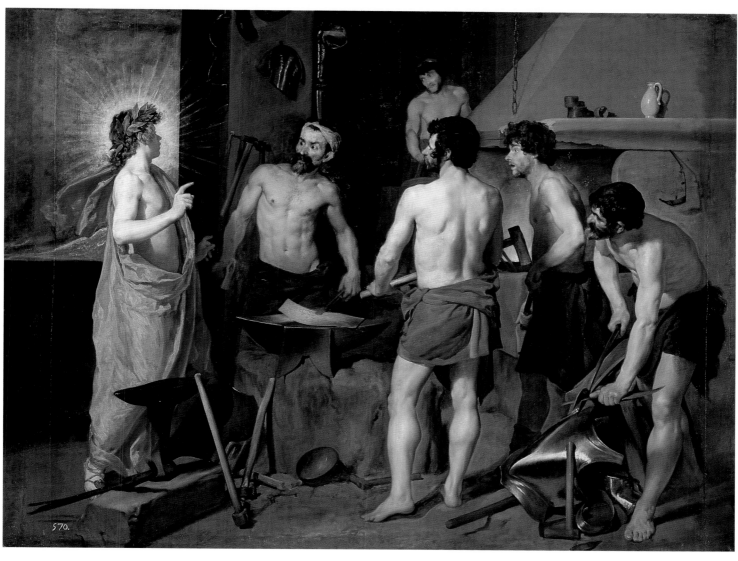

570.

II

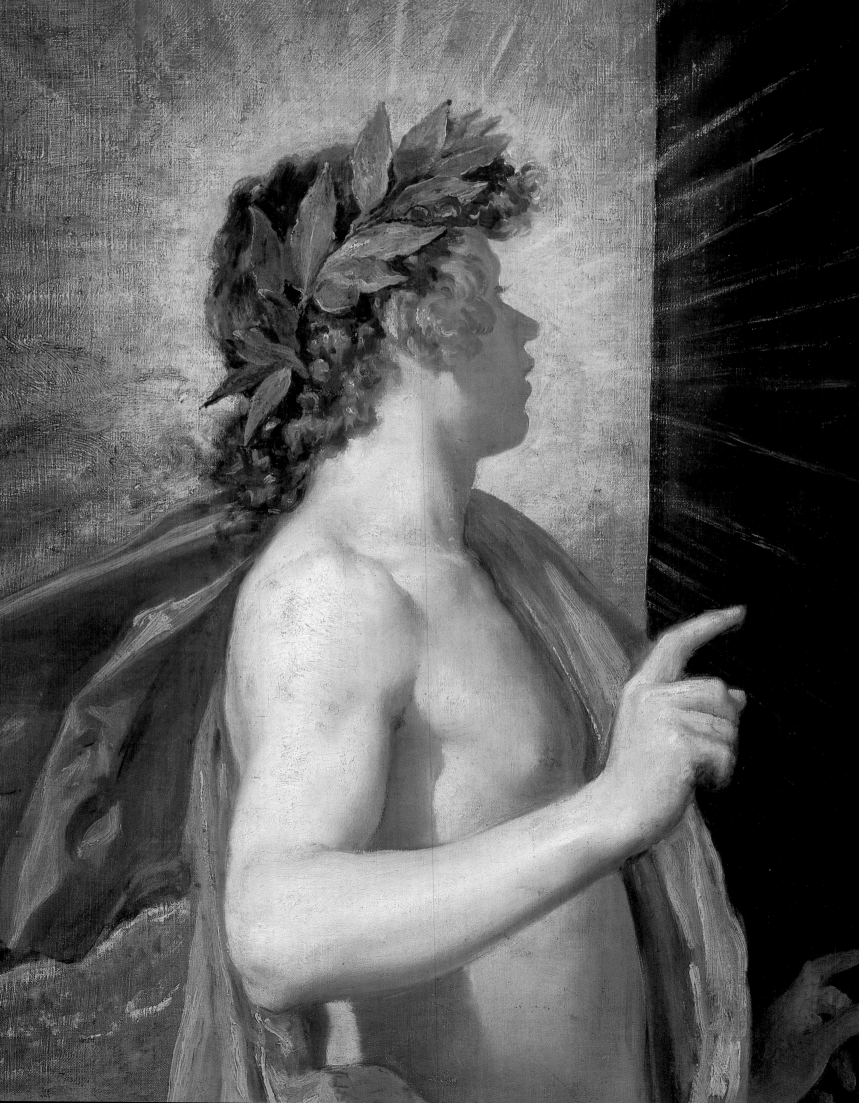

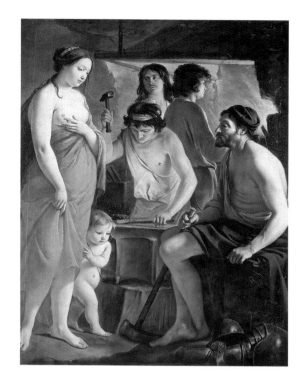

Louis Le Nain. *Venus at the Forge of Vulcan*.
Musée Saint-Denis, Reims.

may have been intended to continue the landscape at the left; if *Joseph's Coat* is, in fact, unfinished, it may have been painted after *The Forge.*

I believe that the influence of Guido Reni is undeniable in *The Forge of Vulcan*—in the elegant friezelike composition, in the influence of ancient sculpture, and in the palette, lighter and less robust than that of *Joseph's Coat* (the latter brings Guercino to mind). Especially delicate is the figure of the young god Apollo, with his ephebic fairness and pearly flesh. His yellow mantle and the aureole of rays about his head seem to illuminate the smithy's shadows. Heat and light radiate from the strip of red-hot metal that Vulcan is working and from the fire in the furnace that outlines the bodies of two of the surprised smiths. Vulcan and his workers stare at their visitor, hanging on his every word—the young god's presence and the gesture of his right hand command attention. Velázquez has endowed this elegant and handsome youth with a certain insolence not seen in the rather languid head (pl. 12) that is often considered a study for this painting. Here the forceful Apollo tells the lame Vulcan that the smith's wife, Venus, has been unfaithful to him with Mars, the god of war, for whom the pieces of (contemporary, not ancient) armor are most likely being forged (some believe that the armor is destined for Achilles).

Camón Aznar (1964, pp. 389ff.) recalls that in Homer's account Helios (the sun-god), not Apollo, informs Vulcan of Venus' infidelity. Apollo appears only when the adulterous lovers are caught in the net woven by the deceived husband, who was regarded with amusement by his fellow Olympians. The identities of Apollo and Helios merged, and in this painting the figure has the dual aspect of the god of poetry, with his laurel wreath, and of the Sun whose light reveals to the world what would be concealed.

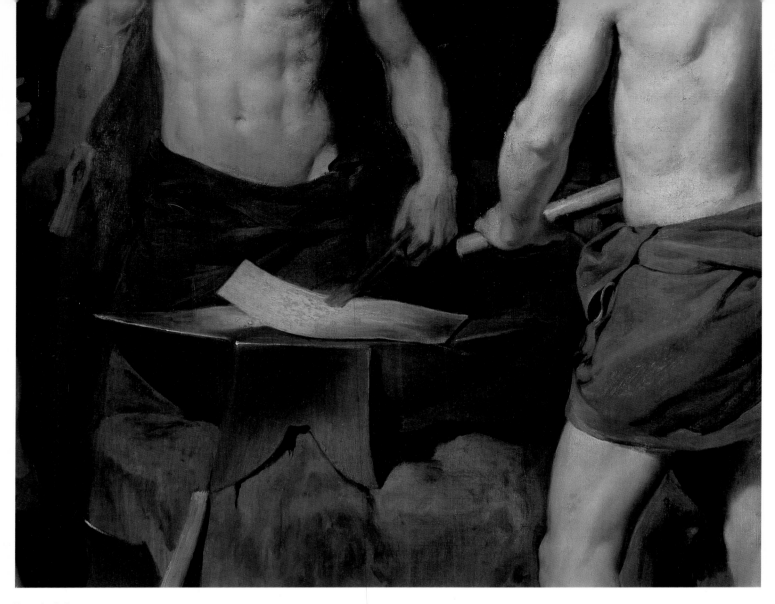

Detail of pl. 11.

Velázquez's choice of subject—a burlesque episode of the cuckolded husband—is typical of the antimythological bent of Spanish artists and writers of the Golden Age, but he gives this scene the same dignity he confers on all he paints, whether it be a betrayed god or a dwarf. The Spanish attitude toward mythological figures and episodes contrasts with the French stance of respectful veneration, as seen in Louis Le Nain's *Venus at the Forge of Vulcan* (Musée Saint-Denis, Reims).

The most academic figure in *The Forge* is the smith whose back is turned to the viewer; he has the coolness of heroic sculpture, even though his head is adorned with thick curls and sideburns. The seminude body of the workman bent over the breastplate is similarly statuesque but is given greater nobility and life. The liveliest of the workers is the ungainly smith between these two, his unkempt head thrust forward as if drinking in Apollo's words—an extraordinary passage of painting. Two notes of color—aside from the blue of the sky glimpsed through the door—enliven the earth tones: the small white jug on the chimney shelf—worthy of a Dutch still life—and the bluish strap of Apollo's sandal, which cools the yellow of the mantle.

Brown (1986, p. 72), citing the disparity in the width of the original canvases (*The Forge* was about 13 in. [33 cm.] narrower than it is now, while *Joseph's Coat* was about 20 in. [50 cm.] wider), observes that "there was once a difference of over eighty centimeters . . . a difference which would have implied to viewers that they were looking at two discrete history paintings by a single artist rather than a pair of related works. For this reason, it seems reasonable to regard each painting as a separate, self-contained entity as far as subject is concerned." I believe, however, that this difference in original measurements is not sufficient reason to prevent our considering these contemporaneous works as a pair. They both demonstrate Velázquez's skill in treating ancient episodes—one from the Bible and one from classical mythology. Each has the same number of figures. And both, in my view, illustrate the same theme: the power of the word over beliefs, emotions, and actions (see pls. 10 and 12). This Platonic theory of the superiority of thought over manual labor had special meaning for Velázquez. He and many other artists were battling for the acceptance of painting as a noble art rather than a purely mechanical endeavor. (The low regard in which the profession of painting was held was a major obstacle to Velázquez's appointment to the Order of Santiago [Gállego 1976].)

Brown (1986, p. 74) reproduces an engraving by Antonio Tempesta that may have served Velázquez as a point of departure for a work that went considerably beyond this source.

LITERATURE

Mayer 61, Curtis 35, López Rey 68, Pantorba 38, Gudiol 59, Bardi 41

PROVENANCE

Bought from the artist in 1634 by Don Jerónimo de Villanueva.

Buen Retiro, inventory of 1701.

Palacio Nuevo, inventories of 1772 and 1784.

Museo del Prado since 1819.

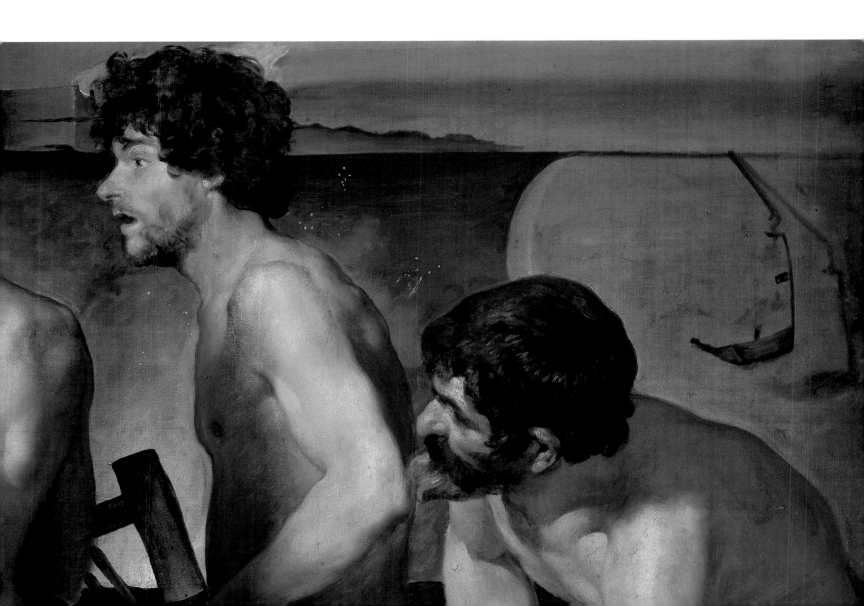

A Study for the Head of Apollo

Oil on canvas
14⅛ × 9⅞ in. (36 × 25 cm.)
Private collection, New York

Like *The Forge of Vulcan* (pl. 11), this study was painted during Velázquez's first sojourn in Italy. The 1630 date of that painting would also pertain to this head, a preparatory study for the figure of Apollo in *The Forge*. Mayer (1927) called it authentic. Lafuente Ferrari included it as no. 37 in his English catalogue (1943), indicating that its authenticity was not definitively established; he did not, however, include it in his Spanish catalogue. Pantorba, who found in it "only a slight savor of Velázquez," did not believe that trace sufficient "to justify the attribution made by some." Gudiol accepted it without reservation and reproduced it (1973, pp. 132–33, figs. 93 and 94) as a full-page colorplate to facilitate comparison with the Apollo in *The Forge*. He (p. 125) called it "a small canvas of extraordinary beauty, freely rendered, and with innovations in technique and pictorial concept in which the influence of the Venetian masters is as great, or even greater, than in the definitive work." Camón Aznar (1964, pp. 328–29), however, does not credit the work to Velázquez, believing that "not even the fact it is a sketch can explain the simplification of painting." Trapier does not allude to it in her comments on *The Forge* (1948, pp. 158–63). López Rey (1978) reproduces it beside *The Forge* (p. 59) and observes (p. 72) that, of Velázquez's earlier studies, "only [this] one is extant, a luminous color sketch showing the youthful face of the god enveloped in a light shadow that in the later composition will invade the entire space of the canvas." In his earlier catalogue (1963, no. 69), he reports that X rays revealed this to be a sketch of the first version of Apollo's head, later modified, and that the grain of the original canvas of the sketch (today relined) was the same as that of the definitive painting. Bardi (1969, p. 93), offering no opinion, reports that this head is "considered by several scholars to be a preliminary sketch; even the most reluctant—like Pantorba—concede at least a touch of Velázquez." Brown (1986, p. 77) accepts its authenticity: "Velázquez's idea is preserved in one of the rare preparatory sketches from his hand.... This pose seems to have been transferred to the canvas and then slightly revised later."

In fact, in comparing one Apollo profile with the other, we realize that the definitive profile, while youthful, achieves an authority and a majesty that nearly justifies Trapier's hypothesis (1948, p. 158) that "Apollo was considered as symbolic of Christ and that the subject of Joseph and his brothers was used as a typological representation of the death of Christ." We must remember that on the same journey and during the same period in Rome, Velázquez also painted (and also without a royal commission) a canvas of

Detail of pl. 11.

similar measurements that, despite differences in style, is often considered the companion to *The Forge*: *Joseph's Bloody Coat Brought to Jacob*.

For that reason scholars have sought a common theme for the paintings. Trapier's hypothesis seems inadequate when applied to a mythological fable of ridiculous and scabrous content: Apollo informing Vulcan, who is forging arms for Mars, that his wife, Venus, is deceiving him with the god of war. In *Joseph* the brothers are showing their father, Jacob, the bloody tunic of his favorite son to convince him that Joseph is dead. Both paintings have been represented as allegories of denunciation or calumny or deceit. Taken together, however, the stories do not allow this interpretation, since Apollo is telling the truth, whereas Joseph's brothers are lying. I have proposed as a common theme "the power of the spoken word" (Gállego 1983, pp. 85–86)— that is, "a variation on the eternal Velázquez theme of the superiority of mind

over hand" (see also pl. 10). To a degree, this thesis coincides with the hypothesis of Tolnay (1949): *The Forge* as an allusion to the noble arts (Apollo) prevailing over the manual arts (Vulcan).

In any case, the more effeminate and languid profile of the present *Head*, along with its flowing, serpentine hair, suggests allegory, whereas the profile in *The Forge* is more resolute and remote, without sacrificing the theatrical look—that of a vain, blond young god—befitting his pagan origins.

What cannot be denied is that the slight alteration in *The Forge* eliminated the *morceau de bravoure* peculiar to the present *Head*. This purposely unfinished air, so consciously cultivated by Velázquez imitators of the end of the nineteenth century, gives the sketch its flavor, while the definitive canvas achieves the timelessness, the "contemporaneity," that so often allows us to identify with the subjects of Velázquez's paintings. It is difficult to believe, however, that one of those extremely skillful Velázquez imitators would have been unfaithful to the serenity of his model—all the more so since we now know that the sketched head bears a greater resemblance to the first version of the figure in *The Forge* than to the final one. In any case it is a handsome piece.

LITERATURE

Mayer 62, López Rey 69, Pantorba 141, Gudiol 60, Bardi 41–B

PROVENANCE

Collection Isola, Genoa, until 1840.

In Sotheby's sale, London, May 21, 1935; bought by an English collector.

Private collection, New York.

The Garden of the Villa Medici

Oil on canvas
18⅞ × 16½ in. (48 × 42 cm.)
Museo del Prado, no. 1210

The date of this small picture and its pendant (another view of the same Roman garden; Museo del Prado, no. 1211) is debated by scholars. Both were undoubtedly painted from life and thus were executed either during Velázquez's first journey to Italy (1629–30) or his second (1649–51). The Prado catalogue notes both hypotheses, without accepting either. In favor of the former there is the fact that Velázquez lived at the Villa Medici in the summer of 1630, as related by Pacheco (*Arte* 1, chapter 8): "He came to Rome, where he spent a year, much favored by Cardinal Barberini, nephew of the pontiff [Urban VIII], by whose order he was lodged at the Vatican Palace.... Later, on seeing the palace or vineyard of the Medicis, in Trinità dei Monte, and finding it a suitable place for study and to pass the summer, as the highest and airiest part of Rome ... he asked the Spanish ambassador, the count of Monterrey, to arrange with the Florentine ambassador for accommodations there ... and there he stayed for more than two months, until a bout of tertian fever induced him to move nearer to the house of the count." Many critics (among them Gerstenberg, López Rey, Gudiol, Pérez Sánchez, and Camón Aznar) incline to the earlier date. Beginning in 1933 the Prado catalogue tentatively supported the later one, on the basis of "current criticism, which, because of their admirable technique, considers them works of the painter's second Roman sojourn"; the latest edition (1985) is more non-committal. The later dating has been favored by Loga, Allende Salazar, Trapier, Brown, Bardi, and others. I am inclined toward the earlier dating, in view of the technical resemblance to the background landscape of *Joseph's Coat* (pl. 10), painted during the first journey, and the proximity of the Casino Ludovisi, with Guercino's frescoes (Gállego 1983, pp. 84–85). These works might be two of the four landscapes purchased from the painter in 1634 for the king by Don Jerónimo de Villanueva, the protonotary of Aragon; a payment voucher (Cruzada Villaamil 1885, p. 32) mentions "four small landscapes," among additional paintings by Velázquez and other artists. Trapier remarked that Velázquez "was not influenced by his contemporaries, but was far ahead of his time, and the painting has often been compared to the Roman landscapes of Corot." She judges that these two works "reflect neither the wild drama of scenes by Salvator Rosa, who was at Rome in [1649], nor the classic beauty of landscapes by Claude Lorrain and Poussin" (1948, p. 311).

Harris (1981) provides important details concerning the date of these landscapes based on a study by Andres (1976) who, following Lafuente Ferrari, dates them to 1650 without mentioning Velázquez's earlier stay in the Villa Medici. In this study Andres discusses two programs of restoration of that

Velázquez. *The Garden of the Villa Medici: Pavilion of Cleopatra-Ariadne.* Museo del Prado, Madrid.

13

residence. The first one, in preparation for the visit of the grand duke Ferdinand II in 1627, was begun in 1626, long before Velázquez's first visit. The second one took place between 1648 and 1649 during the stay in the villa of Cardinal Carlo de Medici, uncle of the grand duke. Two documents mention the restoration of what Andres calls "the grotto" and which probably is the artificial gallery that provides access to the *serliana* in Velázquez's *Afternoon*, although Andres does not connect this to the painting. Harris (1981, p. 538) states: "These are for repairs to what is called 'the grotto,' 'His Highness's grotto' and 'the grotto of the Prince-Cardinal,' and also for repairs to some of the lesser grottoes beneath the balustrade, next to the 'large grotto.' According to the accounts from the carpenter and master mason the work included restoring the walls and entrance to 'the grotto,' making shelves for storing wine, and supports for the roof which was in danger of collapse." The accounts for this work refer to February and March 1649, "but they can hardly have been the only ones; it is very unlikely that all the necessary repairs were completed in a few weeks." From this it can be deduced that when Velázquez arrived in Rome in May 1649, the boards closing the entrance to the *serliana* were still in place as he depicted them in *Afternoon* and remained there during part of his stay. In that case, both paintings (which without any doubt are contemporary) would then have to be dated between May 1649 and November 1650, the duration of the painter's stay in Rome.

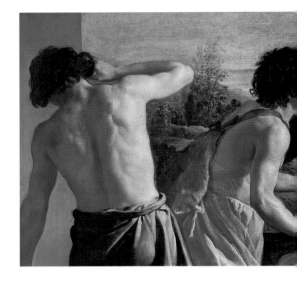

Detail of pl. 10.

Whether these two works are placed in 1630 or twenty years later, their astonishing novelty remains undiminished (as Trapier has shown) but is altered in degree. Brown states that "drawing from nature was commonplace in 1649, but painting in the open air seems to have been done infrequently" (1986, p. 205). Italian treatises usually stated that Agostino Tassi (ca. 1580–1644) was the first landscape artist to take his inspiration from nature and that Salvator Rosa (1615–73) painted in plein air (it is difficult to credit this, since his canvases are beautiful but not at all naturalistic and have a quite baroque theatricality). Those of Poussin, like everything about him, are rooted in the intellect; Claude's are magnificent pageants of light. When he set up his easel in the Villa garden, Velázquez was the first to execute what might be called "impressions" by Monet (hence their common names, *Afternoon* and *Midday*). The landscapists of Rome sketched from nature, sometimes with watercolor effects no less remarkable than those achieved in the present work; they then, however, produced finished oil paintings from the sketches in the studio. Brown (1986, p. 205) reproduces a drawing by the Englishman Richard Symonds (British Library, London) of about 1650–52, representing a "box for plein-air painting." But there are no trustworthy instances of the use of this equipment.

Sebastiano Serlio. Portal from *Trattato de architettura* (Venice, 1537).

The theme is no less difficult to explain than the intention and date of execution. There is utter anachronism (in the direction of a baffling advance) in a picture created without some previous idea, with no set theme. For Poussin, Claude, and Rosa, the Roman landscape painters of the mid-seventeenth century, a landscape had to be justified by some action or story with characters, however inconsequential. Attempts have therefore been made to

analyze the intent of the human figures barely sketched in by Velázquez. In the present work, *Afternoon*, two men chat by a Serlio portal, boarded up as if under repair, but which gives access to a dark interior that we know (for it still exists) to be a grotto. Above the arch runs a balustrade which encloses a terrace; a figure, apparently a woman, perhaps a servant, leans over a wrinkled cloth, possibly a linen sheet or tablecloth, which has been draped over the balustrade. A background of cypresses brings out these details clearly. Below are plantings of boxwood or myrtle, among which stands a bust, seemingly a bearded Hermes. The wall to the right of the portal has pilasters and a vaulted niche in which a statue stands. The pendant *Midday* also shows a Serlio gate but in another location (both still exist) opening upon a broad landscape (that of the present Villa Borghese). At the left of its three portals a gentleman looks out; the central portal is occupied by a reclining Ariadne, similar to that Velázquez brought back to Madrid (Prado). In the foreground, between two beds of boxwood, a gardener leans forward to listen to a crimson-gowned cleric; both are crudely sketched, with so little substance that the background shows through. It is difficult (though not impossible) to imagine that the two gentlemen in the first picture are exchanging comments about the architectural work in progress at the grotto and that the other two are in conference about horticulture. In any case these suppositions would not justify the paintings in the view of the learned theoreticians of the time.

In my opinion, the explanation lies in the repetition of the Serlio portico (an arched opening flanked by two smaller linteled ones) (Gállego 1983, p. 85), an architectural subject much favored by artists of the period. In his *Diálogos de la pintura* (Madrid, 1633), Vicente Carducho, treatise writer cum academic painter par excellence (and enemy of Velázquez and the Caravaggists), states that the painter must be a "skilled and accomplished architect"; in fact, he devotes his eighth dialogue to architecture. Velázquez, however, seems to be telling us that a painter must first be a *painter* and will thus see architecture as a pictorial motif that changes with the point of view and the hour of the day. These works are demonstrations of this thought, like Monet's Rouen Cathedral or Gare Saint-Lazare series (anachronistic though that may seem). Velázquez asks: What is a Serlian portal? And he answers: Visually, whatever the circumstances dictate—an opaque frame for a luminous space or a bright frame for a dark space. In the present painting the portal is represented as under repair, closed off by rough boards in disarray, thus emphasizing Velázquez's intention of deconsecrating the architectural theme. To remove all doubt, there would seem to be an unseen laundry operation on the terrace, with a servant who puts her linen out to dry on the lordly Palladian balustrade. Here the artist leaps forward an age to the antiquarian painters of Roman ruins (such as Pannini, Hubert Robert, and Fragonard), who liked to enliven these scenes with laundresses and clothes laid out in the sun. Velázquez delivers this lesson with characteristic disregard of the unenlightened, confident that his royal patron will understand it, and indeed the picture did pass into the royal collections.

LITERATURE

Mayer 154, Curtis 42, López Rey 157, Pantorba 102, Gudiol 61, Bardi 102

PROVENANCE

Alcázar de Madrid, inventories of 1666, 1686, and 1700.

Rescued from the fire of 1734; transferred to the Buen Retiro, inventories of 1772, 1789, and 1794.

Palacio Nuevo.

Museo del Prado since 1819.

Don Diego del Corral y Arellano

Oil on canvas
84⅝ × 43¼ in. (215 × 110 cm.)
Museo del Prado, no. 1195

Camón Aznar (1964, p. 448) remarks that this portrait of Don Diego del Corral "is one of the finest of all paintings. This figure embodies the archetype of the man of law, sober and intellectual, with a most noble expression of firm and equable judgment."

There is a problem of dating. The sitter died on May 20, 1632, placing the painting prior to that date unless it was completed after his death (Bardi believes the head is not quite finished). In a voucher dated 1624 Doña Antonia de Ipeñarrieta commissioned Velázquez to execute portraits of Philip IV, of Olivares, and of García Pérez de Araciel, her first husband (Trapier 1948, p. 179). It has been suggested that Don Diego's portrait was painted over that of García following the latter's death. Lozano (1927) notes that both men were jurists and knights of Santiago (the red cross of the order appears under the lapel of the robe) and that the features of the second may have been painted over those of the first. This hypothesis has, however, been disproved by radiographs. Lozano, who was not aware of the voucher, thought that Velázquez painted only the face and hands, the papers, the ruffled cuffs, and the hat on the desk. It is clear that the portraits of Don Diego and Doña Antonia (pl. 15) form a pair.

This painting remained unknown until the second half of the nineteenth century. According to Justi, it had been incorrectly attributed. Beruete (1898) vouches for the autograph on the painting, which he ranks "among the best of its period." It caused a sensation when it was exhibited at the Prado as part of the celebration of Alfonso XIII's attainment of his majority. According to Mélida, "among the portraits... it equaled the best, if it did not surpass all save for that of Martínez Montañés" (Pantorba 1955, p. 108).

Diego del Corral y Arellano was a judge of the council of Castile, professor at the university of Salamanca, and inspector of the royal household. He was a member of the Valladolid tribunal that sat in judgment on Rodrigo Calderón (a follower of the duke of Lerma, favorite of Philip III). After a trial instigated by Olivares (favorite of the new king, Philip IV), the accused was condemned to death; Corral was the only one of the three magistrates who voted against that penalty, showing his integrity by opposing the will of the government. A portrait of Don Diego appears in Antonio Pérez's *Authentica fides Pauli controversiis catholicis* (1634), which is dedicated to the magistrate.

Don Diego was born in Santo Domingo de Silos in about 1570 and studied in Salamanca at the Colegio de San Bartolomé. The university of Valladolid possesses some of his works in Latin and Spanish. In 1627, while

Juan Pantoja de la Cruz. *Philip II.*
Monastery of El Escorial.

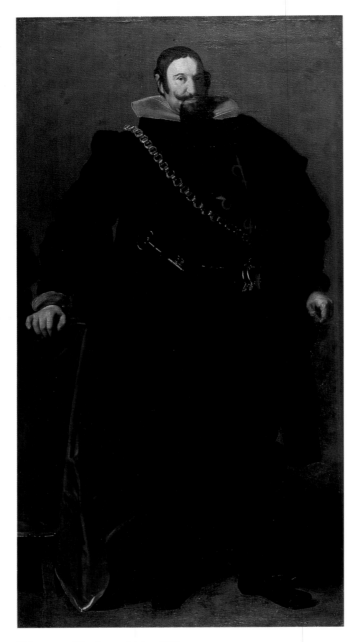

Velázquez. *The Count-Duke of Olivares*.
Museu de Arte, São Paulo.

minister of state of Aragon, he married Antonia de Ipeñarrieta, the widow of García Pérez de Araciel. He died, as stated, five years later, which casts doubt, as Pantorba notes, on the report that they had six children.

The present portrait has an austere grandeur. In this work as in its pendant, Velázquez follows the practice of the immediately preceding Habsburg portraitists; he moves close to the sitter, so that the feet and the floor are seen from above, while the head, near the upper edge of the canvas, appears to be seen from slightly below (that is, with the eye at the level of the paper the magistrate holds in his left hand). The papers in his hands suggest Don Diego's character as a man of intellect and deliberation; this is confirmed by the desk covered in gold-embossed red velvet, a judge's desk on which the model leans lightly in token of possession. The hat, in the style of Philip II,

also has symbolic value, indicating the knight's or judge's privilege of keeping his head covered in the king's presence. The broad half-opened robe, known as a *garnacha*, reveals only one arm of the embroidered cross of Santiago. In the blacks of the robe the painter shows his extraordinary skill, making them not funereal but luminous, and Camón Aznar remarks, "Never have more flowing and iridescent blacks been painted, with such rustling touches." The magistrate's collar—narrow in accordance with the rules of the Pragmatic Sanction against Vanity decreed by the Council for the Reformation of Morals, which banned the large lace or ruffed collars typical of Philip III's reign—exemplifies the austerity of dress evident in almost all Velázquez portraits of the early years of Philip IV's rule. The smoothness of brushwork, however, dates to the 1630s a portrait that, in concept and costume, might belong to the previous period. Velázquez, in this as in other portraits of his so-called gray period, works with the Habsburg archetype originated by Antonio Moro (Anthonis Mor) in the time of Philip II, then followed by Pantoja de la Cruz and Alonso Sánchez Coello, and in turn imitated by Rodrigo de Villandrando and Bartolomé González.

The placement of Don Diego's feet has a force and naturalness rare at this period of Velázquez's oeuvre. Space is resolved (with no drapery) in a penumbra brightened only at the bottom, where the shadow of the subject and his desk provides the necessary horizontality.

The color is subtle and dramatic. The whites, so skillfully apportioned to collar, cuffs, and papers, and the vivid reds of the table cover and the cross of Santiago, successfully contrast with the blackness of the garment and footwear and the medium tones of face, hands, desk, and floor.

The lessons of Moro, enriched with the atmosphere that was Velázquez's alone, had never been applied to such advantage. Besides being a superb painting, this portrait of the magistrate Corral creates an archetype of the high official, conscientious and dedicated to his mission, deserving of the king's honors.

LITERATURE

Mayer 335, Curtis 159, López Rey 494, Pantorba 44, Gudiol 68, Bardi 47

PROVENANCE

In 1668 at the Corral de Zarauz Palace (Guipúzcoa), according to inventory of Juan and Cristóbal da Corral e Ipeñarrieta.

Passed by descent to the marquises of Narros, who brought it to Madrid in the mid-nineteenth century.

Inherited by the duchess of Villahermosa, who bequeathed it (together with that of Doña Antonia de Ipeñarrieta) to the Museo del Prado.

Museo del Prado since 1905.

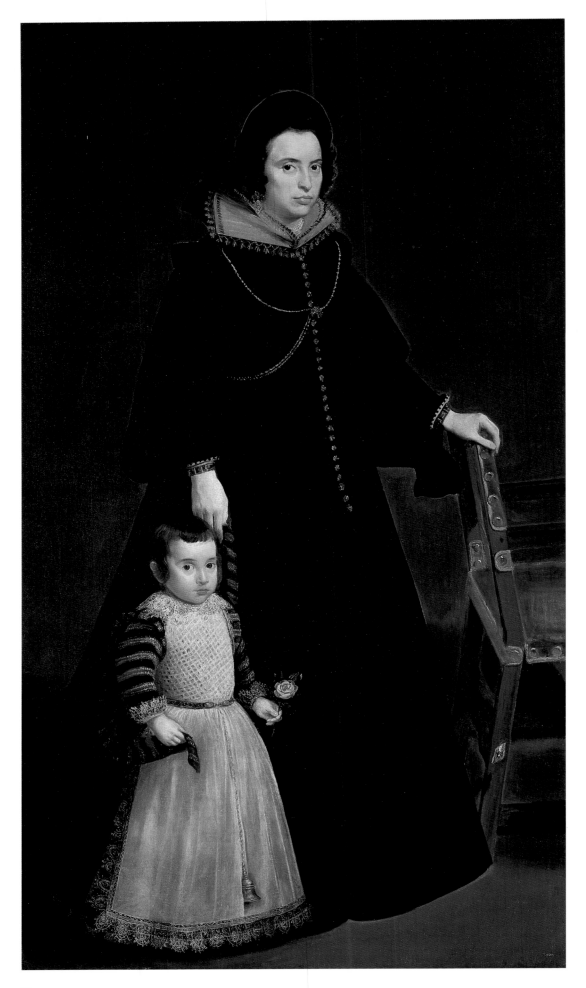

Doña Antonia de Ipeñarrieta and Her Son Don Luis

Oil on canvas
84⅝ × 43¼ in. (215 × 110 cm.)
Museo del Prado, no. 1196

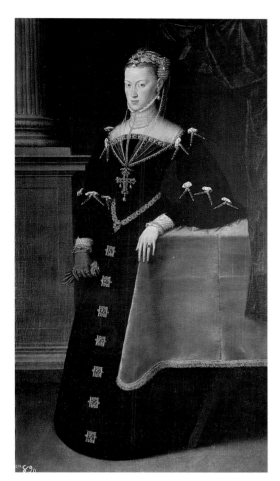

Antonio Moro. *The Empress María.*
Museo del Prado, Madrid.

Doña Antonia de Ipeñarrieta y Galdós was born in Madrid between 1599 and 1603 according to the Prado catalogue, but Pantorba (and others) suppose she may have been born in Villarreal de Guipúzcoa prior to 1598. Left a widow in 1624 on the death of her first husband, García Pérez de Araciel, she married Don Diego del Corral in 1627 (see pl. 14). Her first marriage had no issue, but the second reportedly produced six children, a remarkable number considering that Don Diego died in 1632. Doña Antonia died three years later.

At court Doña Antonia was Prince Baltasar Carlos's governess, a position referred to as *de manga* (by the sleeve) because the servant did not take the royal child by the hand but by the *boba* (a wide, loose-fitting "sleeve") worn by the boy in this portrait. It was thought that the child seen here might be the prince himself, until an inventory of the property of Don Juan and Don Cristóbal da Corral e Ipeñarrieta was found. The inventory (dated 1668 at the ancestral seat in the Basque province of Zarauz) lists a portrait of Philip IV (Metropolitan Museum), one of the count-duke of Olivares (Museu de Arte, São Paulo), and another of "Doña Antonia de Ipeñarrieta with Don Luis, her son."

The record was confused by a receipt that Mélida found in the archives of the ducal house of Granada de Ega in Zarauz, signed and dated by Velázquez at Madrid on December 4, 1624, in which the painter acknowledges a payment of eight hundred reales on account for portraits of the king, of the king's favorite, and of Doña Antonia's first husband (the latter is a lost portrait that some have thought lay concealed beneath that of her second husband, Don Diego del Corral; see pl. 14). Was the portrait of the child Don Luis added later? Many critics think that it is by another hand or that Velázquez might have executed it about 1632. But radiographs do not support either of these hypotheses.

All this aside, the present work is a charming portrait, not deserving the harsh criticisms of Beruete, Allende-Salazar, and Pantorba. The boy wears a red-and-black striped frock with *boba* sleeves and an exquisite apron with fine lace, matching the collar and cuffs; a little bell hangs from his narrow belt. Still, the work undeniably lacks the liberal impasto of the nearly contemporary portraits of the boy prince Baltasar Carlos (ca. 1631, pl. 21; and ca. 1632, Wallace Collection, London). In both the London and Boston portraits, the prince, though a child in skirts, bears the sash and baton of authority of a captain general of the royal troops. He has none of the shy mien of the boy led by Doña Antonia, who is clasping in his hand a rose, not a sword.

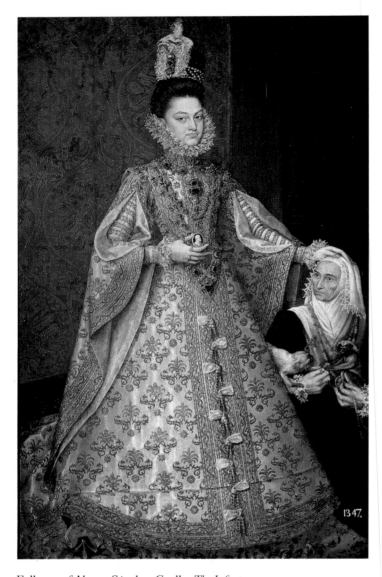

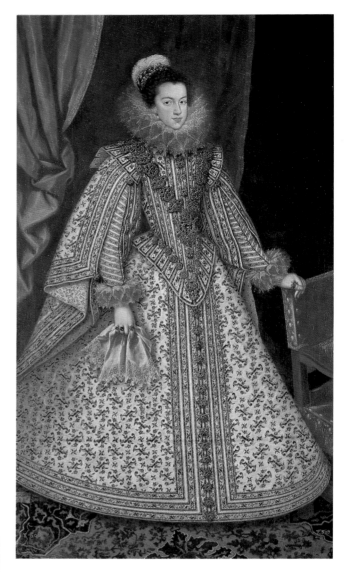

Follower of Alonso Sánchez Coello. *The Infanta
Isabel Clara Eugenia with Magdalena Ruiz.*
Museo del Prado, Madrid.

Rodrigo de Villandrando. *Queen Isabella*
(first wife of Philip IV).
Museo del Prado, Madrid.

Doña Antonia is garbed in black, perhaps in mourning for her first
husband, with a gown *de aceitera* (like a cruet), so called because the conical
skirt recalls the shape of that vessel. The style of the hooped skirt (which
preceded the farthingale)—over which the long pointed bodice with its golden
buttons descends—favors a date earlier than 1630. This rigid and geometric
form, which can be seen in all its exaggeration in portraits (Bartolomé González
and Rodrigo de Villandrando) from the previous reign, was to moderate in
the late 1620s, a change that is evident in portraits of the queen, Isabella of
Bourbon, the first wife of Philip IV (she married him in 1615 when she was
thirteen). The fashion becomes excessive once more in paintings of 1632,
foreshadowing the future farthingale, which reached its widest excesses in
the time of Charles II (portraits by Carreño and Mazo) but whose character-
istic shape is evident in late works by Velázquez (portraits of Doña Mariana
of Austria and of Philip IV's daughters, the infanta María Teresa and the

infanta Margarita). The almost nunlike Doña Antonia, with her stern, watchful expression, appears well suited to her position as governess to the prince at a court where laughter was virtually banned. Serenity and remoteness were the rule under a king who himself loved amusements; Doña Antonia, by her face and figure, might have graced the court of Philip II.

With her right hand Doña Antonia grasps the *boba*, the open "sleeve," which hangs like a cape; the opposite end is held by the boy. Her left hand rests (with an air of power, rather than fatigue, which would be unthinkable in a lady of the royal household) on the back of a chair. The pose is not "realistic" in intention or composition but indicates that, given her high position at court, the lady was entitled to be seated. Ladies of lesser rank would stand or sit on cushions on the dais; "to offer one's chair" was, in the Golden Age, a public display of privilege. The chair is not an armchair, which would be appropriate to royalty, but a simple piece with seat and back of cane secured by nails; here, as in her husband's portrait, it is seen from above.

Doña Antonia's silhouette, with skirt and tall coiffure approaching the picture's edge, emphasizes the haughty, larger-than-life presence of the señora, whose strangely rosy, full-lipped mouth partly belies her hard, intent gaze. The head is altogether excellent, and the adornments, pendants, and collar demonstrate the painter's skill. Brown (1986, p. 140) notes "the subtle way in which the head of the sitter is set against the surrounding space" with "a thin strip of primed canvas," separating the dark tones of hair and background. With her fixed stare this Basque noblewoman gives an impression of missionary zeal, similar to that of Mother Jerónima de la Fuente (pl. 3).

In Camón Aznar's opinion (1964, p. 301), only the head, the hands, and perhaps the chair and the background are certainly by Velázquez: "We believe it would not be absurd to imagine that we have before us a painting by Bartolomé González, brilliantly reworked by Velázquez." Allende-Salazar dates the reworking subsequent to Velázquez's first journey to Italy.

LITERATURE

Mayer 548, Curtis 259, López Rey 580, Pantorba 43, Gudiol 69, Bardi 46

PROVENANCE

In 1668 at the Corral de Zarauz Palace (Guipúzcoa), according to inventory of Juan and Cristóbal da Corral e Ipeñarrieta.

Passed by descent to the marquises of Narros, who brought it to Madrid in the mid-nineteenth century.

Inherited by the duchess of Villahermosa, who bequeathed it (together with the portrait of Don Diego del Corral) to the Museo del Prado.

Museo del Prado since 1905.

A Woman as a Sibyl

Oil on canvas
24⅜ × 19⅝ in. (62 × 50 cm.)
Museo del Prado, no. 1197

The Prado catalogue tentatively identifies this subject as Doña Juana Pacheco, wife of the artist. This identification first appears in the 1774 inventory of the Palacio de la Granja de San Ildefonso (Segovia) in the note, "Said to be Velázquez's wife." In the earliest Prado catalogues there is no such statement; but in the 1850 catalogue Pedro de Madrazo wrote, "Thought to portray the artist's wife," and in 1872 he described the picture as a "portrait of Doña Juana Pacheco, aged about twenty-five." Musso y Valiente, commenting on a lithograph of this picture in the collection of José de Madrazo, remarked that the identification was doubtful, suggesting instead that Velázquez meant to represent a sibyl; in rebuttal Pedro de Madrazo cited the (more than questionable) resemblance of the subject to Juana Pacheco's portrait in *The Painter's Family* by Mazo (Kunsthistorisches Museum, Vienna) of a quarter of a century later. Another argument made in favor of this identification was the inscription "Juana Miranda," afterward expunged, on the reverse of a portrait of a lady by Velázquez in the Berlin Museum; this portrait, which other critics are inclined to identify as the wife of the count-duke of Olivares, does not resemble the *Sibyl* in anything except perhaps the coiffure.

There is also dispute over the nature of the object in the sibyl's left hand, which some take to be a canvas and others a tablet or even a palette, if we may credit an anonymous La Granja inventory of 1786.

Born in 1602, Juana Pacheco, or Juana Miranda, was the daughter of the painter Francisco Pacheco, Velázquez's master; she married Velázquez on April 23, 1618, and died on August 14, 1660, seven days after her husband, by whom she had had two daughters. The elder, Francisca, was married to Velázquez's pupil Juan Bautista Martínez del Mazo, following the custom of masters to marry their daughters to the best of their pupils. There is no documentary evidence that Velázquez ever painted his wife's portrait, but it is believed that two drawings in the National Library, Madrid, may represent her. She is also commonly identified with *The Immaculate Conception* of about 1618, the pendant of *Saint John the Evangelist on Patmos* (both National Gallery, London); the pair may be nuptial portraits "in the divine manner" much favored by Velázquez. It is also surmised that the figure of the Virgin in *The Adoration of the Magi* (pl. 2) may be Juana Pacheco, and the child she holds may be her little daughter. The identification of the sibyl with Juana is supported by Stirling, Curtis, Cruzada Villaamil, Beruete, Lefort, and others; Justi rejects it, and Allende doubts it.

According to the most recent Prado catalogue, this picture was painted

about 1632, when Juana Pacheco would have been thirty, perhaps a trifle too old to have served as a model for the sibyl. There is also no resemblance between the sibyl and the figures thought to be Juana in *The Immaculate Conception* and *The Adoration of the Magi*. Camón Aznar (1964, p. 415) states that "the agreement in pigments and brushwork with the Rome productions is absolute," and he thus assigns this painting to 1630, the year of Velázquez's first Italian journey. This dating makes it unlikely that Juana was the model —she had remained behind in Madrid, and Velázquez habitually painted from life. Brown (1986, p. 162) follows Camón's opinion. Pantorba favors a date subsequent to that voyage, and Gudiol puts it at around 1631.

It must be admitted that the representation of a sibyl (if the figure is, in fact, a sibyl) is quite in the Roman fashion. Besides the six sibyls of Michelangelo on the Sistine Chapel ceiling, Velázquez could have seen several other representations of this figure, but in the present work "there is little resemblance to the turbaned sibyls of Guercino and Domenichino" (Trapier 1948, p. 181). In fact, the headdress of the Velázquez woman is not a turban but a net or cap of plaited ribbons forming a large knot at the nape of the neck. The coiffure, with its wispy ringlets, is hardly classical either, but the tawny cape with its ample folds imparts some majesty. The pearl necklace adds an unexpected touch of feminine adornment, perhaps an ironical re-

Michelangelo. *The Persian Sibyl*. Sistine Chapel.

Guercino. *The Libyan Sibyl*. H.M. Queen Elizabeth II.

minder that the sibyl is after all a woman. The fact that the figure is in
profile, looking into space, is not a certain indication of prophetic powers.
We do not know what, if anything, is in the unseen right hand. In short, the
figure might be a sibyl or might just as well be an allegorical representation
of History or even Painting or Drawing. The academic character of the pose
is undeniable; the strong, medallion-like profile is unusual for this painter.
The sibyl, no less than Doña Augustina Sarmiento in *Las Meninas*, seems
foreign to present-day notions of feminine beauty, which of course need not
be the same as those of the seventeenth century. The picture suffers from a

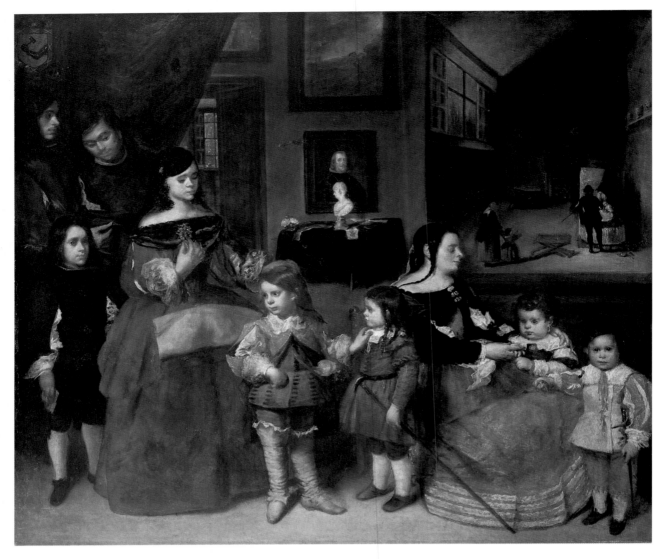

Juan Bautista Martínez del Mazo. *The Painter's Family.*
Kunsthistorisches Museum, Vienna.

certain pedantic pretension to seriousness, exceptional in this least preten-
tious of painters. I am tempted to impute some element of satire, but that
may be going too far.

The scant popularity of this picture—its failure to inspire much sympa-
thy in the viewer, considering that we are in sympathy even with the feeble-
minded or degenerate as portrayed by this artist—does not detract from its
painterly merits. Replying to Picón's remark that it is "not to be counted
among the painter's best [works]," Pantorba writes that it is a "painting of
most excellent quality," and he rightly notes the elegance of the fingers hold-
ing the tablet (Pantorba 1955, p. 109). Camón (1964, p. 415) notes the "mar-
velous pearl-gray tone, enveloping, honeyed, with the very lightly colored
cape. . . . There is not a single discordant note." Gudiol (1974, p. 148) praises
the "classical yet vividly realistic style." I take this work to be an Italianate
exercise, this time not in the manner of Caravaggio but with some of the

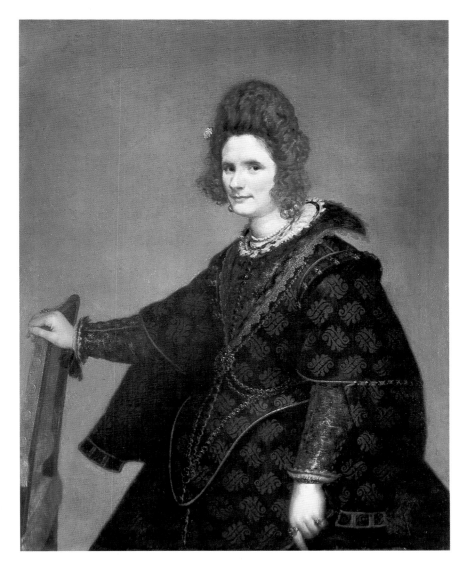

Velázquez. *Portrait of a Lady*. Staatliche Museen, Berlin.

LITERATURE

Mayer 557, Curtis 261, López Rey 590, Pantorba 45, Gudiol 84, Bardi 53

Not mentioned in the first Prado catalogue (1819). Found in the Prado catalogues of Pedro de Madrazo of 1843, 1845, 1850, and 1854. In 1872 he lists it as a portrait of Juana Pacheco at the age of about twenty-four in the "artist's first style"; this identification remains in the catalogues of 1873, 1876, 1878, 1882, 1885, 1889, 1893, 1903, 1907, 1910, and 1920. From 1933 to the present the model is identified as Juana Pacheco but with a question mark "(?)" added.

PROVENANCE

The painting is noted for the first time in the 1746 inventory of La Granja de San Ildefonso, in the collection of Queen Isabella (née Elizabetta Farnese), who acquired it after 1714.

Mentioned in the 1774 and 1794 inventories of the same palace.

In the Octagonal Room, Palacio Nuevo, before 1814.

Museo del Prado since 1830.

gravity of a Guido or Guercino, though painted from life. The yellow and gray of the habit and the yellow and green of the headdress form a gilded, medium palette, not often used by Velázquez.

Saint Anthony Abbot and Saint Paul the Hermit

Oil on canvas
101⅛ × 74 in. (257 × 188 cm.)
Museo del Prado, no. 1169

This canvas was created for a chapel in the gardens of the Buen Retiro, probably the hermitage of Saint Paul, completed early in 1633; the altarpiece of Saint Paul's was finished by May 1633 (Brown and Elliott 1980). The technical excellence of this work is such, however, that Madrazo, Cruzada Villaamil, and Justi place it as one of the artist's last; Beruete holds that it was the very last to come from his hand. Mayer judges it to be no earlier than 1642. Loga and Allende-Salazar attribute it to the 1630s, about the time of other paintings with remarkable landscape backgrounds for the Buen Retiro and the Torre de la Parada. Gudiol places it in 1635–40, Bardi in 1642. Camón Aznar speaks of a possible influence of sacred landscapes by Gaspar Dughet, painted in fresco at the church of San Martino ai Monti in Rome, implying a date after Velázquez's second voyage to Italy (1649–51). The Prado catalogue follows Allende and gives 1634 as the probable date.

So many precedents have been cited for this work that one is reminded of Ortega y Gasset's remark (1943, p. 954) about *The Surrender of Breda*. In writing of all the precedents heaped up for that painting, he commented that they "would have tended rather to prevent Velázquez from conceiving this unique and original presentation." There is nothing easier (or, in general, more futile) than to seek the inspiration of a work of art in precedents, which proliferate with contemplation of the subject. One precedent usually (and quite plausibly) mentioned for the present painting is a print by Dürer of the same subject; another is the mountain landscapes of Joachim Patinir, which were in El Escorial for Velázquez to see. Brown rightly notes the influence of fresco painting, with its effects of transparency, as pointed out by Camón; he refers to the frescoes at the Villa Sacchetti in Castelfusano by Pietro da Cortona, which Velázquez could have seen on his first visit, thus explaining "the curious points of similarity in the use of transparent colors on a neutral, sandy ground" (1986, p. 96).

Interestingly, in about 1659 the hermitage of Saint Paul was decorated with frescoes by Agostino Mitelli and Angelo Michele Colonna of Bologna, whom Velázquez engaged on his second visit to Italy because of the scarcity of Spanish fresco painters. (However, in consequence of that commission, Spanish fresco painters abounded in the time of Charles II.) According to Palomino (1724), the subjects were not sacred but secular, such as the fable of Narcissus. It should be remembered that the Retiro hermitages and gardens were not places of solitude. They were the scenes of picnics on the appropriate feast days, and if these fell in winter, like that of Saint Anthony Abbot, the lack of ripe natural fruits and blossoming flowers was made up by

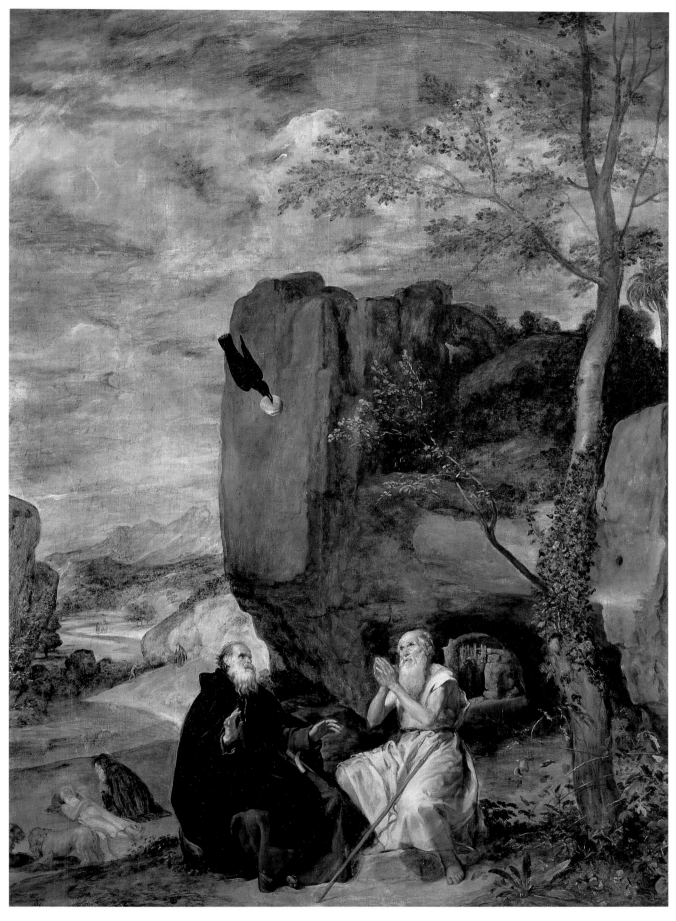

17

Details of pl. 17.

The Count-Duke of Olivares on Horseback

Oil on canvas
123⅜ × 97⅛ in. (313 × 239 cm.)
Museo del Prado, no. 1181

As usual with Velázquez, this canvas bears no date, and the year of its execution is in dispute. In the lower left corner of its great expanse (wider though not as tall as *Philip IV on Horseback* [118⅝ × 123⅝ in. (301 × 314 cm.); Museo del Prado, no. 1178]), there is a scrap of paper, as if meant for signature and date, but Velázquez left it blank (unless the inscription has been expunged). This need not surprise us, for the painter was an easygoing man who took things calmly. "Well, you know his phlegm," the king wrote to his ambassador at Rome, asking him to speed the return of Velázquez and recommending that he travel by sea "and not by land, as he might easily be delayed . . . given his natural propensity" (*Varia Velazqueña* II, document 120 of February 17, 1650). It is also possible that, with his no less characteristic irony, Velázquez left it blank to suggest that no one else in Spain could paint such a picture, and therefore the signature was superfluous (he did not, however, omit it from his portrait of Innocent X, for in Rome there might be one who could).

Scholars have based their hypotheses on the painting's date on two historical events. Jusepe Leonardo's *The Relief of Breisach* (Museo del Prado, no.

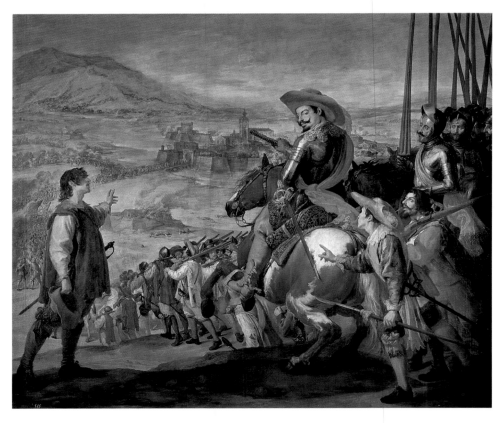

Jusepe Leonardo. *The Relief of Breisach*.
Museo del Prado, Madrid.

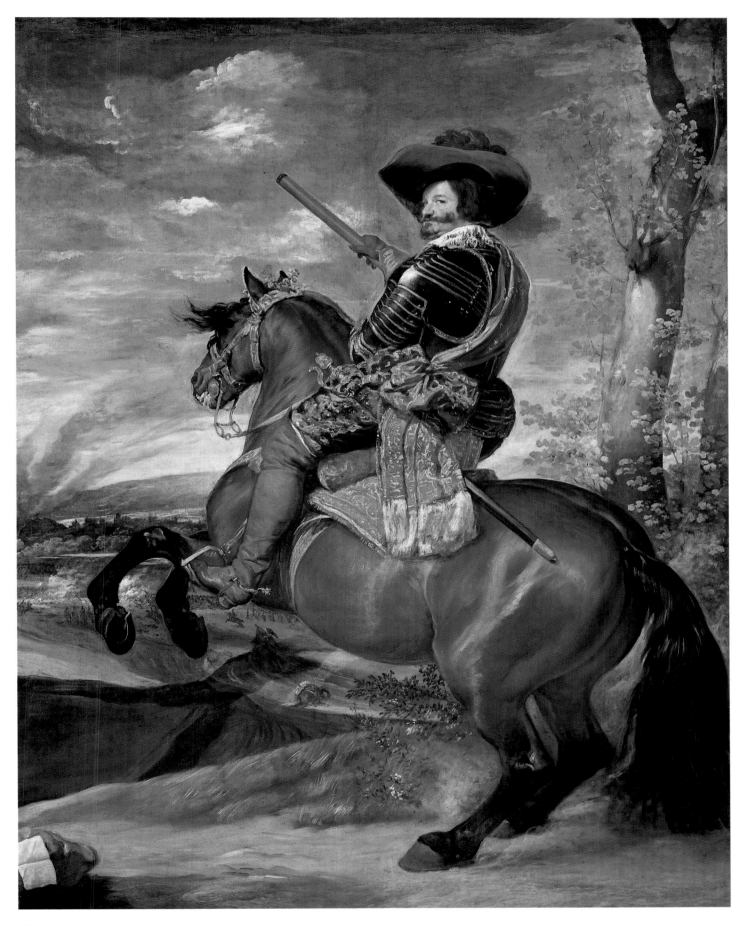

859) was executed between 1633, the date of that action, and 1635, when the painting was placed in the Hall of Realms at El Retiro. It shows a mounted figure in the same pose as Olivares and may have been based on the present work. On the other hand, the two painters may have had a common source. Many examples have been cited in favor of this alternative—an engraving by Jacques Callot, an equestrian portrait by Van Dyck, and Antonio Tempesta's engravings of the Roman caesars (specifically Julius Caesar), which have also been cited as sources for *Prince Baltasar Carlos on Horseback* (Museo del Prado, no. 1180). I myself am not an eager searcher for precedents; they are always to be found if sought.

The other event is that of the Battle of Fuenterrabía (1638) between the Spanish and the French, to which the fire and the troops in the background might refer. Although Olivares, no more fond of physical combat than his royal master, was not present, the day was deemed won through his policy and the dispatch of two companies, who recaptured the Basque frontier city, and he was named its governor. López Rey recalls in this regard that El Valido (The Favorite) was represented by Mayno in *The Recapture of Bahia* (Museo del Prado, no. 885), though he was not present there either. So it seems likely enough that the present portrait was commissioned by Olivares to commemorate Fuenterrabía. The Prado catalogue notes that it was "painted about 1634," omitting mention of any particular passage of arms. Palomino (1724) praises this painting and its "Andalusian war horse, which drew from the Baetis [Guadalquivir] not only the fleetness but also the majesty of its waters, [and] charging into the fray, sweats under the weight of armor and the joy of battle"; he notes the background where "one seems to see the dust, to smell the smoke, to hear the din and to dread the slaughter," but he says nothing of Fuenterrabía. In fact the battle scene might be a symbolic one, standing for the many won by Spaniards under this remote commander; as Virgilio Malvezzi remarked (Camón Aznar 1964, p. 467), "in not fighting beside his men [Olivares] forfeits the name of a great soldier, but by commanding them he gains that of a great general."

Gudiol's dating is 1632–33; Bardi and others give 1634. Undoubtedly the work is related to the series of equestrian portraits of kings and queens which Velázquez began just before his first voyage to Italy and ended soon after his return—that is, from 1629 to 1635. I have noted (Gállego 1968, pp. 222–23) the differences in the equestrian postures of the sovereigns—queens sit placidly, while their horses walk as for a solemn entrance; kings and crown princes curvet (see Baltasar Carlos riding under the direction of Olivares; pl. 23). The duke of Lerma, Philip III's favorite, was portrayed by Rubens on horseback but not in curvet. (The royal code of equitation is attested by Pluvinel's *Maneige royale* with engravings by Crispin de Passe [1625] where Louis XIII appears executing *voltes en corbettes*.) The horse as a royal emblem appears in other works of Rubens, Van Dyck, and Ribera. In the present painting Olivares places himself on a par with royal personages. One may wonder at the favorite's presumption in likening himself to the king, with the ribbon and baton of commander in chief, the horse's forelegs raised in cur-

Antonio Tempesta. *Julius Caesar on Horseback.* The Metropolitan Museum of Art, New York.

Detail of pl. 18

The Count-Duke of Olivares on Horseback

Oil on canvas
50¼ × 41 in. (127.6 × 104.1 cm.)
The Metropolitan Museum of Art, Fletcher Fund, 1952 (52.125)

This canvas appears to be a reduced copy of the equestrian portrait of Olivares in the Prado (pl. 18). Similarly, a reduced copy of the equestrian portrait of Philip IV in the Prado is in the Galleria degli Uffizi, Florence. These reduced copies have been attributed by many specialists to Mazo, Velázquez's son-in-law and student.

The similarity of the position of the horse in the present painting to one in Jusepe Leonardo's *The Relief of Breisach* does not seem overly significant, since there are many other precedents, particularly an engraving of Julius Caesar by Antonio Tempesta. Of greater interest is the presence in the Spanish royal collections of a painting of a white horse, rearing in the same curvet, which is believed to have been a sketch for the Prado portrait. While the horse in the Metropolitan picture is also white, the Prado horse is a chestnut; in size, however, the supposed sketch corresponds to the Prado picture. At Velázquez's death the study was inventoried as a "large canvas, with a white horse; no figure" (no. 578). One might wonder whether Olivares was hesitant as to which color he preferred for his mount. White was deemed the most appropriate for a general, based on the legend (still current in Spain) of the miraculous apparition during the battle of Clavijo (845) of the apostle Saint James, on a white horse, riding to the aid of the Asturian king Ramiro against the Moors. This white steed is traditional in the iconography of *Santiago, matamoros* (Saint James, the Moor-Slayer; the large canvas of José Casado del Alisal [1832–86] in the church of San Francisco el Grande, Madrid, is the best interpretation of the theme). In fact, after the death of Velázquez, this riderless horse was "completed" with a figure of Saint James, which was removed in our century.

Curtis, Lefort, Beruete, and others believe that the Metropolitan painting is an autograph work. Other specialists, among them Waterhouse, Soria, Salinger, and Gaya Nuño, believe it is a sketch, or study, for the Prado painting. Still others believe it is a replica executed by Velázquez himself: Stirling, Justi, Harris, Kubler, Gudiol, and Pita Andrade, who believes that it served as model for the copy acquired in 1652 by Luis de Haro, marquis of Carpio (Olivares's nephew). Pantorba's view is that the master was probably involved, at least in the retouching. Many experts, however, beginning with Mayer, and joined by Lafuente Ferrari, López Rey, Camón Aznar, Soehner, and Bardi, believe this is a portrait by Mazo. Camón Aznar (1964, p. 473) nevertheless praises this painting, which "constitutes a feast for the eyes; it is merry, succulent with color, alive with light," although he notes stylistic and

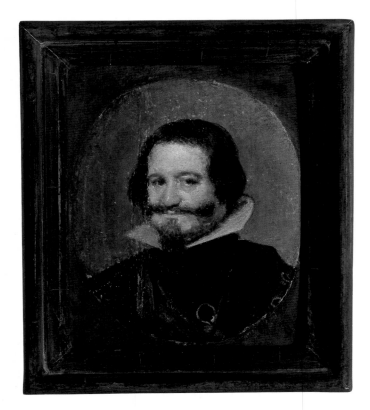

Velázquez. *The Count-Duke of Olivares.*
Palacio Real, Madrid.

chromatic characteristics more typical of Mazo, such as the "off-white tonalities," the "lumpy pigment," the "touches that blend neither with the sky nor the earth," and the blues, "rather turbid and steely, lacking Velázquez's infinite transparency." Brown, who includes *A White Horse* as a study for the Prado portrait, rejects the Metropolitan painting (1986, p. 292 n. 27). Following the 1952 cleaning, Caturla, Hendy, Sánchez Cantón and Lafuente Ferrari voiced the opinion that this is a autograph work; Jordan recently seems to have adopted that position.

This painting was exhibited in "*Velázquez y lo Velazqueño,*" held in Madrid in 1960. In the catalogue (no. 99) there is a summary of the contradictory opinions; Stirling and Justi regard it as an autograph work, and Mayer and Madrazo debate its authenticity and enumerate differences with the Prado painting: The landscape is more abrupt; the sky in the Metropolitan canvas is more heavily overcast; the tree is completely different, as is the color of the horse—chestnut in the Prado painting, and white, with a gala beribboned crupper, in the Metropolitan painting. The catalogue of the Alte Pinakothek, Munich (Soehner 1963) attributes the picture to Mazo. More recently Liedtke and Moffitt (1981) devoted an article to the Prado portrait and "the closely related picture in the Metropolitan Museum," but without addressing the question of authenticity.

According to their position in regard to its authenticity, critics date the Metropolitan portrait prior to or later than the Prado painting. There is a

Velázquez. *A White Horse.*
Palacio Real, Madrid.

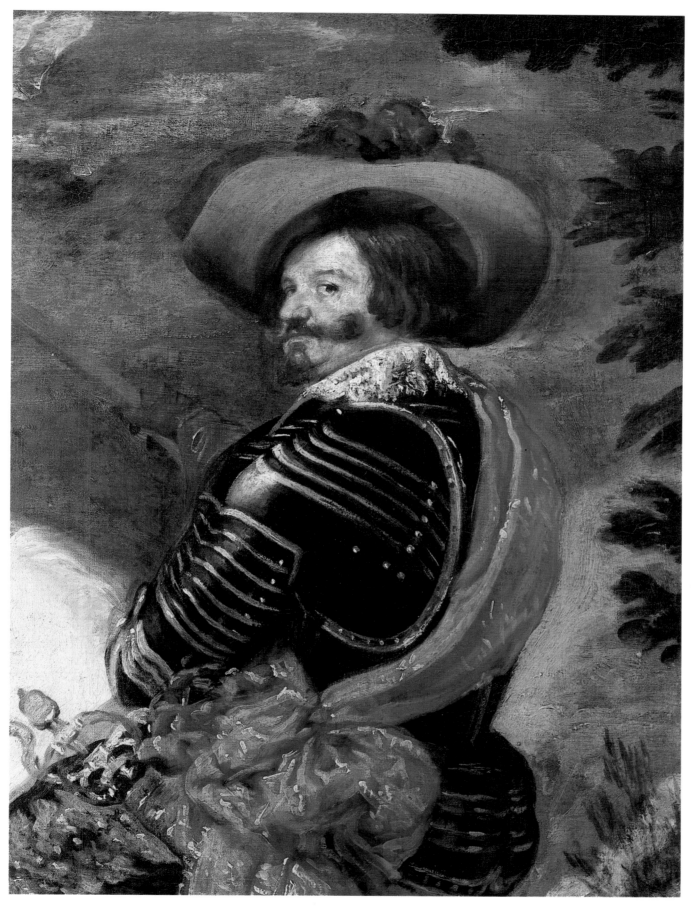

Detail of pl. 19

copy of the Metropolitan painting in the Alte Pinakothek, Munich, and another in the collection of the marquis of Vallcabra, Madrid.

Don Gaspar de Guzmán, count-duke of Olivares, was born in Rome on January 6, 1587, and died in Toro in 1645 (for further information, see pl. 18). Olivares was Philip's powerful favorite from 1621 to 1643, when he retired in disgrace to his palace in Loeches. A scion of a great Andalusian family, he was a lover of horses and no less an aficionado of the arts, as evidenced by his many literary protégés, including the writers Francisco de Rojas, Lope de Vega, Pedro Calderón de la Barca, Rodrigo Caro, Pedro Soto de Rojas, Guillén de Castro, Juan de Jaúregui, Fernando de Herrera, Luis de Góngora, and Francisco de Quevedo (although the latter would become his enemy). Despite his fondness for lavish display and festivities, when he came to power he persuaded his young sovereign to formulate a code of conduct, whose articles the king made law in 1623. Coaches and luxury items were forbidden; the numbers if servants was limited (Olivares had one hundred sixty-six); and

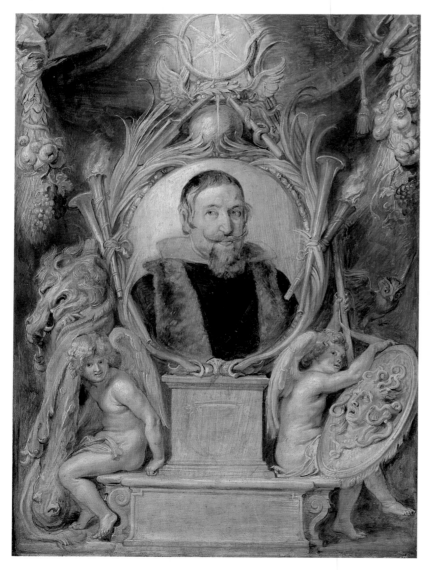

Peter Paul Rubens. *The Count-Duke of Olivares*.
Musées Royaux, Brussels.

LITERATURE

Mayer 313, Curtis 168, López Rey 216, Pantorba 192, Gudiol 74, Bardi 69-A

PROVENANCE

Don Gaspar de Guzmán, marquis of Heliche (Olivares's great-nephew), 1651(?).

Colonel M. Lemotteux, Paris, 1806 (probably removed from Spain during the Peninsular War).

Colonel Thomas Bruce, seventh earl of Elgin and eleventh earl of Kincardine, Broom Hall, Dunfermline, Scotland (1806–41). It remained in the hall until 1952.

Sold by James Bruce, tenth earl of Elgin and fourteenth earl of Kincardine, to the Metropolitan Museum in 1952.

the severe elegance of Philip IV became the standard: black suit and simple starched *golilla* in lieu of the large collar trimmed with the Flemish lace and elaborately frilled ruffs typical of the preceding reign. Olivares could be open-handed; he sent the Prince of Wales (the future Charles I of England) gifts worth one hundred thousand ducats and paintings worth forty thousand ducats.

Nevertheless, the testimony of Venetian ambassadors—Alvise Mocenigo (in Madrid, 1623–31), Francesco Correr (1631–34), Giovanni Giustiniani (1634–38), and Alvise Contarini (1638–41)—confirms the simplicity and austerity of Olivares's life. "He lives without ostentation," noted Giustiniani. "He presents himself as poor and inexperienced, not wealthy and powerful, in order to avoid envy," wrote Contarini. We may deduce that Olivares used wealth to achieve his end, which was to maintain his hold over Philip IV, who was very partial to social diversions and the arts. Perhaps, like the sovereign himself, he deceived foreigners and masked the decline of the kingdom with brilliant spectacles. The uprisings in Portugal and Catalonia, however, dealt the death blow to Olivares's power.

Velázquez painted standing portraits of Olivares in 1624 (Museu de Arte, São Paulo) and 1625 (Hispanic Society of America, New York) and bust-length portraits sometime between 1635 and 1638 (Hermitage, Leningrad).

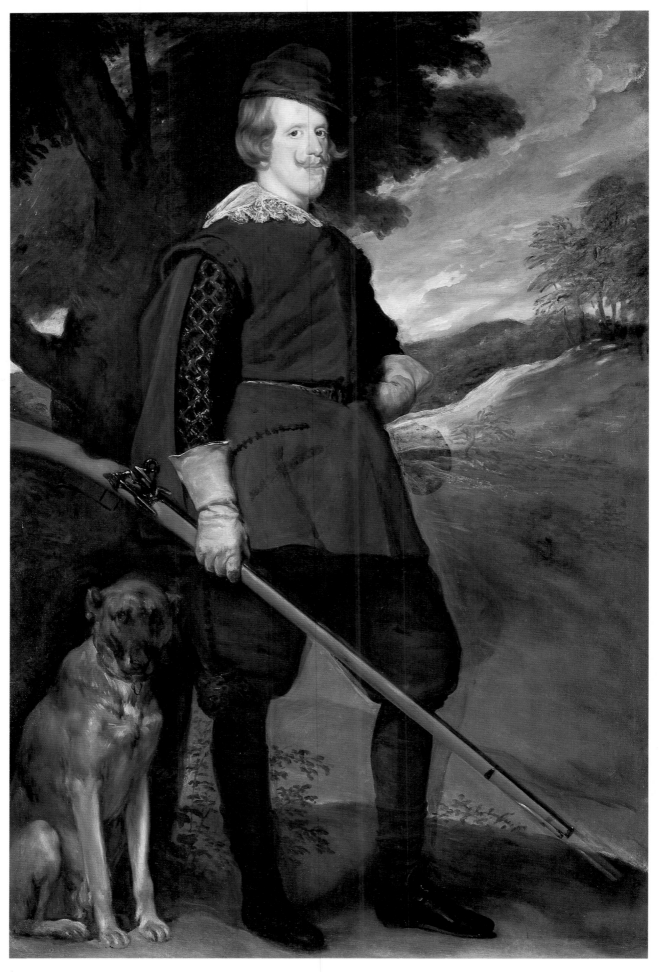

Philip IV as a Hunter

Oil on canvas
75¼ × 49⅝ in. (191 × 126 cm.)
Museo del Prado, no. 1184

The critics are in near accord on the date of this painting, which the Prado catalogue places between 1634 and 1636; López Rey estimates 1632–33; Bardi, 1635; and Gudiol and Pantorba, 1635–36. Camón Aznar (1964, p. 556), assuming a date of about 1632, reasons that the painting was touched up and "judging from the retouches and corrections . . . entirely reworked" in 1638. According to this scholar it should be noted that the king was bareheaded in the first version and the hat was added later, "so that he would not appear bareheaded" beside Prince Baltasar Carlos (pl. 22) and the cardinal-infante Ferdinand (Museo del Prado, nos. 1189 and 1186), who are wearing visored caps. As these three portraits were intended for the Torre de la Parada, a hunting lodge which was first used in 1636, these paintings are considered earlier than that date.

Numerous pentimenti showed up when this canvas was cleaned in 1983, revealing a silvery atmosphere and an exquisite harmony of colors, previously masked by the varnish. The earlier positions of the left hand and leg were different, and the gun barrel had been longer. It is possible that the dog was cropped slightly about the time the painting was moved to the Palacio Nuevo in the second half of the eighteenth century.

Philip IV, son of Philip III, was born on April 8, 1605, and became king of Spain on March 31, 1621, when he was fifteen. Diego Velázquez, born in 1599, was thus of the same generation, and it is natural that the king should have wished to surround himself with contemporary artists to succeed those of the previous reign. Philip IV was if not a friend to Velázquez—that would have been inconceivable at the time when the painter's admission to the Order of Santiago had met with countless obstacles (see Gállego 1983, in relation to *Varia Velazqueña*, part 1)—certainly an extraordinarily understanding patron. He respected the innovations of Velázquez, an attitude unheard of in other courts (cf. André Félibien des Avaux, *Entretiens*).

By the time Velázquez painted this portrait of the king, he had made his first journey to Italy in 1629–30 and had achieved artistic maturity and total self-assurance in his work. In the 1630s, a period of great productivity for the artist, he created images of extraordinary technical and conceptual brilliance, and he portrayed a number of members of the royal family and the court as hunters. He also painted equestrian portraits for the Hall of Realms in the Buen Retiro, where his *Surrender of Breda* was hung, along with other pictures of contemporary history by various painters (including Mayno, Zurbarán, Pereda, and Jusepe Leonardo). Velázquez himself probably selected these

Velázquez. *Philip IV as a Hunter.*
Musée Goya-Jaurès, Castres.

Details of pl. 20.

Prince Baltasar Carlos with a Dwarf

Oil on canvas
50⅜ × 40⅛ in. (128.1 × 102 cm.)
Museum of Fine Arts, Boston, no. 01-104

The critics are in accord on the date of this painting; in yellow letters, now almost obliterated, the age of the prince is given, as by Trapier, López Rey, and Gudiol: AETATIS AN...MENS 4 (one year and four months of age). Prince Baltasar Carlos, son of Philip IV and Isabella of Bourbon, was born in Madrid on October 17, 1629, and thus this portrait can be dated about February 1631. According to Pacheco (*Arte* I, chapter 8), after his first trip to Italy Velázquez "returned to Madrid following an absence of a year and a half and arrived at the beginning of 1631. He was very well received by the count-duke, who ordered him to go and kiss His Majesty's hand, with humble thanks for not commissioning another painter, but rather waiting for him to paint the prince's portrait, which he did forthwith."

Since Pacheco does not mention the dwarf, some have surmised that he was referring to the painting in the Wallace Collection, London, where the prince is alone; but he looks about three years old in the London picture, which means that it cannot be his first portrait. A more controversial figure is the dwarf, who in Camón Aznar's opinion (1964, p. 437) is female, since "from head to toe, the whole attire is feminine," a questionable point that Brown (1986, p. 290 n. 31) accepts parenthetically as a hypothesis. Brown (1986, pp. 81, 83) believes the Boston portrait may have been painted in 1632, on the occasion of the oath of allegiance of the Cortes of Castile to the heir to the throne. But the prominence of the dwarf, even if regarded as having symbolic significance, is hard to reconcile with an official portrait. In any case, if this picture had been painted in 1631 or 1632, the dwarf could not be Francisco Lezcano (pl. 30), as Moreno Villa supposed, since he did not enter the prince's service until 1634. Pantorba (1955, p. 106), however, suggests that the dwarf is a later addition, since "the stunted figure..., far more lively than the prince, is the best thing in the work" and "we believe it was not painted before 1634."

That hypothesis leads me to another, no less risky, but which perhaps reconciles both dates and facts (Gállego 1974). The Boston painting might represent a "picture within a picture," a type of composition that Velázquez had explored in his Sevillian works *Christ in the House of Martha and Mary* (National Gallery, London) and *The Supper at Emmaus* (National Gallery of Ireland, Dublin). But the most ambiguous paradigm is found in *The Weavers* (Museo del Prado), where it has not yet been resolved whether the figures of Pallas Athena and Arachne—if they can be so identified—are outside or inside the background tapestry representing the Rape of Europa (Gállego 1984).

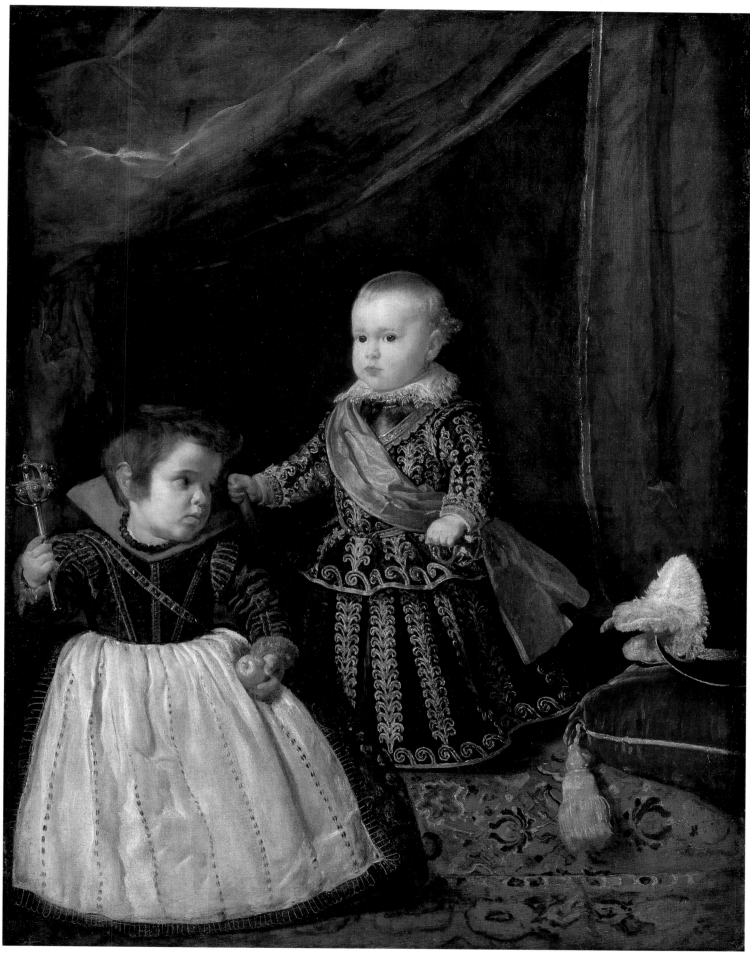

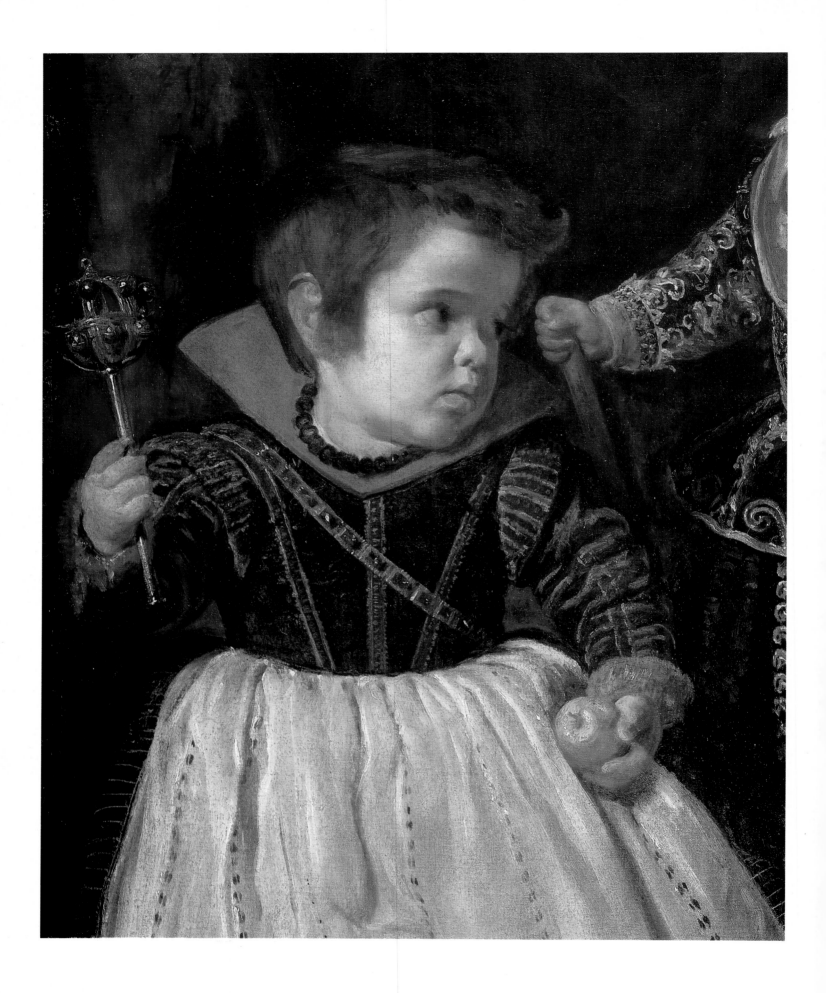

etails of pl. 22.

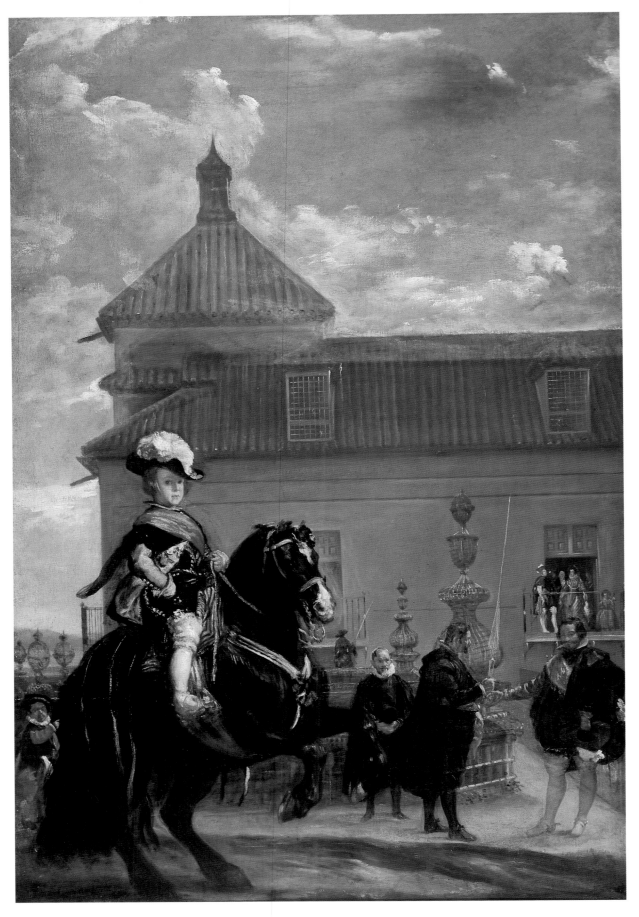

23

Prince Baltasar Carlos in the Riding School

Oil on canvas
56¾ × 35⅞ in. (144 × 91 cm.)
His Grace the Duke of Westminster

The authenticity of this work has been disputed, and specialists such as Trapier and Camón Aznar do not even allude to it. Pantorba includes it (with erroneous dimensions) as no. 159 in his catalogue, among unsubstantiated works; he notes that it is both previous, and superior, to the canvas on the same theme in the Wallace Collection (whereas Justi believes the opposite). Pantorba is of the strong opinion that "it is this painting, or another (today unknown) of which this and the Wallace example are copies, to which Palomino was referring when he wrote: '[Velázquez] created another painting, with the portrait of this prince, whom Don Gaspar de Guzmán... was teaching to ride horseback'" (1955, pp. 227–28). Gudiol theorizes that this is the canvas known to have been in the collection of the marquis of Carpio (Olivares's nephew) in 1648 and recorded by Palomino as being in the house of the marquis's son, Don Diego Gaspar de Haro. Stirling-Maxwell, Bürger, and Viardot accept it as an autograph painting, based on Palomino's account and on the treatment of the figures, whose energy is characteristic of Velázquez. Cruzada Villaamil, although he had not seen this work, was dubious about its

Workshop of Velázquez. *Prince Baltasar Carlos in the Riding School*. Wallace Collection, London.

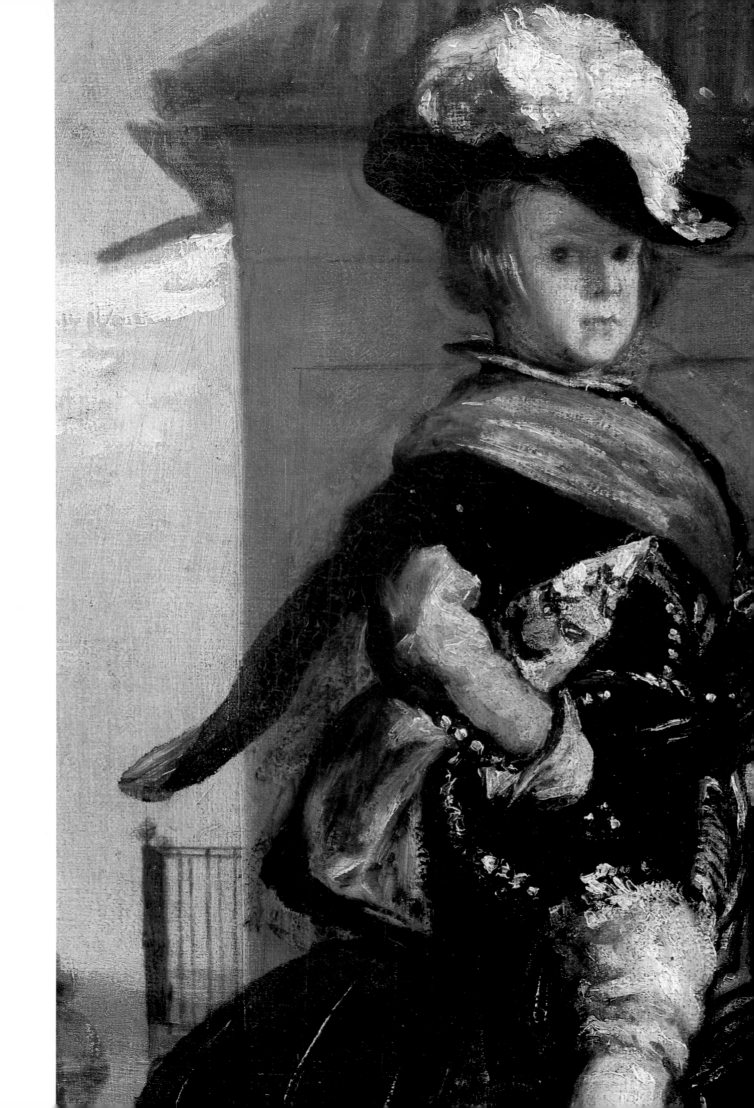

Detail of pl. 23.

Details of pl. 23.

Don Pedro de Barberana y Aparregui

Oil on canvas
78 × 43⅞ in. (198.1 × 111.4 cm.)
Kimbell Art Museum, Fort Worth, no. 81.14

This painting was unknown until López Rey published it in 1972. It was included by Gudiol (1973, no. 87), López Rey (1978 and 1981, no. 45), and Brown (1986). Gudiol (1973, no. 87, pp. 148–49), interpreting an inscription on the back of an old relining canvas, identified the subject as Pedro de Barberana y Aparregui. Further information on the painting has been given by Jordan (1981) and Brown (1986, p. 141).

According to Gudiol, who considers this painting "a principal work" from the period 1631–35, Barberana was born in 1579 in the town of Briones (Rioja) and was permanent warden of its castle; he died in Briones in 1649. He had "large landholdings and held various offices, among them, auditing the royal accounts, which earned for him the honor of being painted by the king's own painter." According to the catalogue of the Kimbell Art Museum, Barberana "was a member of the king's privy council." He was admitted to the Order of Calatrava on October 14, 1630, and it is possible that the portrait was commissioned to celebrate that appointment, for the cross of the order (four arms of equal length) is prominently featured on his breast and his cape. These military orders were created during the Reconquest (the Order of Calatrava was founded in 1158). In the seventeenth century such honorary titles brought with them specific material advantages.

If we compare this painting with the contemporaneous portrait of Don Diego del Corral (pl. 14), we see that only the tip of this magistrate's cross of

Detail of pl. 14.

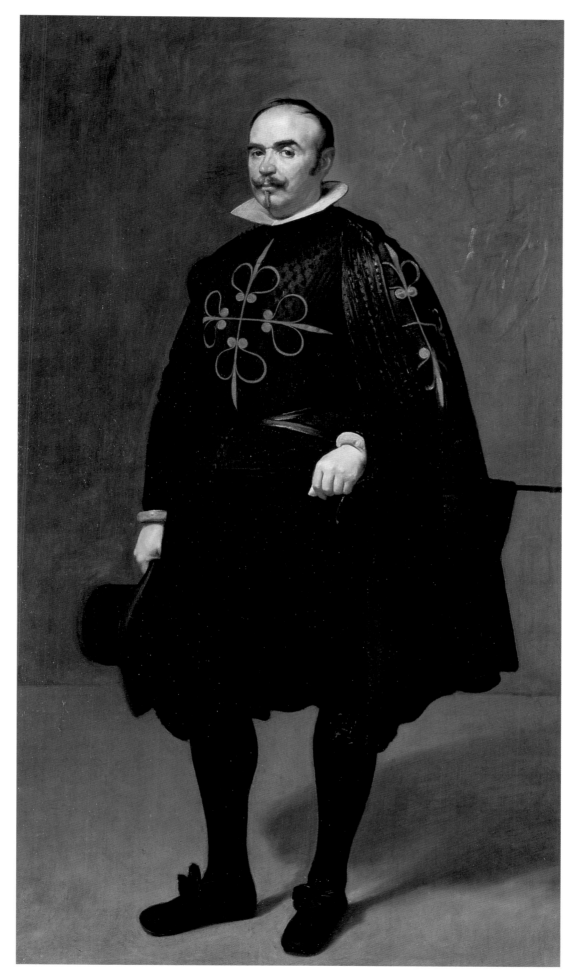

Velázquez. Detail of his self-portrait in *Las Meninas*.
Museo del Prado, Madrid.

Santiago is visible. The resemblance between the crosses (that of Santiago is distinguished by the swordlike length of the lower arm) deceived López Rey, who wrote that in 1631 Barberana had been named a knight of Santiago (1978, p. 71). The cross of Santiago appears in Velázquez's self-portrait in *Las Meninas* and in his portrait of the poet Francisco de Quevedo (copy of a lost original, Instituto Valencia de Don Juan, Madrid).

López Rey (1972, p. 78) calls attention to similarities between the portraits of Barberana and Corral: the pose (each figure is standing, in command of the situation); the shapes of brow and temple; the curve of the nose and the eye sockets emphasized by chiaroscuro; the play of light on black garments; the uneasy expression on each face. For Gudiol (1973, pp. 148–49) this "is a straightforward painting that shows . . . some corrections in the definition of the silhouette and, in the background, strokes where Velázquez impulsively removed the excess paint from his brush. We have here a work of incomparable realism, so much so that the sensation of life emanating from the figure is actually disturbing." This author also notes the delicate resonances of grays

Copy of Velázquez. *Francisco de Quevedo*.
Instituto Valencia de Don Juan, Madrid.

PROVENANCE

Private collection, New York, 1972.

Kimbell Art Museum, Fort Worth, since
1981.

and ochers against dark or black masses which contribute to the chromatic harmony between the red of the cross and the reddish and pink flesh tones of the model. He adds, "But if one thing is striking in this painting, and gives it particular meaning, it is the triumph of capturing a vivid likeness over the truth of art for art's sake." Brown (1986, p. 141) points out that "in composition [the painting] is conventional, but in execution it is bold. Velázquez has neutralized the illusion of space in order to concentrate attention on the figure.... The de-emphasis of the space and the heightening of the volume combine to produce the illusion of a human presence."

189

The Buffoon Called "Don Juan of Austria"

Oil on canvas
82⅝ × 48⅜ in.(210 × 123 cm.)
Museo del Prado, no. 1200

The Prado catalogue refers to this picture as *The Buffoon Called "Don Juan of Austria"*; there is no record of the subject's real name. The sobriquet doubtless was an ironic reference to the emperor Charles V's natural son, Don Juan of Austria, who was born at Ratisbon in 1545. He was governor of Flanders in 1576 and died near Namur in 1578; during his short life he distinguished himself in the war with the Moriscos (1568–71), as well as at the Battle of Lepanto (1571), which ended the Turkish domination of the

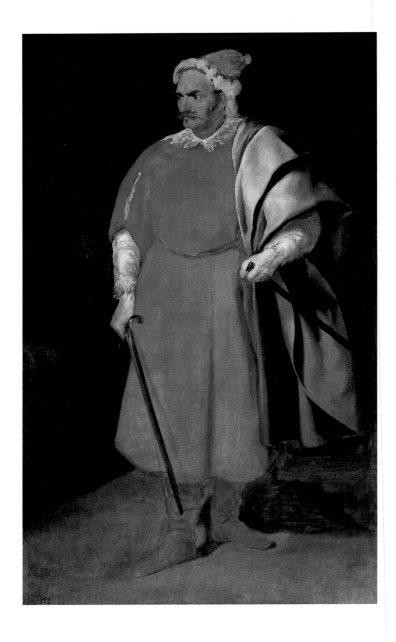

Velázquez. *The Buffoon Called "Barbarroja."*
Museo del Prado, Madrid.

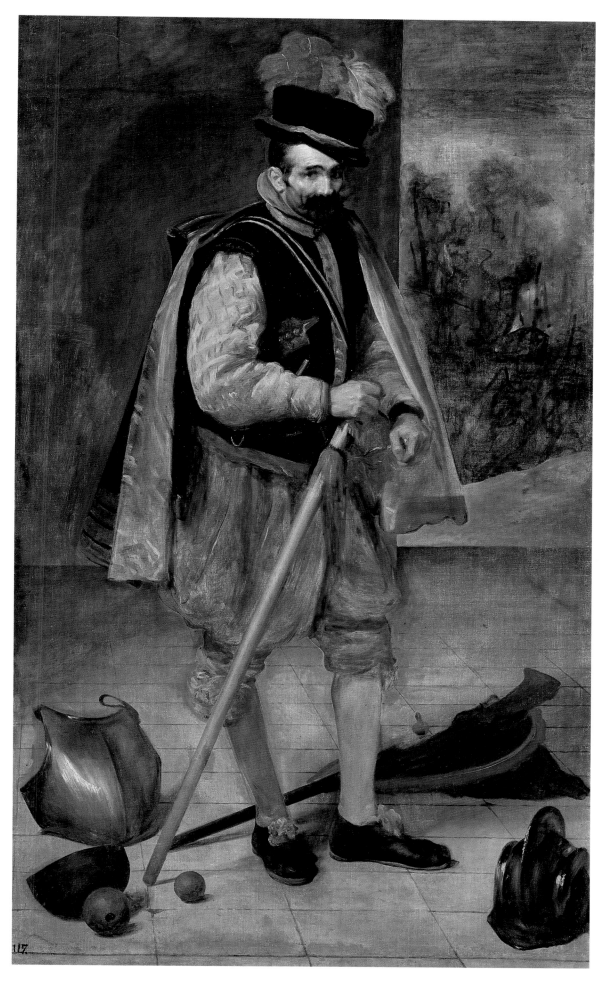

Jusepe de Ribera. *Don Juan of Austria on Horseback.*
Palacio Real, Madrid.

Mediterranean, and he also took Tunis and Bizerte (1574). Moreno Villa (1939) mentions that it was not unusual for humble persons attached to the palace to be named after kings or princes.

In this context, however, it should be recalled that in 1629 there was born in Madrid, fruit of the illicit love of Philip IV and the actress María Calderón (La Calderona), a son who was named Juan José of Austria and who was likewise to win glory by warlike deeds that made him enormously popular in Spain, to the point of alarming Queen Mariana as to the rights of her son Charles II to the crown. This second Don Juan of Austria led an uprising against the regent queen mother. In Naples, where he put down the Masaniello rebellion, his portrait was painted by Jusepe de Ribera, whose daughter he seduced. It is not impossible that the buffoon's nickname refers

to this Don Juan José, especially if the date of the Velázquez portrait is as late as some believe. More likely, it reflects the fool's delusions of grandeur, wearing his antique garb with trophies on the floor and a sea battle scene in the background, an allusion either to Lepanto or to the many mock naval engagements held in the grand pool of the Buen Retiro beginning in 1634.

There are reports of this buffoon from 1624 to 1654, although he had no fixed allowance or wages and did not live in the Alcázar. Pantorba (1955, p. 175) wonders whether he might not have been "some old soldier, present at victories like those which gave luster to the early reign of Philip IV," perhaps "a veteran of the defense of Cádiz." If so, Camón (1964, p. 697) would be right to call this painting "the most tragic portrait of all Velázquez's oeuvre" and the "symbol of our decadence." In the palace archives examined by Moreno Villa, "Don Juan" is always mentioned as an *hombre de placer* (entertainer). He might be a military counterpart of the buffoon Barbarroja (Museo del Prado, no. 1199), famous for his amusing pranks and sallies.

Don Juan of Austria.
Real Academia de la Historia, Madrid.

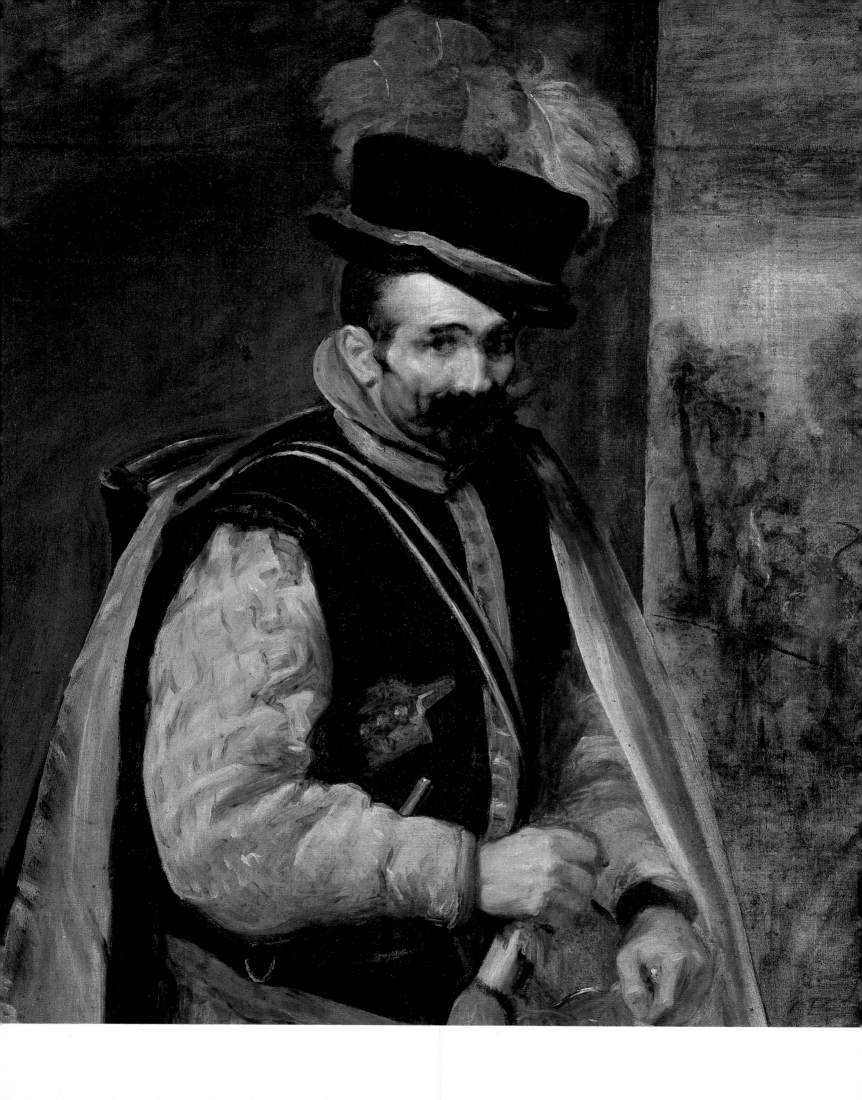

Don Juan de Calabazas

Oil on canvas
69¼ × 42⅛ in. (176 × 107 cm.)
Cleveland Museum of Art, Leonard C. Hanna, Jr. Bequest, no. 65.15

Opinions vary as to the authenticity of this painting. Among the earliest doubt-
ers was Ponz (1793), who described the painting as being "in the manner of"
Velázquez. Trapier (1948, p. 115) rejects the attribution, pointing out that the
description of a portrait of a jester in the 1701 Buen Retiro inventory ("One
buffoon, one *vara* and a third wide and two and a half high, of Calabacillas,
with a portrait in one hand and a billet in the other, by Velázquez, valued at
25 doubloons") is not applicable to the present painting, "in which the buffoon
holds a small toy windmill in one hand and a miniature (a later addition
judging from the costume) in the other."

In an attempt to resolve the difficulty of the *billete*, or letter, in the buf-
foon's hand, López Rey quotes a description of a painting by Velázquez in a
1789 inventory (entry 178) of the Buen Retiro: "Portrait of Velasquillo the
buffoon, which an old inventory [of 1701] says to be of Calabacillas, with a
portrait in one hand and a *reguilete*. . . ." He theorizes that in 1701 the scribe
mistakenly wrote *billete* for *reguilete*. The Real Academia dictionary (1970, p.
1124), however, defines *reguilete*, or *rehilete*, not as a paper pinwheel, but as a
"dart," a torero's "banderilla," or a "small block of wood or cork with feath-
ers that is batted in the air with a racket" (a shuttlecock). The name
"Velasquillo" (a diminutive of either Velasco or Velázquez) may refer to still
another buffoon, since in 1637 a Cristóbal Velázquez is listed among the
palace servants.

Steinberg (1965) thinks that the portrait might have been painted by
Alonso Cano. Moffitt (1982) similarly rejects Velázquez's hand and observes
that this painting is based on Cesare Ripa's allegory of madness, "which, in
his opinion, is at variance with Velázquez' individualized and sympathetic
approach to subjects of this type" (cited in Brown 1986, p. 270). The connec-
tion with Ripa is, in any case, an absorbing bit of information that cannot be
denied; in his *Iconologia* (1603) Ripa describes the personification of *Pazzia*
(Madness) as "an adult male dressed in full-length black clothing; he will be
laughing and, in his right hand, mounted on a reed, he will carry a little
paper pinwheel [*girella di carta*], an amusing toy which children, with great
skill, cause to whirl in the wind." This interesting association of madness
with the windmill/pinwheel is also alluded to by Cervantes. In *Don Quixote*,
following the adventure of the windmills, which the hidalgo had taken for
giants, Sancho exclaims to Quixote: "Did I not tell Your Mercy. . . that they
are only windmills and that the only person who would not recognize them as
such is someone who has windmills in his own head?"

Brown, along with Steinberg and Moffitt, is not inclined to accept this

ÆSOPVS

27

Aesop

Oil on canvas
70½ × 37 in. (179 × 94 cm.)
Museo del Prado, no. 1206

The Prado catalogue dates this painting to 1639–40. Loga puts it in 1629; Beruete, in the last decade of the artist's life; Allende - Salazar, Pantorba, and Brown, about 1640; López Rey, 1639–42; Gudiol, 1637–40; and Bardi, 1639–40. Camón Aznar (1964, p. 415) follows Loga and assigns this work to Velázquez's first journey to Italy, thus separating it from its pendant, *Menippus* (Museo del Prado, no. 1207), contrary to the majority of authors (and the Prado catalogue), who regard these similarly sized canvases as contemporaneous and intended for the Torre de la Parada, a hunting resort in the hills of El Pardo near Madrid. In 1603 Rubens had painted a philosophical pair for the duke of Lerma, *Democritus* and *Heraclitus* (both in the Museo del Prado). Installed in La Parada in 1638, these pictures are much the same height as Velázquez's *Aesop* and *Menippus* but are somewhat narrower (70½ × 33⅞ in. and 71¼ × 24¾ in. [179 × 86 cm. and 181 × 63 cm.]). For the same pavilion, for which Rubens and his studio painted many mythological subjects, some associated with the chase and some not, Velázquez also painted *Mars* (pl. 28) and the hunting portraits of Philip IV, Cardinal-Infante Don Fernando, and Prince Baltasar Carlos (all in the Museo del Prado; pls. 20 and 22); Velázquez's portraits of the dwarfs Diego de Acedo and Francisco Lezcano (both in the Museo del Prado; pl. 30) were later in the same location.

There is no need to relate all of these pictures to the hunt, as a passion for classification might seem to demand. It does not have to be argued that Aesop's fables provided motifs for some works in La Parada by the Flemish painter Paul de Vos or that beasts in these tales were targets for royal guns. The presence of Menippus, a Greek philosopher of the Cynic school (third century B.C.), and of Democritus and Heraclitus, is certainly difficult to account for in terms of the hunt. More likely, in a sporting pavilion there was ample scope for miscellaneous decorations and for the satire of antique culture quite prevalent in the Golden Age, in painting as well as in literature (Gállego 1968, part 1, chapter 3, and Cossío 1952). If Democritus, who scoffed at everything, and Heraclitus, who wept over the world, lent themselves to Spanish satire, then Aesop, who portrayed men in the likeness of beasts, and Menippus the Cynic would not have been out of place.

The simple dignity in which Velázquez clothes even his buffoonish figures is apparent in the features of Aesop, which correspond, as Gerstenberg (1960, p. 212) points out, to the bovine type (characterized by the Italian physiognomist Giovanni Battista della Porta in *La vera Fisonomia* [1586] as "*magna frons, carnosa facies, valde magni oculi*" [great forehead, fleshy face,

Velázquez. *Menippus.*
Museo del Prado, Madrid.

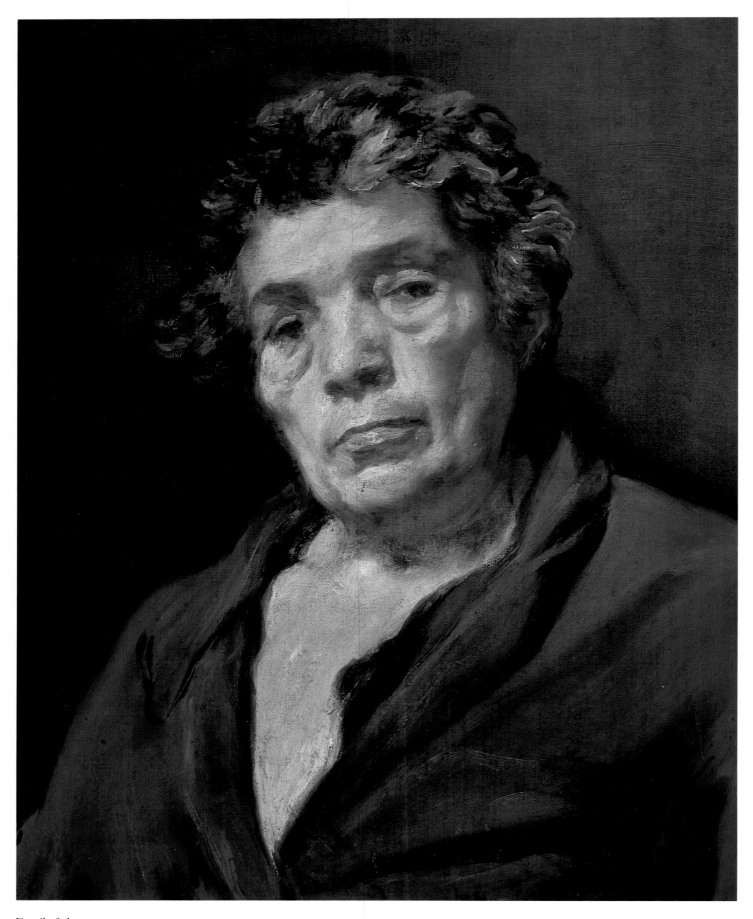

Detail of pl. 27.

Detail of pl. 27.

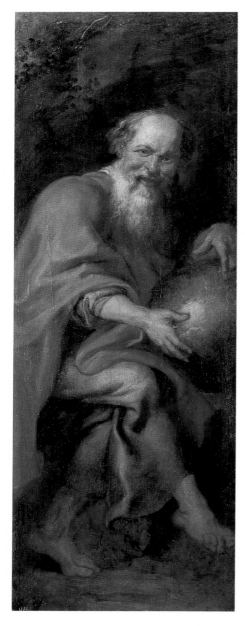 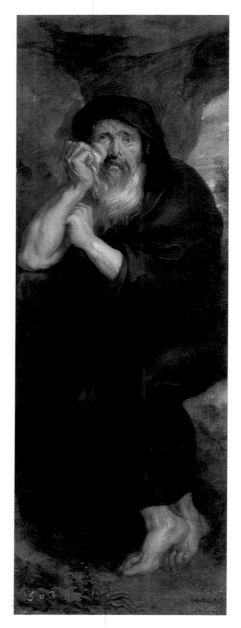

Peter Paul Rubens. *Democritus.*
Museo del Prado, Madrid.

Peter Paul Rubens. *Heraclitus.*
Museo del Prado, Madrid.

very large eyes]). According to Brown (1986, p. 163) the painter "takes revenge on the fableist, who used animals to characterize human behavior"; Brown also traces the position of the left hand, "which subtly reinforces the cowlike qualities of the face," to the phlegmatic type in Cesare Ripa's *Iconologia* (1603). Ripa's text for the "flemmatico per l'acqua" reads: "*huomo di corpo grasso, & di color bianco... tenendo ambe le due mani in seno*" (a man thick of body and pale in color ... holding both hands to his breast). Melancholy "for water" may explain the bucket at the feet of the figure, a black cloth (?) hung over its edge, perhaps the towel that, according to Ripa, is wrapped around the phleg-matic's head; Aesop, in his harsh judgment upon man, has let it fall into the

cooling water. (I consult my Venice edition of 1669, pp. 98-99.) For López Rey these are attributes of the tannery, and the black fabric is leather. As Brown (1986, p. 163), following Gerstenberg, remarks, this may be "an unabtrusive reference to the fable in which a man living next to a tannery eventually learns to tolerate the noxious odors of the leather."

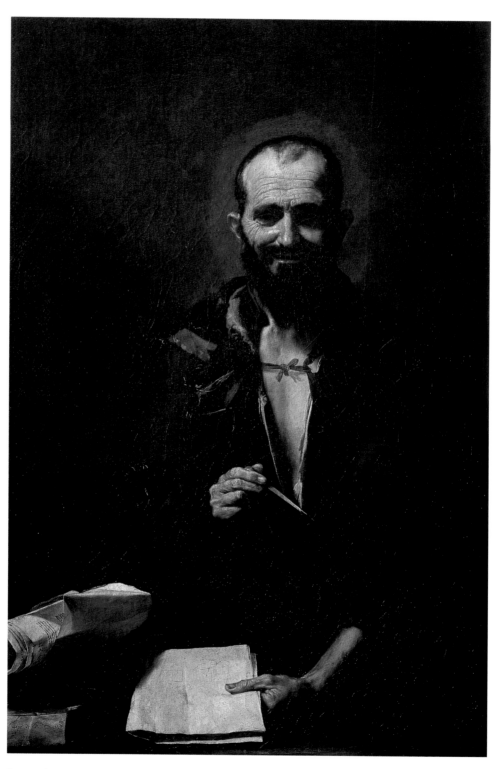

Jusepe de Ribera. *Archimedes*. Museo del Prado, Madrid.

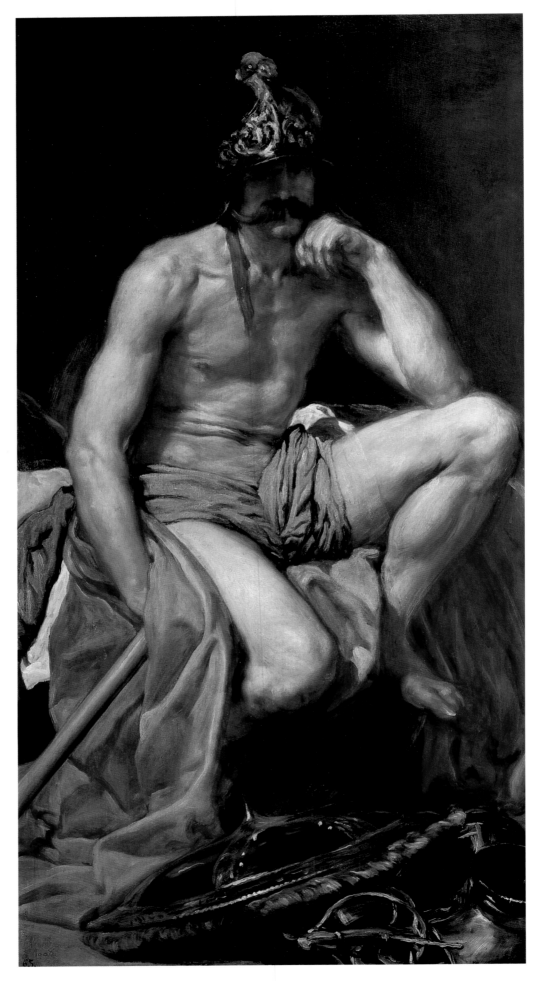

Mars

Oil on canvas
70½ × 37⅜ in. (179 × 95 cm.)
Museo del Prado, no. 1208

The date of this painting is in doubt: The Prado catalogue puts it between 1640 and 1642; Bardi, 1640; López Rey, 1639; Gudiol, 1637–40; Cruzada Villaamil, Mayer, and others, years later; Beruete, 1651–60; and Camón Aznar, about the time of Velázquez's second journey to Italy, 1649–51, with the suggestion that the model may be the buffoon Antonio Bañules (Camón Aznar 1964, p. 703). The date is important in connection with the rout of the Spanish *tercios* at the Battle of Rocroi in Flanders (1643), which marked the beginning of Spain's military decline.

In any event, this Mars, despite his evident melancholy, is a ridiculous figure. Velázquez here displays an ironic view of mythological representations (Gállego 1968, pp. 53ff.), as did the writers Rodríguez de Ardila, Góngora y Argote, Polo de Medina (who portrays a Mars evocative of this one), Cervantes, Lope de Vega, and Quevedo y Villegas and the painter Ribera. Brown (1986, p. 168) perhaps too quickly dismisses both interpretations, that of military decadence (because he doubts that the king's painter would presume to express that idea) and that of satire. For him, this canvas continues the narrative of Apollo's revelation of the amours of Mars and Venus, with

Michelangelo. *"Il Pensieroso."* Medici Tomb, New Sacristy of San Lorenzo, Florence.

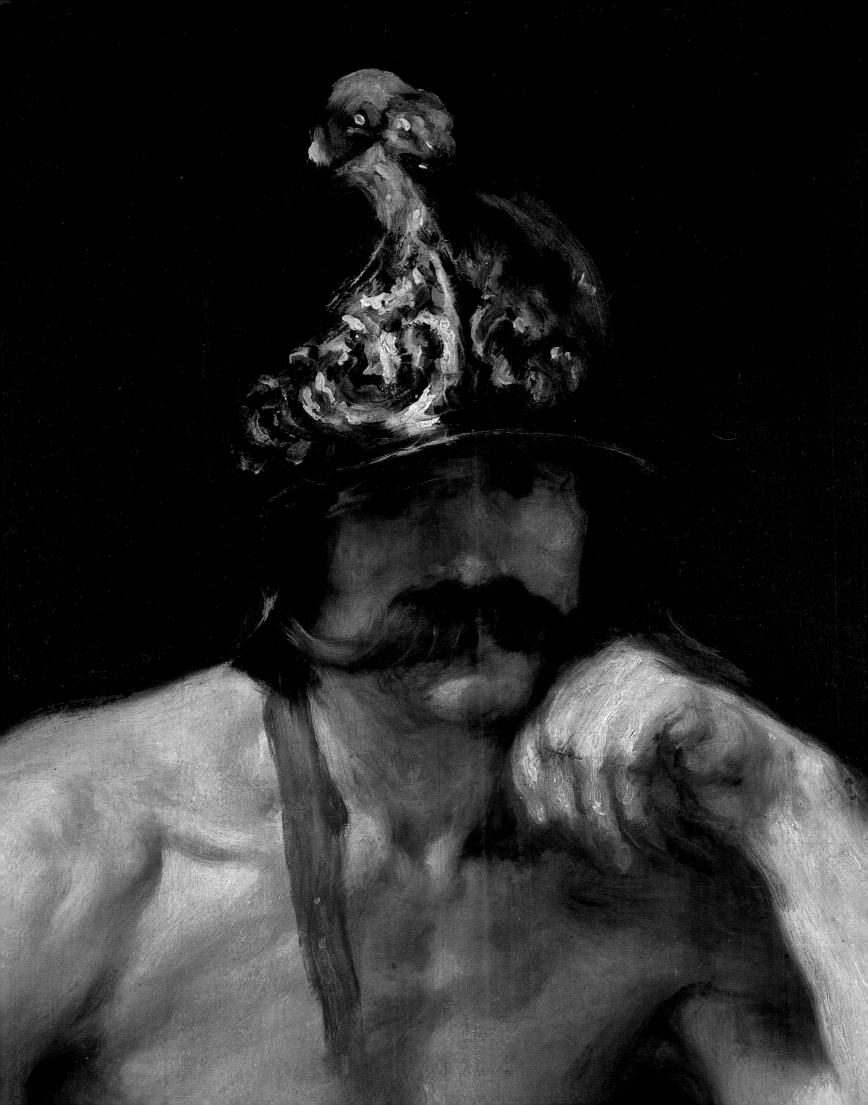

Details of pl. 28.

Rembrandt (?). *Man with a Golden Helmet.*
Staatliche Museen, Berlin.

Ludovisi Mars. Museo Nazionale, Rome.

Vulcan's revenge, a series Velázquez began in Rome in 1630 with *The Forge of Vulcan* (pl. 11). Mars "sits in a daze on the corner of a bed, still too shocked and chagrined to put on his clothes, as he reflects on the sudden, disastrous conclusion of his affair with the goddess of love." Even if the bed of Venus can be identified with a campaign couch, I fail to see why Mars would have donned his helmet for such a meditation. In any case, the comic-situation approach to mythology, both in *The Forge* and in *Mars*, is far removed from the veneration with which other artists treated the god of war.

This figure is one of a number of quasi-satirical representations of characters in the classical tradition, like *Aesop* (pl. 27) and *Menippus*, and like them it was intended to decorate the Torre de la Parada, where it still was in 1703.

The picture represents a man unclothed save for a blue cloth about his loins, a red robe on which he sits, and the casque, or helmet, that has reminded scholars of the disputed Rembrandt in the Berlin Staatliche Museen, because of the crass brightness of its gilding on a dark background. The face is adorned with the mustache of a soldier in the *tercios* (as we see them in *The Surrender of Breda*), grotesquely accentuating his mood of depression. The head rests on his left hand, somewhat recalling Michelangelo's *"Pensieroso,"*

LITERATURE

Mayer 51, Curtis 31, López Rey 61,
Pantorba 82, Bardi 81, Gudiol 108

PROVENANCE

Torre de la Parada about 1642.

Palacio Nuevo before 1772, inventories of
1772 and 1794.

In 1816 given by Ferdinand VI to the
Real Academia de Bellas Artes
de San Fernando, Madrid.

Museo del Prado since 1827.

apparently a precedent. As for the nude itself, mention has been made of Roman statues, especially the *Ludovisi Mars*, though surely the present canvas was painted from life. There are some suggestions of Rubens in the bright, reddish flesh tones and mature musculature, which detract from allegory and add humanity (as in the Flemish painter's free copies from Titian). The right hand, half-concealed by the robe, holds a wooden club or truncheon. At the feet lie an ornate tourney shield, a contemporary sword with a large hilt, and a piece of armor. Velázquez, as in *The Buffoon Called "Don Juan of Austria"* (pl. 25), has emphasized the warlike attributes to offset the pretentious and ridiculous aspects of this sad apparition, whose uncouth appearance has been noted by many authors from Richard Ford (1851) to our own day—an exact opposite of the Mars of the Italian mannerists (for example, Primaticcio).

The technique is smooth and easy, and in the somewhat discordant brighter colors, the blues and the reds, it seems to follow the French custom —muting warm tones with a cool one—rather than seeking a modulation in the Venetian manner.

The Needlewoman

Oil on canvas
29⅛ × 23⅝ in. (74 × 60 cm.)
National Gallery of Art, Washington, D. C., Mellon Collection, no. 81

This is one of Velázquez's most debated works; since it is unfinished, scholars tend to doubt that it is an autograph work, or if they accept it, they place it near the end of the painter's career—Gudiol, for example, suggests about 1650; Lafuente Ferrari (1943) catalogues it as no. 771 and dates it between 1641 and 1643; Bardi proposes 1640. But as López Rey points out, because the painting is unfinished, it is impossible to ascribe a firm date to it. Neither Trapier nor Camón Aznar mentions it. Pantorba, who catalogues it as no. 164 among unverified works, does not see the hand of Velázquez in "this unfinished work, or, if you wish, 'draft' for a more ambitious work. There is something of Velázquez's diction about the head; as a preparatory study, it might be accepted, but even then with grave reservations."

In the inventory of Velázquez's belongings made at his death, there is listed "another head of a woman doing needlework" (no. 169). For Sánchez Cantón (1942) the inventory entry may mean that only the head of that half-length figure was finished, and if that is correct, the entry "documented a valuable and baffling canvas: no. 81 in the National Gallery of Art, Washington, D.C. I had occasion to see it in December, 1930, in the home of Mr. Mellon.... Poor lighting, and haste, did not allow me to study it properly. The impression of characteristics peculiar to Velázquez's paintings was blurred by anomalies." The inventory entry tells Sánchez Cantón that "another painter, logically Mazo, put his hand to the [unfinished] canvas." Sánchez Cantón later rejected the attribution to Velázquez, labeling it "unacceptable" (1942 and 1944). In 1945, in yet another shift of opinion, he seemed disposed to accept that Velázquez did at least paint the head. Soria and Pantorba deny any Velázquez contribution. Bardi, in reviewing these opinions, nevertheless catalogues it among the master's originals as "generally attributed." Gudiol (1973, p. 292) believes "this masterly study" is an autograph work, emphasizing "the luminosity of the large white kerchief covering the woman's shoulders and the bold simplification of the hands, which, as in other of the painter's works, approaches mere suggestion of the essential, that is, the minimum that will allow the viewer's eye to reconstruct the total form."

Brown (1986, p. 158) accepts this as an autograph painting, a model of how the maestro worked: "First he laid down a gray-green prime coat and then quickly sketched the outline of the figure. After establishing the larger color areas, he must have stepped back to judge the balance of the composition. Here, as in many of his works, he apparently did not like what he saw, and made certain adjustments.... Once this correction was made, Velázquez concentrated on bringing the head nearly to completion."

LITERATURE

Mayer 558, López Rey 605, Pantorba 164, Gudiol 160, Bardi 84

PROVENANCE

Marquis de Gonvello, Kerlevant.

Christiane de Poles, Paris.

Wildenstein and Co., Paris.

Andrew Mellon, until 1936.

National Gallery of Art, Washington D.C., since 1937.

The Dwarf Francisco Lezcano, Called "El Niño de Vallecas"

Oil on canvas
42⅛ × 32⅝ in. (107 × 83 cm.)
Museo del Prado, no. 1204

In the first Prado catalogue (1819) this picture is described as *"Una muchacha boba"* (A dim-witted girl); the next catalogue (1828) reports that the subject is a male: "Portrait known as the Boy of Vallecas, painted with a firm and pastose touch and good chiaroscuro effect." In the 1872 Prado catalogue Madrazo says that he looks barely twelve years old and that the work must have been painted, like the portraits of the dwarfs El Primo and Morra (both in the Museo del Prado, nos. 1201 and 1202), between Velázquez's first and second trips to Italy (1630–49). The latest edition of the catalogue indicates that "it was believed to have been painted about 1646; but the records compel dating it one decade earlier." López Rey places it in 1643–45, and Camón Aznar (1964, p. 643), around 1642–43. Gudiol gives no date; Beruete dates the present work with almost all the portraits of buffoons in the period after the artist's second journey to Italy.

These differences in dating are due in part to the spurious sobriquet. In 1885 Cruzada Villaamil observed: "Called the Boy of Vallecas, reason unknown." In fact, this sobriquet (like the name "Bobo de Coria" [Fool of Coria] given the portrait of Don Juan de Calabazas; pl. 26) came into use at a much later date than the painting; it has survived so long, however, that it is still used today. The dwarf's name was Francisco Lezcano or Lezcanillo (or Lazcano, according to Camón), and he was called "El Vizcaíno" because he came from the Basque province of Vizcaya. The appellation of Vallecas (a suburb of Madrid, today swallowed up by the capital) was added half a century after the portrait was painted. He has been documented at the palace from 1634 as the dwarf of Prince Baltasar Carlos. Moreno Villa (in his remarkable *Locos, enanos, negros y niños palatinos*, 1939) identifies him as the boy appearing beside his master in the magnificent *Prince Baltasar Carlos with a Dwarf* (Museum of Fine Arts, Boston; pl. 21), a picture he believes was painted about 1635. The Boston picture, however, dates from some years earlier— about 1631 or (according to Brown 1986, p. 83) 1632, when the oath of allegiance of the Cortes of Castile was sworn to the heir to the throne, who was then two years and four months old. Camón Aznar (1964, p. 454) suggests that the official *juramento* portrait was that of the prince standing alone (Wallace Collection, London), an idea shared by López Rey but rejected by Brown, who states that the sitter is about four in the London picture. In both paintings the prince wears a captain general's insignia and sash and carries a baton. In any case, the Boston portrait predates Lezcano's arrival in Madrid, and therefore he cannot be the dwarf in that picture.

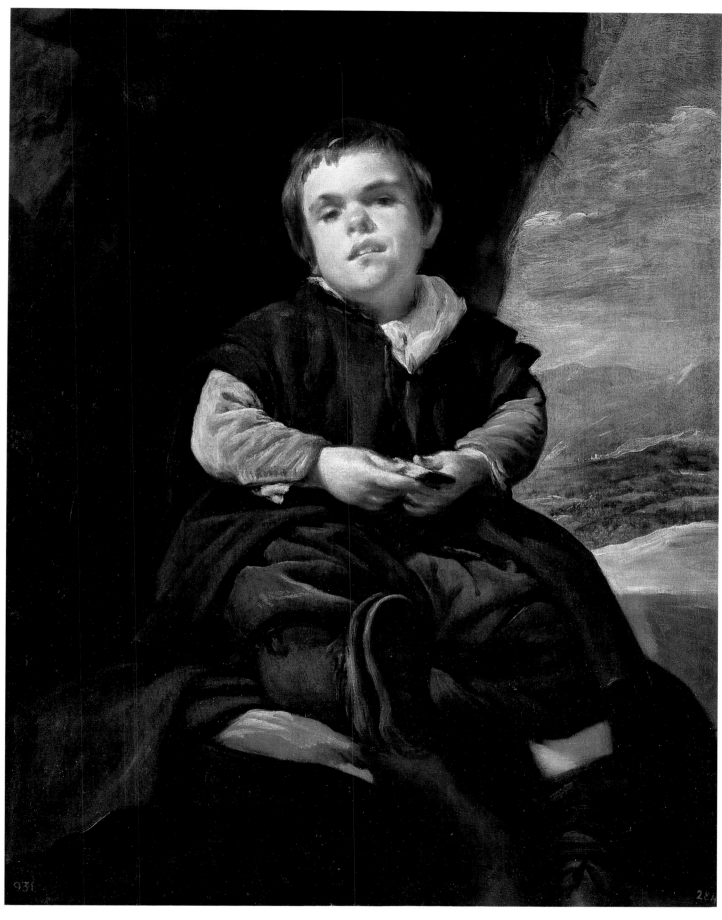

Detail of pl. 30.

Lezcano is clad in green wool, a color appropriate for the chase (in the ducal hunts in *Don Quixote*, the duchess wears green, and the nobles give Sancho a green mantle that he rips when fleeing from a wild boar). This garment blends with the landscape of the sierra of Madrid that rises in the background (the same as that in *Prince Baltasar Carlos as a Hunter* [pl. 22]). The cave or shelter is a propitious setting for meditation, of the kind that Ribera's hermits usually seek (Gállego 1968, part 2, chapter 3). Lezcano's white shirt is wrinkled but clean; his arms, clothed in a pink overshirt, protrude from the tabard's *mangas bobas*. His right leg is extended straight ahead, revealing his deformity; he wears clumsy shoes, and his stocking has slipped down around his left ankle. The costume, which is certainly not a beggar's, has a disheveled appearance in keeping with the disordered mind of the

Detail of pl. 21.

31

A Woman as a Sibyl

Oil on canvas
25³/₁₆ × 22¹³/₁₆ in. (64 × 58 cm.)
Meadows Museum of Art, Southern Methodist University, Dallas

Mayer accepts this sketch as an autograph work, believing that the model for the figure of Arachne in *The Weavers* was also used for this sibyl. López Rey, however, relates it in manner and execution to *Venus at Her Mirror* (National Gallery, London), assigning a date between 1644 and 1648, which Gudiol accepts. Bardi (no. 41–B) relates the profile to that of Apollo in *The Forge of Vulcan* (pl. 11), especially to *A Study for the Head of Apollo* (pl. 12), while noting that the attribution to Velázquez is not unanimous. Pantorba and Camón Aznar do not mention this work. Brown (1986, pp. 178–81), assigning it to Velázquez and to the 1640s, calls it a "small but sparkling picture of uncertain subject" and points out its relationship to *A Woman as a Sibyl* in the Museo del Prado (pl. 16): "Both show half-length female figures in strict profile, facing to the right, and holding a tablet." He acknowledges, however, that the Dallas figure lacks the customary attributes, apparel, and coiffure of a sibyl. For Jordan (1974, pp. 20–21) it might be an allegory of Painting.

Cesare Ripa. *Iconologia: Historia.*
The Metropolitan Museum of Art, New York.

Hendrik Goltzius. *Clio.*
The Metropolitan Museum of Art, New York.

LITERATURE

Mayer 570, López Rey 591, Gudiol 134, Bardi 41

PROVENANCE

Private collection, Milan.

Julius Böhler, Munich.

Reinhardt Gallery, New York.

Isabel van Wie Willys, Toledo, Ohio.

Sale of collection of Mrs. Isabel van Wie Willys, Wildenstein and Co., New York, October 25, 1945, lot 25.

Private collection, New York.

Meadows Museum of Art, Dallas, since 1974.

In Brown's view none of these interpretations is altogether convincing, for there are few clues in the picture: "a young woman with disheveled hair and clothes holding a small tablet to which she points." Accordingly, she might even be Clio, who is usually represented with a tablet on which she records the events of history. In support of that hypothesis Brown reproduces an engraving by Hendrik Goltzius (1986, pl. 205) in which the figure holds a pen in her right hand and an inkwell and a tablet in her left. According to Cesare Ripa's *Iconologia* (Rome, 1603), History should be a winged woman, clad in white, looking back and supporting with her left hand a tablet or a book in which she writes. Some features appear in the present image; others do not. López Rey, as I have remarked, prefers to identify her with Arachne, on the basis of the dubious similarity of features, dress, color, and light.

López Rey thinks the young woman is holding a cloth, perhaps on an embroidery frame, or an artist's canvas. Perhaps, according to a legend familiar in Pacheco and Velázquez's time, the shadow cast by the finger on the fabric alludes to the origin of painting—the outlining of a shadow on a wall.

Without the benefit of a direct examination, I cannot attest to the authenticity of this little piece.

Juan de Pareja

Oil on canvas
32 × 27½ in. (81.3 × 69.9 cm.)
The Metropolitan Museum of Art, New York, Fletcher Fund, Rogers Fund,
and Bequest of Miss Adelaide Milton de Groot (1876–1967), by exchange,
supplemented by gifts from the friends of the Museum, 1971 (1971.86)

Until The Metropolitan Museum of Art acquired this work in 1971, it had
been in a private collection and had been known primarily to specialists.
After it had entered the collection of the earl of Radnor in 1801, Stirling-
Maxwell was among the first to propose that this painting might be the por-
trait of Juan de Pareja that Palomino (1724) had praised so highly. A similar
painting was found in the collection of the earl of Carlisle (Castle Howard),
and Stirling-Maxwell catalogued both in 1848. Bürger (1865) listed neither
painting; Curtis (1883) cited both; Cruzada Villaamil (1885), quoting Palo-
mino, mentioned one, reporting it lost; Justi (1888) commented on both.
Beruete (1898) confirmed that "the portrait of Pareja painted by Velázquez is
without doubt the one in the possession of the earl of Radnor." This painting
appeared in an 1893 exhibition of old master paintings in the Royal Academy,
London, which exhibited it again in 1904 and 1921. The Carlisle painting,
slightly smaller than the Radnor, was acquired by Archer M. Huntington and
donated to the Hispanic Society of America, New York, in 1925, which con-
ceded that "it is not the better version, but a close replica . . . evidently painted
in the studio of the master and under his direction. In the treatment of the
gray-green costume the lack of spontaneity, the loss of crispness of touch,
and the comparative weakness of the highlights are noticeable" (Hispanic
Society 1954, p. 246).

There is little disagreement about the date of execution. Palomino (1724,
p. 106) suggests 1650, immediately preceding the portrait of Innocent X
(Galleria Doria-Pamphili, Rome), writing that "because [Velázquez] wished
to prepare with the exercise of painting a head from life, he painted that of
Juan de Pareja." I question this conclusion, given the fact that the dark tone
of the face of the "moor" has little relation to the florid complexion of the
pope; this view, however, is usually accepted without discussion.

Palomino (p. 128) also offers biographical information about Pareja: "A
native of Seville, mestizo by birth, and of odd color. He was the slave of Don
Diego Velázquez, and although his master (for the honor of art) never al-
lowed him to assist in anything having to do with painting or drawing, but
permitted him only to grind colors and from time to time prime a canvas and
do other chores about the studio and house, he performed these with such skill
that, unbeknownst to his master, and stealing hours while he was sleeping, he
eventually made paintings well worthy of esteem." As I have written else-
where (Gállego 1976, p. 85), the custom of having a slave apprentice was not

unusual; Velázquez's master, Pacheco, had a Turkish slave, and Murillo had one of unknown nationality.

Palomino recounts an interesting, though perhaps apocryphal anecdote. Pareja knew that the king had the habit, when entering Velázquez's studio in the Alcázar, of turning around (or having turned) the paintings lined against the wall, and one day he placed a small painting of his own in that location. Palomino writes: "The moment the king spied it, he went to it.... Instantly Pareja, awaiting just such an opportunity, knelt at his feet and implored him to champion him, for he had learned the art without his master's consent." Philip IV commented to his painter: "We shall speak no more of this, but be advised that any man who has this skill cannot be a slave." Velázquez, who perhaps was well acquainted with his assistant's cunning, placed no obstacle in the way of his manumission. And a grateful Pareja "for the remainder of his years served first Velázquez... and then his daughter, who married Don Juan Bautista del Mazo." Brown (1986) does not refer to this anecdote but, based on a document signed by Velázquez in Rome, cites 1654 as the year of Pareja's emancipation.

According to Palomino, Juan de Pareja was born in Seville and died "in the year 1670, at a little more than sixty years of age." Brown (1986) states that Pareja was born in Antequera and that his birthdate is unknown. When Pareja accompanied his master to Italy in 1650, he would have been about forty, the age he appears to be in the portrait in which his master gave him the proud bearing of an Othello. *The Calling of Saint Matthew*, a large canvas by Pareja, is in the Prado; it is signed "Pareja, 1661," on a piece of paper the painter himself, portrayed full-length, holds in his hand. This portrait made

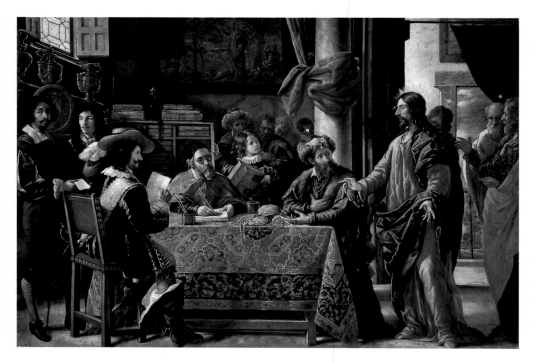

Juan de Pareja. *The Calling of Saint Matthew.*
Museo del Prado, Madrid.

Juan de Pareja. Detail of *The Calling of Saint Matthew.*
Museo del Prado, Madrid.

Detail of pl. 32.

possible the identification of the present portrait, which Velázquez painted some ten years earlier. Not in *Saint Matthew*, *The Flight into Egypt* (Ringling Museum, Sarasota), or in *The Baptism of Christ* (1667; Museo de Huesca), which bears startling similarities to the work of El Greco, does Pareja demonstrate evidence of his master's influence. Unlike Mazo, who successfully imitated Velázquez's technique, Pareja is much more conventionally Italian in style. But according to Palomino, "he had such a singular skill for portraits" that he was confused with Velázquez. If the portrait of the playwright Agustín Moreto (Museo Lázaro Galdiano, Madrid), attributed to Velázquez on the reverse, is by Pareja, as Camón Aznar believes (1978, pp. 390–92), he was indeed a fine portraitist, although more indebted to Murillo than to his master. López Rey records that Pareja went to Madrid with his brother Jusepe about 1630, which would be when he entered Velázquez's workshop, long before the Rome portrait, which López Rey dates somewhere between July 10, 1649, and March 19, 1650.

As I have noted (Gállego 1983, p. 111), Velázquez was initiated into the Congregazione dei Virtuosi al Pantheon on February 13, 1650, and was therefore eligible to show the portrait of Pareja on the following March 19, along

Juan de Pareja (?). *Agustín Moreto*.
Museo Lázaro Galdiano, Madrid.

Juan de Pareja. *The Baptism of Christ.*
Museo de Bellas Artes, Huesca.

with paintings by his fellow members. The portrait was exhibited in the portico of the Pantheon—then the church of Santa Maria de la Rotonda—as was the custom of painters on the feast day of Saint Joseph. According to Palomino, quoting the Fleming Andreas Schmidt, "all else seemed painting, this alone truth." That triumph had been presaged by the admiration of Roman friends to whom Velázquez had sent the painting, with Pareja himself as bearer: "They stood staring at the painted canvas, and then at the original, with admiration and amazement, not knowing which they should address and which would answer them."

The painter and critic Beruete (1898) offered an aesthetic judgment of this portrait that remains valid: "The expressively modeled head, of copper skin tone, stands out about the whiteness of the collar.... The background is green-grey. By the spirit and spontaneity of the portrait, it is obvious that Velázquez...painted it...in a burst of activity." Gudiol (1973, p. 269) "observes a sudden return to the sober palette of the first years, with a preponderance of black," and he is amazed by the precision of a face with such "linear fluidity. Only areas of color, the method of laying on paint with brilliant dragging brushstrokes, sporadically capitalizing on a certain roughness, define the sitter's features."

The almost disdainful nobility of the slave, dressed in lordly fashion in rich Flemish lace collar (forbidden in Spain to freemen and shunned by Philip IV, who favored austere dress), the directness of his gaze, even the baldric, or belt, across the chest, underscore the somewhat militant tempera-

LITERATURE

Mayer 351, Curtis 180, López Rey 517,
Pantorba 98, Gudiol 135, Bardi 106

PROVENANCE

Cardinal Trajano d'Acquaviva
(1694–1747), Rome.

Collection Baranello, Naples, before 1798.

Sir William Hamilton, Naples, by 1798.

Hamilton's sale, Christie's, London, 1801;
sold for 39 guineas.

The second earl of Radnor, Longford
Castle, Salisbury (Wiltshire), by 1811.

The Metropolitan Museum of Art since
1971.

ment so reminiscent of the jealous husband of Shakespeare's Desdemona. This is one of Velázquez's most vital portraits, despite (or perhaps because of) the chromatic simplicity that concentrates all the power in the subject's face.

It is likely, as Pantorba postulates (1955, p. 178), that the Carlisle copy was painted by Pareja under Velázquez's guidance (Rousseau 1971 and Fahy 1971). In addition to this copy (now in the Hispanic Society of America, New York), there is another in the Musée des Beaux-Arts Chéret, Nice.

33

Portrait of a Man (The "Pope's Barber")

Oil on canvas
19 × 17½ in. (48.3 × 44.4 cm.)
Private collection, New York

The first exhibition of this painting, in London in 1909, was in the Grafton Galleries, where it was listed as the property of Sir Edmund Davis of Chilham Castle. In 1936 Mayer included it in his catalogue of Velázquez, classifying it as a post-1646 autograph work and suggesting that the subject might be someone in the court of Innocent X, perhaps a buffoon. After further consideration, he suggested a barber.

In his biography of Velázquez, Palomino (1724) states that, in addition to the portrait of the pope, Velázquez painted the portraits of Cardinal Camillo Astalli Pamphili (Hispanic Society of America, New York); Donna Olimpia Maidachini, sister-in-law of the pope (painting lost); Monsignor Camillo Massimi (Bankes Collection, Wimborne, Dorset), a chamberlain to the pope and a noted painter; Monsignor Cristoforo Segni, the pope's majordomo (a disputed painting in the Kisters collection, Switzerland); Monsignor Michel Angelo, barber to the pope; Ferdinando Brandamo, the pope's first minister; Girolamo Bibaldo; and Flaminia Triunfi, an excellent painter. Palomino cites "other portraits, also, of which I make no mention, for being only sketches, although not lacking in likeness to the original subjects. All these portraits he painted with long brushes and in the vigorous manner of the great Titian, and in no way inferior to his heads." This painting is a finished work, not a sketch.

This portrait generally is accepted as an autograph work. Only Pantorba (1955, p. 235) includes it among "works of unverified authenticity," although he concedes "the admirable pictorial quality—worthy, even, of Velázquez—of this portrait," which he dates about 1649 or in the last decade of the painter's life. I believe the probable date is 1650. Gudiol (1973, p. 282) writes that "the features are strongly outlined by their own shadows, which produces a marked effect of relief. The technique, on the verge of chiaroscuro, is simple, direct, and coherent, rather than dramatic or analytical. The variations of tone and differences of touch in the treatment of the pigment also define the areas of the face, beginning from the darkness of the background, which serves as reference for the values of the eyes, to the sheen of the skin of the forehead. This work, in sum, is one to which the painter contributes everything."

I believe that in this concentration on the features, with the hair, robe, and white collar, sketched in lightly but with great finesse, Velázquez evoked certain portraits of the Venetian school—by Tintoretto and the Bassanos— and of the Spanish school—by El Greco and Tristán. This is an admirable piece, in which an undistinguished physiognomy acquires a hint of nobility and a subtle expression of affable and resigned melancholy. Velázquez's fas-

33

Velázquez. *Cardinal Camillo Astalli Pamphili.*
The Hispanic Society of America, New York.

cination with color was important in the contemporaneous portraits of the pope, a symphony of crimsons (Galleria Doria-Pamphili, Rome); of Camillo Massimi, deep blues; and of Camillo Astalli, luminous roses. By renouncing color here, Velázquez achieved a masterpiece of austerity, paradoxically radiant in its tenebrist environment. It is difficult to believe, as Mayer does, that this could be a fragment of a larger painting. Pantorba himself, before "such a handsome painting...where it might well be said that we feel the breath of the man portrayed," believes that a refusal to accept this as an autograph painting shows an "excess of caution."

López Rey (1968, p. 119) states: "For subtlety in the depiction of human clay, the portrait supposed to be of *Monsignore Michelangelo*, barber to the Pope, is one of Velázquez's outstanding works....As in the portrait of *Pareja*, the background is of a greenish grey lightly brushed in, and the head is also thinly painted, with impasto used for the highlights on the face, the black hair and the edges of the transparent white collar on the black costume. The outlines are broad, and that of the right shoulder is made the more fluid by a stroke of white which, vivid and thick about the neck, thins to a tenuous glimmer as it slopes down. Strong highlights on the forehead, nose, upper lip and neck accent the glints and flecks of impasto which give vivacity to his

LITERATURE

Mayer 463, Curtis 229, López Rey 482, Pantorba 170, Gudiol 139, Bardi 101

PROVENANCE

Sir Edmund Davis, Chilham Castle, England.

Private collection, New York.

features. It is not surprising that, before the identification of the rascally-looking sitter was suggested, he was assumed to be a buffoon, even though he is not clowning, or dwarfish, or otherwise misshapen. Indeed, whatever the nature and ways of the barber to the Pope may have been, Velázquez achieved in this portrait, presumed to be of him, the very image of the earthly—and he did so by just the use of paint and brush."

Brown (1986, p. 297 n. 28) believes that there is no basis for identifying the model "as the Pope's barber, Michel Angelo Augurio, or as any member of the papal court." In any case, the appellation has persisted, with a higher degree of probability than others that have been proposed (Gállego 1983, chapter 7).

María Teresa of Spain

Oil on canvas
17½ × 15¾ in. (44.5 × 40 cm.)
The Metropolitan Museum of Art,
The Jules Bache Collection, 1949 (49.7.43)

This portrait is later than the other belonging to the Metropolitan Museum (Robert Lehman Collection, 1975 [1975.1.147]) in which the daughter of Philip IV and Isabella of Bourbon seems younger than she does here. Pantorba judged this to be the last portrait Velázquez painted of María Teresa, probably around 1654. Bardi, in contrast, thought the date might have been 1651, since the model seems more youthful than in the official portrait "with two watches" (Kunsthistorisches Museum, Vienna), which is dated 1652. Gudiol also gives 1651 as the date of execution. He believes it was painted shortly after the earlier portrait, pointing out that "the face in this canvas is more theatrically treated, with touches of a kind of light rarely used by Velázquez" (1973, pp. 285–86). López Rey gives 1651 or 1652 as the likely date, soon after Velázquez had returned from Italy and some three years after the Lehman portrait was completed. In the Lehman portrait María Teresa must have been about ten, and in the Vienna painting "with two watches"—which this critic dates toward the end of 1652 or the beginning of 1653—a few months past her fifteenth birthday. She appears to be about thirteen in the present painting.

The authenticity of the present painting is generally accepted. It is also generally held that it is a fragment of a larger canvas. López Rey (1978, pp. 42, 154–55) notes additions on all four sides.

In discussing Velázquez's series of royal portraits in the 1650s, Brown (1986, p. 217) comments: "Less than twenty works are known to have been painted by him in the last eight-and-a-half years of his life, of which only fourteen still survive, mostly portraits of the royal family. The substantial increase in the production of royal portraits by Velázquez and his workshop was motivated principally by the second marriage of the king to his niece, Mariana of Austria, in 1649. The arrival of the queen and the birth of two children, Margarita and Felipe Próspero, provided new subjects for Velázquez' brush. Also, pictures were needed of the infanta María Teresa, then reaching marriageable age and thus of interest to princely suitors, who were eager to judge her appearance."

Justi (in successive German editions and in the Spanish edition of 1953) emphasizes the diplomatic purposes to which the many portraits of Velázquez's later years were put: Specifically, paintings were sent to Vienna and Brussels, as well as to Paris, to facilitate the marriages of the children of the Spanish king with other members of European royalty. Brown reports that despite hostilities between France and Spain, Cardinal Mazarin requested a portrait

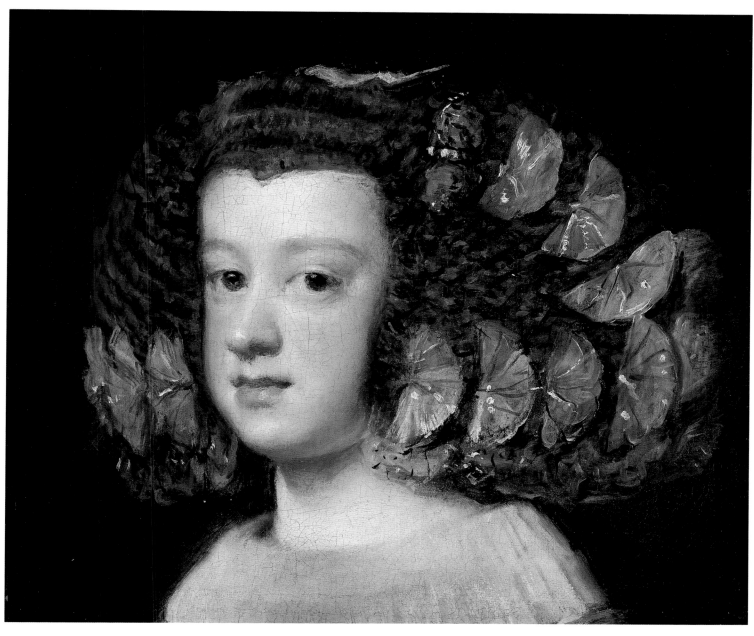

34

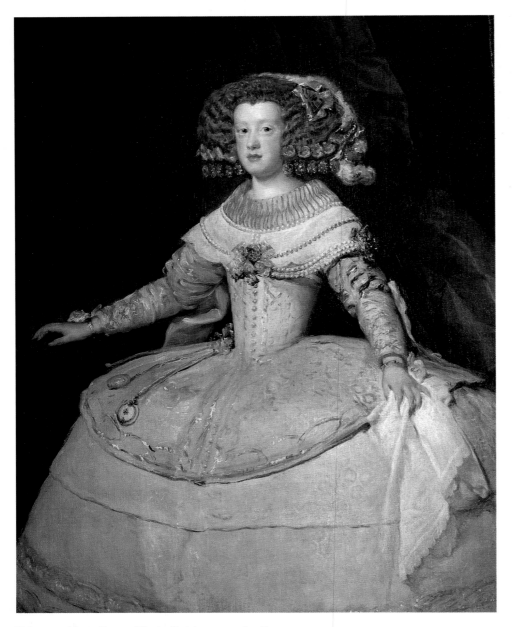

Veláquez. *Maria Teresa of Spain* ("with two watches").
Kunsthistorisches Museum, Vienna.

of María Teresa with a view to her marriage with the future Sun King—a marriage that in fact would later take place. Archduke Leopold William was also a suitor for the hand of the infanta. Numerous requests for portraits arrived from Paris, in part owing to Anne of Austria, sister of Philip IV and queen of France. As Brown (1986, p. 217) remarks, "the dove of peace, it seems, was now in the air, carrying portraits instead of an olive branch."

The number of portraits demanded and the low compensation paid for them explain the frequent involvement of Velázquez's workshop in these pieces. For the present portrait, which was sent to France, Velázquez was paid only five hundred reales. A workshop replica would achieve the object of most of

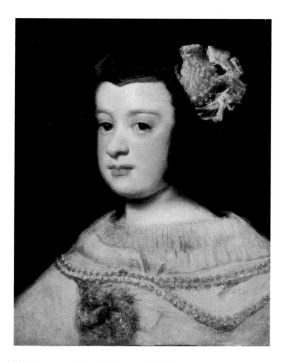

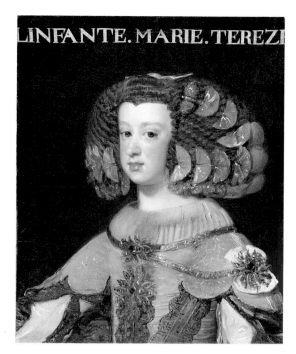

Velázquez. *María Teresa of Spain.*
The Metropolitan Museum of Art,
Robert Lehman Collection.

Workshop of Velázquez. *María Teresa of Spain.*
Philadelphia Museum of Art,
John G. Johnson Collection.

LITERATURE

Mayer 521, Curtis 249, López Rey 385,
Pantorba 107, Gudiol 145, Bardi 109

PROVENANCE

Collection Ledieu, Paris, 1833, catalogued
by Curtis.

Colonel Payne Bingham, New York, after
1899.

Duveen Brothers, New York, 1918.

Jules S. Bache, New York, from 1928.

The Metropolitan Museum of Art since
1949.

these portrait commissions—to allow a sovereign to view the features of a
potential bride—as well as an autograph work could.

In this beautiful head the infanta, with modesty and reserve, does not
meet the viewer's gaze. This demeanor suggests that this painting preceded
the portrait "with the two watches," in which María Teresa, with a regal air,
looks straight at the viewer. The girl's coiffure is both original and delightful.
She has arranged in her crimped hair (or wig) a series of ribbons or sheer
cloth adornments in the form of butterflies. Pantorba (1955, p. 188) wonders,
"Given this complicated and ornate hair arrangement, what would an artist
with fewer technical resources than the master have done? Despite all the
challenges, the head is saved by the virtue of the Velázquez brush, skilled, as
none other, in deftness and grace."

Two other versions with this coiffure, which are replicas or copies, are
reproduced by Bardi (1969, 109-A and 109-B). The most interesting
(Philadelphia Museum of Art) bears the French inscription "*LINFANTE MARIE
TEREZE*" (similar to the one that until a few years ago was found on the
Louvre portrait of the infanta Margarita), which suggests that it may have
belonged to the French royal family. Interestingly, part of the bust and arms
of the subject are visible in this copy, indicating that it was painted before the
original was trimmed.

Queen Mariana

Oil on canvas
91 × 51⅝ in. (231 × 131 cm.)
Museo del Prado, no. 1191

This portrait is one of the best of the painter's last decade. It had to be painted after his second journey to Rome (1649–51), since before his departure the new queen had not yet arrived in Madrid. In 1651 she was unwell following her first confinement, and therefore apart from stylistic considerations, datings must begin with 1652. The Prado catalogue gives 1652–53, with which López Rey and Pantorba agree. Gudiol gives 1652, as do Brown (1986, p. 218) and Bardi. A replica (Musée du Louvre [formerly Museo del Prado, no. 1190]) was sent to Vienna in 1653, bracketing the dates still more closely. Pantorba assigns the number 108 in his catalogue to the portrait of Philip IV in armor with a lion at his feet (Museo del Prado, no. 1219)—an

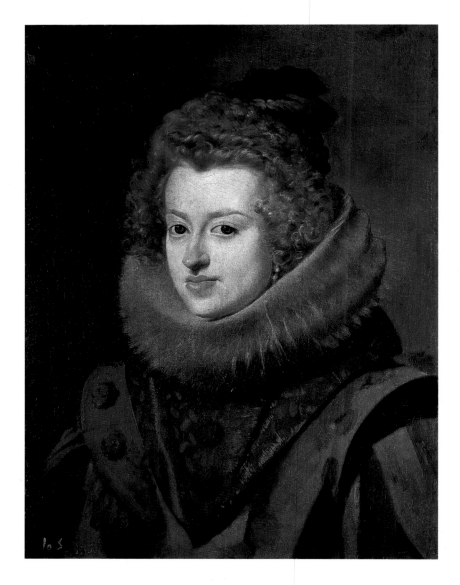

Velázquez, *The Infanta María, Queen of Hungary.*
Museo del Prado, Madrid.

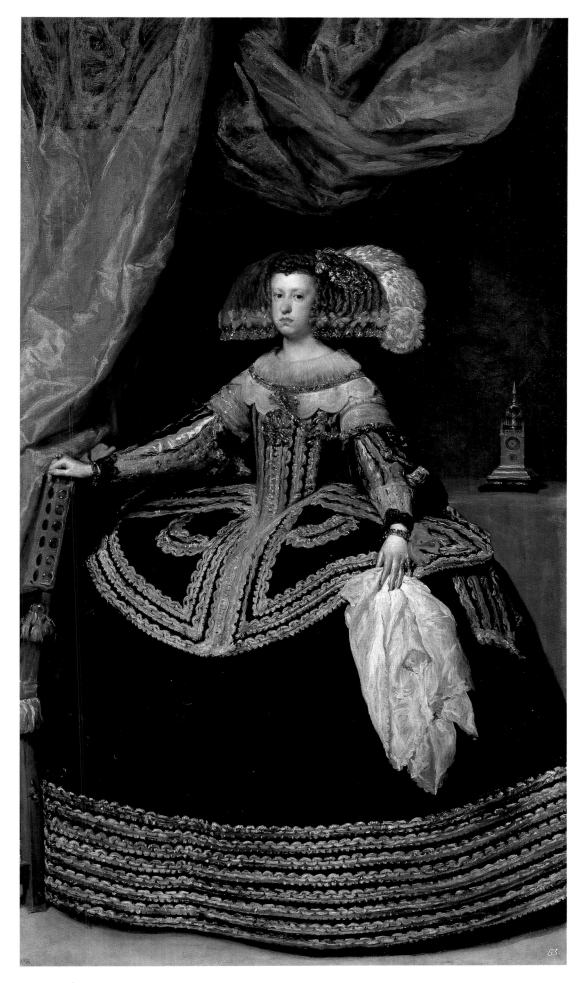

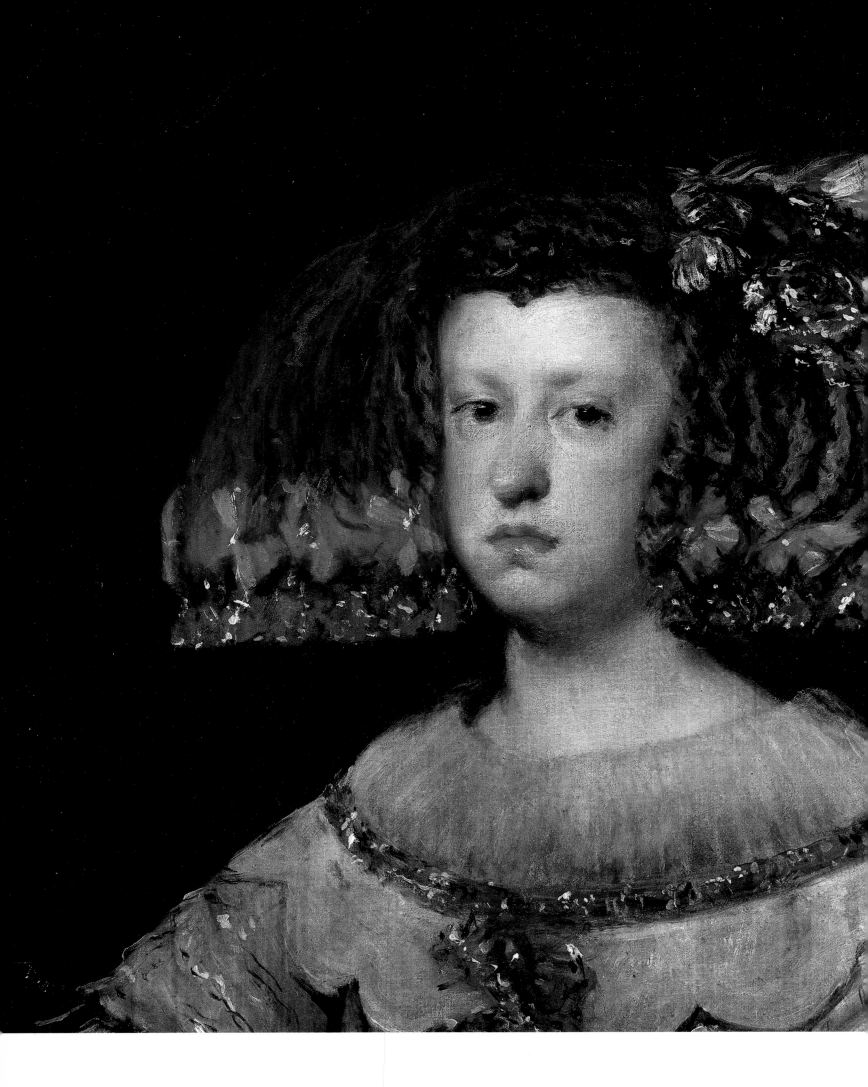

Detail of pl. 35.

"unfinished picture [that] would have been painted between 1652 and 1654 [and that] makes a perfect pair with the next portrait, of the queen, with the same dimensions" (p. 189). The Prado catalogue lists this portrait of the king as painted about 1653, noting that it was paired with the present painting at El Escorial. (It is curious that the king's portrait was left unfinished ["The lion is hardly more than sketched," according to the catalogue]). The works came to the Prado together, where eventually they were hung as pendants. Both appear to have been augmented at the top with a red hanging. A recent cleaning of the present painting revealed a strip on the left side, which was added by Velázquez and on which he painted the queen's right hand.

Doña Mariana of Austria, daughter of the emperor Ferdinand III and of Philip IV's sister María of Hungary, was born in Neustadt on December 21, 1634, and was to have married Prince Baltasar Carlos, her first cousin. But when he died in 1646, her uncle Philip IV, whose queen, Isabella of Bourbon, had died two years earlier, decided to marry Mariana; despite the great difference in their ages (the king, born in 1605, was over forty; his bride was under fifteen) and their close consanguinity, he decided on this course to preserve Habsburg hegemony in Europe. The marriage was solemnized by proxy on October 7, 1649, and was consummated upon the arrival of the new queen in Madrid. Their daughter, Infanta Margarita, was portrayed many times by Velázquez (pl. 37) and was the central figure of *Las Meninas*. She was born in 1651 and afterward became empress of Austria. A son, Prince Felipe Próspero, born in 1657, is the subject of the most moving of Velázquez's portraits (Kunsthistorisches Museum, Vienna; pl. 40); he died in childhood. The crown passed to Prince Carlos, born 1661, when his father Philip IV died in 1665. Doña Mariana was regent until 1675; she is portrayed in mourning dress in several portraits by Mazo and by Carreño. She died on May 16, 1696. These later portraits present a powerful but somber image of Doña Mariana, appropriate to her widowhood but not to her early years in Madrid. As I have remarked (Gallégo 1983, p. 118), "we need not suppose that she was so sad. . . . In 1652 Mariana was cheerful, fond of luxury and diversion. In 1657, on the occasion of her lord's birthday, Mariana spent no less than four thousand ducats on apparel of *imitation* gold and silver, lest people say she was spending so much in such hard times. . . . In July of the same year, the king and queen launched a galley on the pool at El Retiro, with a crew of Tritons and Nereids. The ostentatious marquis of Heliche [i.e., the duke of Medina de los Torres] organized revels of unbelievable extravagance and expense; *les plaisirs de l'île enchantée* at Versailles were in emulation of these sumptuous festivals at Madrid."

At the same time rigorous court ceremonial oppressed Mariana's spirits. The lady of the chamber would rebuke her for laughing at the antics of the buffoons. Her regency was embittered by a preoccupation with securing the male succession, in a family whose boys tended to be sickly, against the partisans of Don Juan of Austria (an illegitimate son of Philip IV).

In this marvelous portrait Doña Mariana wears a costume of black and silver, which Velázquez enlivens with the reds of the bows at her wrists and in

her peruke, the plumes of the headdress, the velvet of the table cover, and the great portière that marks the royal station of this plain young woman. Her face is excessively made up, but her hands are fine and aristocratic: The right rests on the back of the chair that is her prerogative as queen, while the left, carelessly elegant, holds the enormous handkerchief that was part of fashionable court dress. A gilt clock, in the shape of a tower, stands on the "table of justice," which is draped in magnificent scarlet; these elements emphasize this queen's character, punctilious in her duties and dispensing her mercies *en punto*, "to a nicety" (on this symbolism, see Gállego 1968, pp. 213–19).

There is unsurpassed pictorial beauty in the rather muted harmony of grays, reds, bluish blacks, and golden yellows. The handkerchief with its ample folds is worthy of El Greco, and the hand that holds it is painted with astonishing freedom, in great strokes of white, pink, and black. The peruke (later retouched, according to Brown) is brown, gray, and pink. The golden jewels twinkle on the silver-gray brocade and braiding. The silhouette, graceful and commanding, recalls the strength of the early "gray period" royal portraits and is framed in a symphony of color harmony that Manet might envy. The picture suffers from the addition of the upper drapery, which dimin-

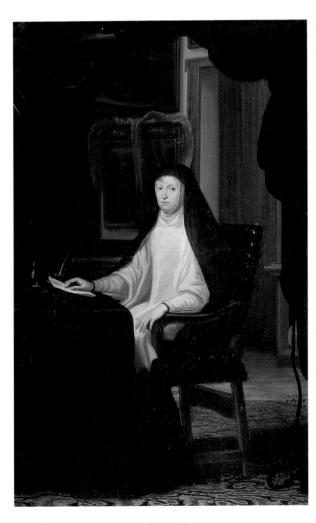

Juan Carreño de Miranda. *Queen Mariana.*
Museo del Prado, Madrid.

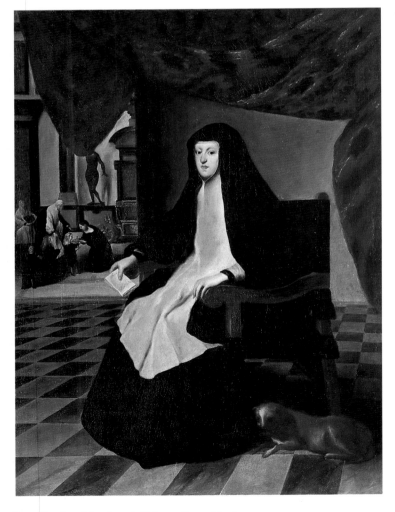

Juan Bautista Martínez del Mazo. *Queen Mariana.*
Museo del Greco, Toledo.

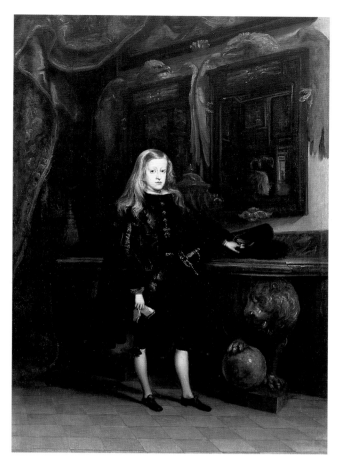

Juan Carreño de Miranda. *Charles II of Spain*.
Museo de Bellas Artes, Oviedo.

LITERATURE

Mayer 484, Curtis 237, López Rey 355,
Gudiol 147, Pantorba 109, Bardi 110

PROVENANCE

El Escorial in 1700, inventories of 1746,
1771, and 1794.

Museo del Prado since 1845.

ishes the queen's tall stature. The brushwork is so free (those "distant patches" admired by Quevedo) that only so sophisticated an amateur as Philip IV could have allowed it; Louis XIV would have demanded more "finish." The pose too has that grand simplicity so characteristic of Velázquez; there is no hint of affectation—everything is natural yet majestic. As I have remarked (Gállego 1983, pp. 117–18), "everything in this great canvas interests us as much as, or more than, does the face. In outfitting the human figure with all this paraphernalia, Velázquez returns to the egalitarian concept of his Sevillian still lifes. More than three centuries before Cézanne, he seems not to believe in any absolute that would relegate a handkerchief to a lesser category than the human countenance. Thus, with his customary discretion—preserving the traditional scheme of the Habsburg portrait—this gentleman of the chamber destroys the very principle of portraiture, the half-divine superiority of a being of royal blood over other beings, of a human being over things not human."

Related portraits—other than that in the Louvre (which Justi and Madrazo prefer to that in the Prado)—are those in Vienna, Sarasota, Kansas City, Lisbon, Madrid (Academia de San Fernando), New York (Metropolitan Museum), Dallas, and Lugano, as well as the Prado's *Orante* (no. 1222).

Queen Mariana

Oil on canvas
18⅛ × 16⅞ in. (46 × 43 cm.)
Meadows Museum, Southern Methodist University,
Dallas, no. 78–01

This bust of Queen Mariana is one of a series related to the Prado full-length portrait (pl. 35). In all the portraits of the queen produced in Velázquez's workshop, her head is in the same position, but the style of her coiffure does undergo some changes. Brown (1986, pp. 221–22) believes that some years after the full-length portrait, "Velázquez had to revise the image of the queen to take account of the introduction of a new style of wig in which the hair is worn in waves rather than ringlets and surmounted by an ostrich feather." The new, waved wig is trimmed with what appear to be glass pearls, which have replaced the red-ribbon rosettes. The white plume emphasizes this greater severity. The features and the rouged cheeks, however, are so unmarked by the passage of time that they give credence to the theory that the queen did not pose again. Brown (1986, p. 222) believes that "judging from a workshop picture [*Mariana of Austria*, Ringling Museum, Sarasota], the new appearance of the queen was meant to be grafted onto the earlier composition, thus efficiently saving Velázquez the trouble of inventing a fresh image."

López Rey (who in his 1979 catalogue included the present painting with no. 125) states that its conservation history indicates old retouching on the lower edge of the gorget. In Mayer's opinion this head is a study related to the portrait of the queen in the Collection Thyssen-Bornemisza, Lugano (López Rey, no. 365), a hypothesis Bardi adopted. Lafuente Ferrari accepts this Dallas head as an autograph work. Pantorba includes it (no. 182) among unauthenticated works, arguing that the Lugano portrait (no. 115) was the model for this and other old copies. Sánchez Cantón does not address the question. Camón Aznar cites the Lugano portrait as the standard for these busts, although he questions whether it is an original by the master or a workshop or student copy—which is what MacLaren believes. Of the many copies, "it is agreed that the original by Velázquez is the one in the collection of Baron Rothschild in Paris, a painting that Lázaro Galdiano judged magnificent" (Camón Aznar 1964, pp. 801–807).

Among the cited examples, the best known is the Lugano bust, with the new hair treatment and with dress, gorget, and jeweled accessories different from those of the full-length Prado painting. Also well known is the similar painting in the Real Academia de San Fernando, Madrid, a companion to the bust of Philip IV in the same museum. Both were acquired in 1795, and both are declared autograph paintings in the recent museum guide (Azcárate

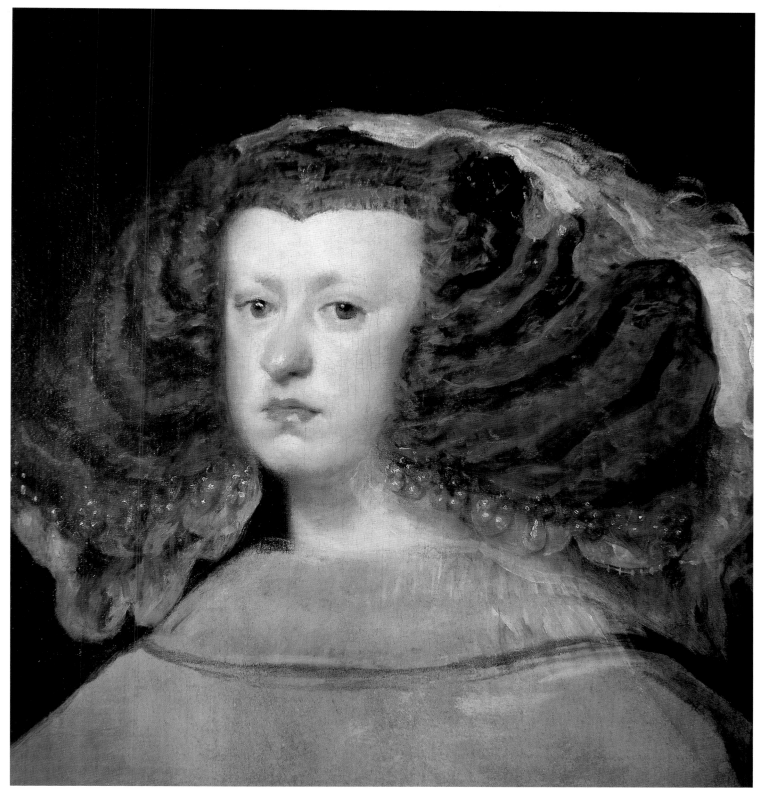

1988, pp. 56–57). Camón Aznar, however, assigns this painting to the Velázquez workshop (1964, p. 804). He also points out that a different copy, now in the Museo Romántico, Madrid, could be the work of Mazo, as could the painting in the Rasch collection, Stockholm.

Also related to the full-length Prado portrait are the bust in the Hispanic Society of America, New York (Bardi, no. 118–C); the bust in the Museu Nacional, Lisbon; and the half-length figure in The Metropolitan Museum of Art (Bardi, no. 118–D), which Camón Aznar considers a work of the Velázquez

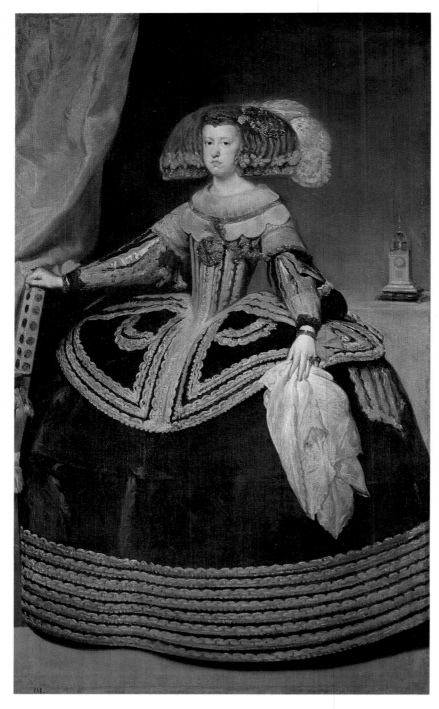

Velázquez. *Queen Mariana*.
Musée du Louvre, Paris.

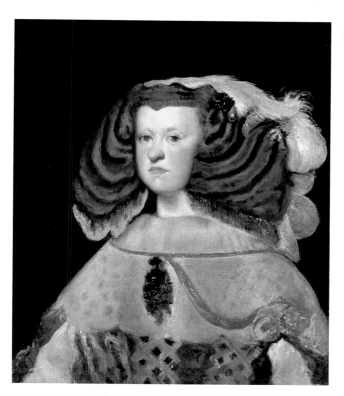

Velázquez. *Queen Mariana.*
Collection Thyssen-Bornemisza,
Lugano.

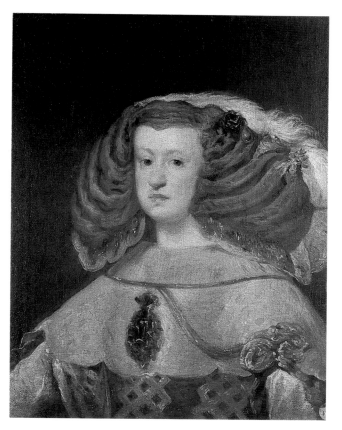

Velázquez. *Queen Mariana.*
Real Academia de Bellas Artes
de San Fernando, Madrid.

LITERATURE

Mayer 493, López Rey 364, Pantorba 182,
Gudiol 161, Bardi 118-A

PROVENANCE

Wildenstein and Co., Paris, before 1925.

Acquired by Baron Maurice de Rothschild
in 1925; in the collection of his heirs until 1978.

Meadows Museum since 1978.

workshop (1964, p. 805). He also reproduces as a workshop painting (p. 802) a bust in the Musée des Beaux-Arts, Pau, with a new coiffure resembling that usually worn by the infanta Margarita. Pantorba, referring to the Lugano painting, which he considers authentic (1955, no. 195, p. 115), presents a series of works related to it, although he numbers only the one exhibited here, with the qualification that he cannot confirm its authenticity in the absence of a personal analysis.

Allende-Salazar (1925, p. 286) thinks the present head could have been a study for a dual portrait of the king and queen reflected in the mirror in the background of *Las Meninas*, but scholars are unsure whether that mirror reflects the king and queen themselves or a painting (no dual portrait exists today).

The Infanta Margarita

Oil on canvas
50⅝ × 39⅜ in. (128.5 × 100 cm.)
Kunsthistorisches Museum, Vienna, no. 321

The scholars are close to agreement about the date of this marvelous por-
trait: 1653, according to López Rey, Gudiol, and Brown, while Bardi and
Pantorba lean toward 1654. We are indebted to Justi for his firm identification
of the subject, long considered to be the infanta María Teresa (Stirling [1848]
first proposed this identification, which was also affirmed by Curtis [1883]).
Margarita had been confused with her step-sister because she also bore the
name Teresa (Margarita Teresa), which came into vogue with the Spanish
devotion to Saint Teresa of Ávila.

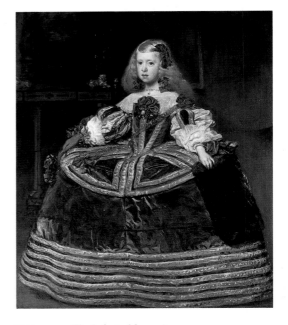

Velázquez. *The Infanta Margarita.*
Kunsthistorisches Museum, Vienna.

The daughter of Philip IV and his second wife, Mariana of Austria,
Margarita was born on July 12, 1651, and appears to be two to three years old
in the present portrait. Velázquez painted five known portraits of the infanta,
the first being this one from Vienna and the last that in the Prado (no. 1192);
the latter is thought to be the artist's final work, and it was completed by his
pupil and son-in-law, Mazo, after his death in 1660.

The Kunsthistorisches Museum has a rich collection of portraits of
the Spanish royal children. One of a girl in a light dress is similar to and
contemporaneous with the central figure in *Las Meninas* (Museo del Prado,
no. 1174), dated 1656, and another, from 1659, wears a blue dress and sable
muff. Also in the museum are a portrait of the infanta María Teresa (contem-
poraneous with or somewhat earlier than the present painting), which is known
as the "infanta with two watches," and portraits of the princes Baltasar Car-
los (1640) and Felipe Próspero (1659). All of these were sent by Philip IV to
his Austrian cousins to prepare the way for Habsburg dynastic marriages.
The two princes, however, died before reaching manhood and never married
their cousins. The infanta Margarita would become the empress of Austria
on her marriage to the emperor Leopold on December 12, 1666. She
died on March 12, 1673, and lies in the imperial crypt in Vienna.

In Velázquez's portraits of the infanta Margarita, she appears to have a
pleasing, vivacious temperament. In *Las Meninas* this charming invader, with
her small retinue of young ladies (*meninas*) and dwarfs, has moved into the
artist's studio. Without being beautiful (neither her father nor mother was
handsome, at least to our twentieth-century eyes), she is winsome and enchant-
ing and has an elegant simplicity.

This painting, one of Velázquez's finest, is the most attractive of his por-
traits of the infanta. Margarita stands, apparently on a dais covered with a
black-and-red carpet. Her right hand rests on a small table, which is covered
with a silky blue-green cloth. The glass vase, holding roses, irises, and small
daisies, is executed with a remarkable freedom of style; a rose, somewhat

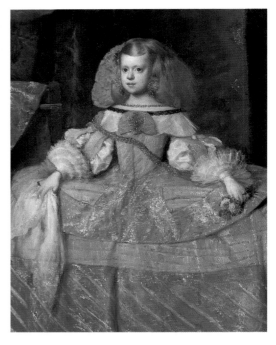

Velázquez. Detail of *The Infanta Margarita.*
Museo del Prado, Madrid.

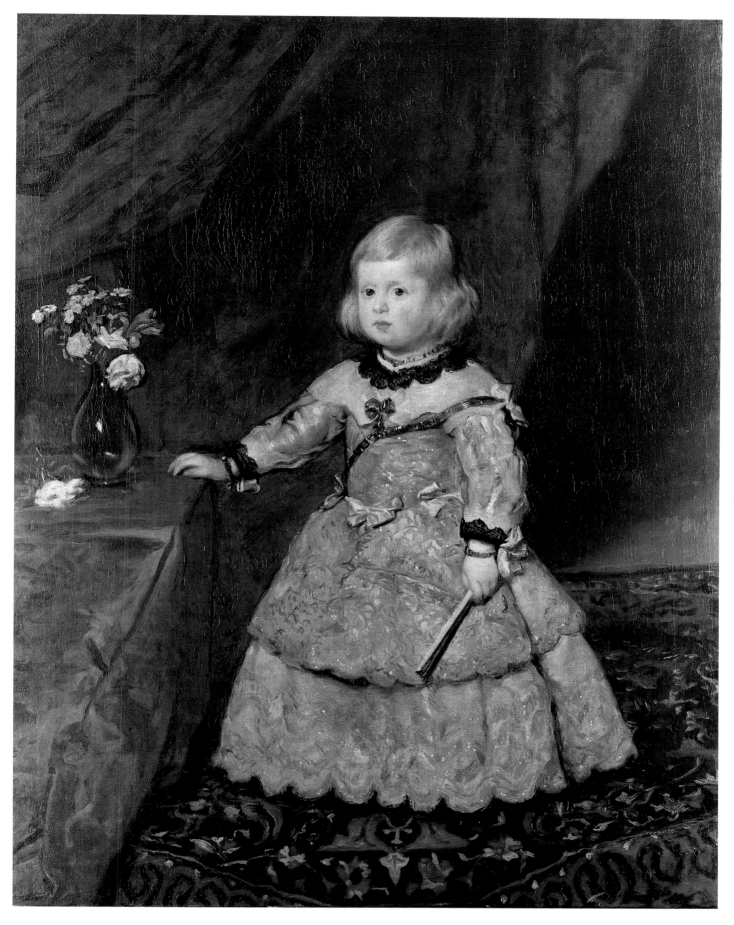

LITERATURE

Mayer 524, Curtis 253, López Rey 394, Pantorba 111, Gudiol 152, Bardi 113

PROVENANCE

In all probability, a gift from Philip IV to the court of Vienna.

In 1816 at the Imperial Gallery, Vienna, whence it passed to the Kunsthistorisches Museum.

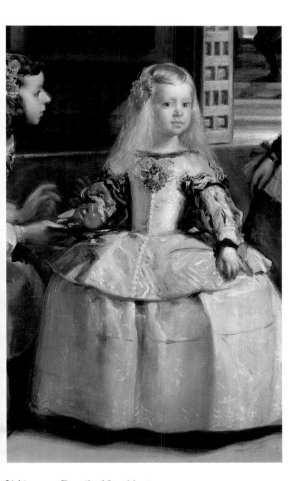

Velázquez. Detail of *Las Meninas*.
Museo del Prado, Madrid.

faded, has fallen to the table. A large dark green curtain frames her still baby-like head with its iridescent skin, plump cheeks, and chubby, firmly closed mouth; her dark eyes have a rather distant expression. The dress is splendid—salmon pink cloth and silver brocade, with black lace collar and cuffs. She wears a gold necklace and brooch, and a gold chain is worn across her chest like a bandoleer in the fashion of the time. Everything in this portrait affectionately underscores the contrast between the majestic conventions of a royal portrait and the charming innocence of a little girl. She wears bows at her wrists and waist, like her mother (pl. 35), but not in her very simply styled hair.

This picture's delicate color harmony is a delight of nimble technique. Before the wall's dark background, the curtain and the pleats of the table-cloth trace a diagonal pattern, which highlights the luminous figure of the girl, offset by the horizontals of table and dais. The flared skirt—*de aceitera* (like a cruet)—emphasizes the background diagonal on the left and contradicts it on the right. The bouquet may have symbolic significance—the roses and irises are royal flowers—or it may be an analogue of the sitter, who herself rather resembles a flower. (In Spanish *margarita* means "daisy.") The vase itself is remarkably bright and transparent, an effect achieved with just a few brushstrokes.

A very fine replica of this portrait is in the Palacio de Lirio, home of the dukes of Alba, Madrid, and is considered by many an autograph copy (Gudiol, no. 153). According to Sánchez Cantón, it was painted from life, in preparation for the final portrait in Vienna. Camón Aznar (1964, p. 822) thinks certain aspects of the costume warrant attributing it to the master, even though head and hands are more carelessly executed. In the opinion of Justi, Beruete, Mayer, Allende-Salazar, and Lafuente Ferrari, it is not by Velázquez but is a copy by Mazo. This canvas omits the vase with flowers in the Vienna painting, and it is slightly smaller. In any event, it is a beautiful painting which, if by Mazo, would prove his assimilation of the style of his master and father-in-law.

Philip IV

Oil on canvas
25¼ × 28⅛ in. (64.1 × 53.7 cm.)
National Gallery, London, no. 745

This portrait of the king of Spain is one of the last that Velázquez painted of him; in Gudiol's opinion (1973, p. 292) it is the final one. It is often compared with no. 1185 in the Museo del Prado, executed between 1655 and 1660, according to the catalogue, which places it earlier than the London portrait. Unlike the Prado portrait, the present work shows Philip IV wearing a gold chain with the Golden Fleece. Here there are gilded buttons on his

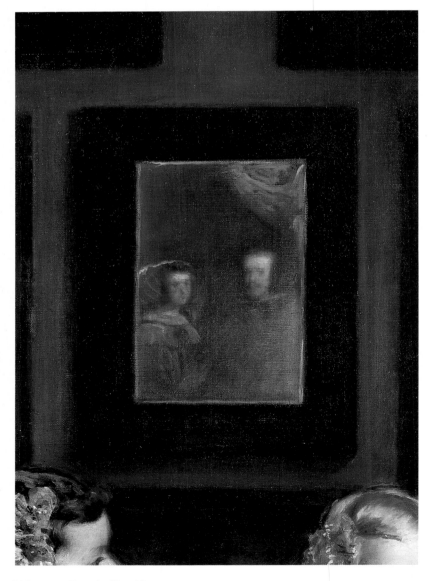

Velázquez. Detail of *Las Meninas*.
Museo del Prado, Madrid.

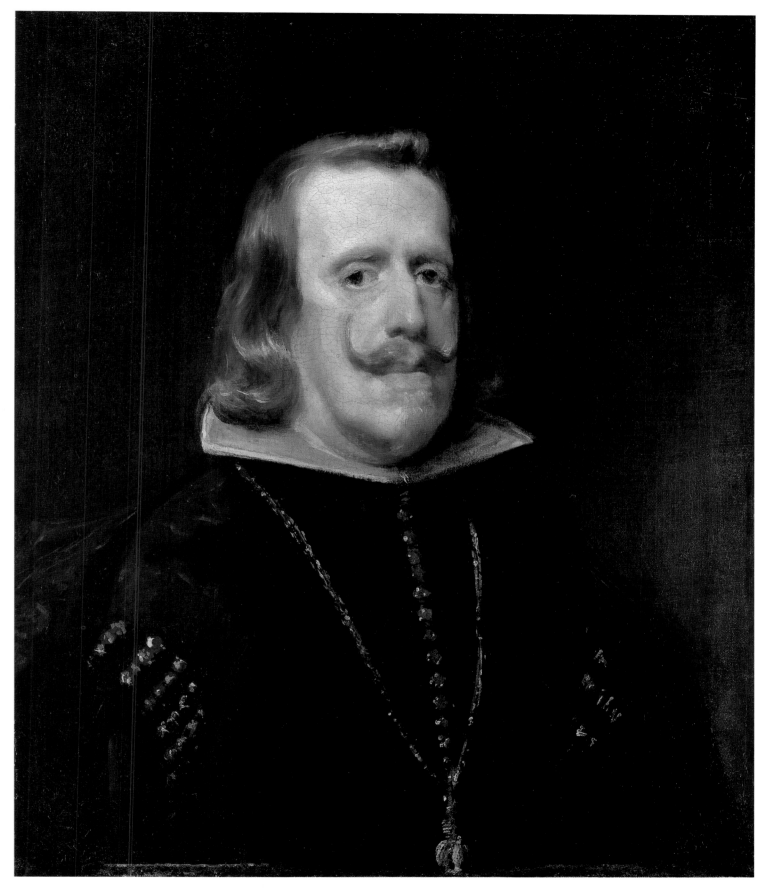

38

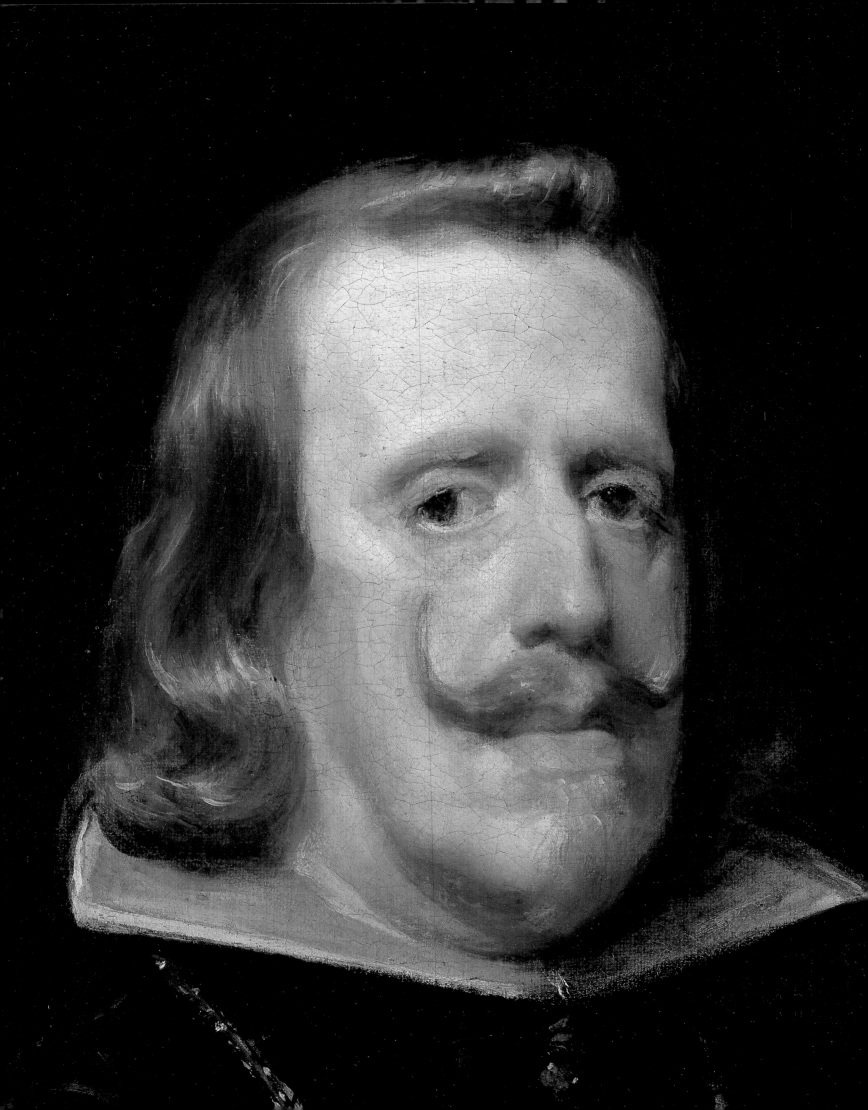

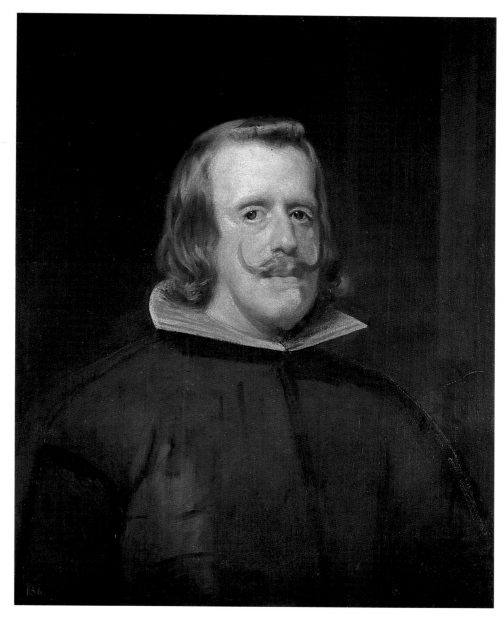

Velázquez. *Philip IV.*
Museo del Prado, Madrid.

costume, and embroidery on his sleeves; the cloth (wool or velvet) is a dull
black, whereas in the Prado picture the material has a silky sheen. The heads
are similar, and each is set off by the same ruff, with some pentimenti in the
London portrait. According to MacLaren (1952, pp. 66–70) there has been
some erosion of the dark parts of the ruff, as well as of the long blond locks
on the left and the background on the right. Having compared its dimensions
to those of the copies, he also suggests that the canvas might have been
trimmed on the left.

In Pantorba's opinion these two portraits are the only remaining busts of
all those Velázquez painted of the king. Both are originals, not copies of each
other, since in the Prado portrait Philip IV looks two or three years younger

than he does in the London picture. The subject is about fifty years of age, and the date of those pictures can be placed around 1656, the year Velázquez painted *Las Meninas*, in which a double portrait of Philip IV and Mariana of Austria appears in a mirror in the background. Their positions (he on the right, she on the left) are a reversal of their actual portraits, thus supporting the hypothesis that the mirror reflects their likenesses, not the models themselves. The London portrait is also reversed in the excellent engraving that Pedro de Villafranca executed of this painting as the frontispiece for the *Descripción breve de San Lorenzo el Real de El Escorial.* But Trapier (1948, p. 333) thinks that, given some slight differences, the print records a lost portrait. The 1946–47 cleaning of the canvas revealed, according to MacLaren, that "while the head is certainly by Velázquez, the dress and chain are by an assistant." This critic says that only three of the numerous copies of these portraits follow the Prado work, whereas twenty repeat the one in the National Gallery. MacLaren dates the London picture to 1657.

Pantorba reasons that, because the painting in the National Gallery is more finished, the London portrait was not "daubed" directly from life but was modeled after the Prado painting. Camón Aznar (1964, p. 795), on the other hand, thinks it is doubtful that the London painting is an original Velázquez. Armstrong believes the opposite. In both works, however, the technique is masterfully simple.

Philip IV ascended the throne in 1621. Velázquez's first portrait of the king, according to Pacheco, was painted in August 1623. The present one is possibly the last, circa 1656–57. For almost a quarter of a century we can follow the effects of aging on the regal features; there is an expression of weariness and a certain sadness in the last portraits, executed when political problems in the peninsula and the rest of Europe, as well as in the Indies, were multiplying. Jerónimo de Barrionuevo relates in his *Avisos* (November 8, 1656) that, around the time of this portrait, the king visited the pantheon of his ancestors at El Escorial and spent two hours there, alone on his knees, "beside the crypt where he was to be interred. He came out with his eyes bloodshot and puffed from weeping.... He was heard to say that now is the time to put his affairs in order and look inward," for the eternal salvation of his soul (Gállego 1983, pp. 121–22). Barrionuevo attributes these words to him: "Truly, I am so troubled that I wish to die, for who can live with what befalls me each day, contriving so poorly that everything goes amiss?"

Nevertheless, as I have noted (op. cit.), Velázquez was reluctant to express those disappointments on the monarch's face: The king has to maintain his distance, his mythological serenity. All these factors help us understand his distant and rather weary expression in the last portraits of him by Velázquez, who was always true to his art though respectful of his royal patron.

The best-known copies of this portrait are those in Vienna (Pantorba, nos. 175 and 176) and Cincinnati (Pantorba, no. 177); other important copies are in the Pinacoteca, Turin; the Hermitage, Leningrad; the Louvre; the Glasgow Museum; the Academia de San Fernando, Madrid; the Instituto de Valencia de Don Juan, Madrid; and the former Huth collection, London.

Pedro de Villafranca. *Philip IV*, from *Descripción... de El Escorial* (1657).

LITERATURE

Mayer 247, Curtis 123, López Rey 273, Pantorba 174, Gudiol 163, Bardi 115–D

PROVENANCE

In 1862–64 in the convent of San Donato, Florence, in the collection of the Russian prince Anatole Demidoff, who died in 1870. The collection was initiated by his father in 1814, which makes it likely that the portrait left Spain after the War of Independence.

Sold in Paris by Emmanuel Sano in June 1865 to the National Gallery, London, together with a Ruysdael landscape, for £1,200.

National Gallery, London, since 1865.

Mayer reports (nos. 248, 249, 250, 251a, 252, 259, and 260) a large number of busts of Philip IV derived from the painting at the National Gallery, London. MacLaren provides an enormous list of copies and versions of this work, pointing out that "they vary greatly in quality and many are very poor, some being obviously pastiches of later date" and that this list is far from complete. The copies in Edinburgh, Geneva, and Madrid (Academia de San Fernando) are accompanied by busts of Queen Mariana, forming pairs (for further information, see MacLaren and Pantorba).

39

Mercury and Argus

Oil on canvas
Originally 32⅝ × 97⅝ in. (83 × 248 cm.);
 now, with added strips, 50 × 97⅝ in. (127 × 248 cm.)
Museo del Prado, Madrid, no. 1175

NOT IN EXHIBITION

Almost all scholars place this work in the last years of Velázquez's life, usually in 1659. It is thus his final multifigured painting, contemporary with the portraits of Prince Felipe Próspero (no. 40) and of the infanta Margarita in blue and silver (Kunsthistorisches Museum, Vienna). The very last portrait— the infanta in pink and silver (Museo del Prado)—was left unfinished at Velázquez's death and was completed in 1662–64 by his student and son-in-law, Mazo. Camón Aznar (1964, pp. 488ff.), however, believes that *Mercury and Argus* was painted between the Sevillian's arrival in Madrid in 1623 and 1634. Noting that he has "always been surprised at such an absolute difference in tonality between this work and the paintings of Velázquez's last years," Camón argues that "this painting is characterized by the palette typical of his Roman period and even admits the tradition of his gray Madrid phase," with "a grayed ocher tonality that corresponds to a period no later than 1634." Trapier (1948, pp. 361ff.), expressing the position of most critics and of the Prado catalogue, establishes a date in the late 1650s. She discusses two events: first, the arrival in Madrid, in October 1659, of the marshal-duke of Gramont, who came on behalf of Louis XIV to ask for the hand of the infanta María Teresa; and, second, in relation to that visit, the decoration of the Hall of Mirrors in the Alcázar, Madrid, for which Velázquez painted four paintings on mythological themes: *Venus and Adonis, Psyche and Cupid, Apollo and Marsyas,* and the present painting. The first three—whose titles alone are the stuff of dreams—were destroyed in the 1734 fire in the Alcázar. This was a dark day for Spanish painting but an auspicious one for architecture, since it gave rise to the construction of the Palacio Nuevo, one of the grandest buildings of its kind in Europe. The Alcázar had never been a satisfactory royal residence, despite the efforts Velázquez and others had made in creating great ceremonial spaces—for example, the celebrated Octagonal Room and the Hall of Mirrors. Brown (1986, pp. 241ff.) discusses Philip IV's renowned collections and notes the masterpieces that were hung in the Hall of Mirrors (among them works by Rubens, Van Dyck, Domenichino, Tintoretto, Leandro Bassano, Ribera, Orazio Gentileschi, and Velázquez).

 Mercury and Argus was damaged in the 1734 fire, and strips were therefore added to its top and bottom. This canvas was a pendant to *Apollo and Marsyas*; they were installed above a pair of windows, which explains their unusual longitudinal format. The varnish was darkened in the fire, and Gudiol was of the conviction that "an adequate cleaning would restore the canvas to

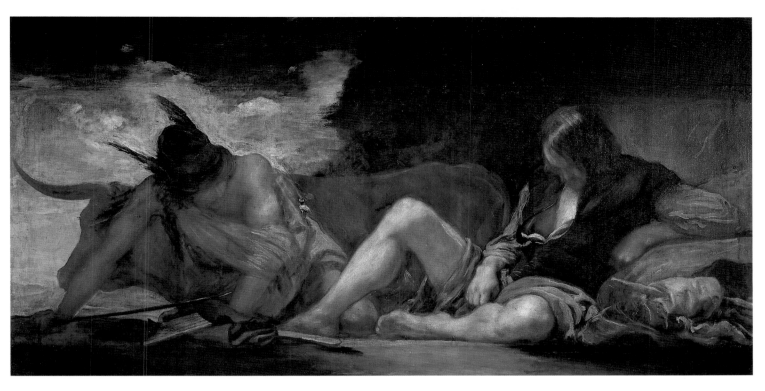

39

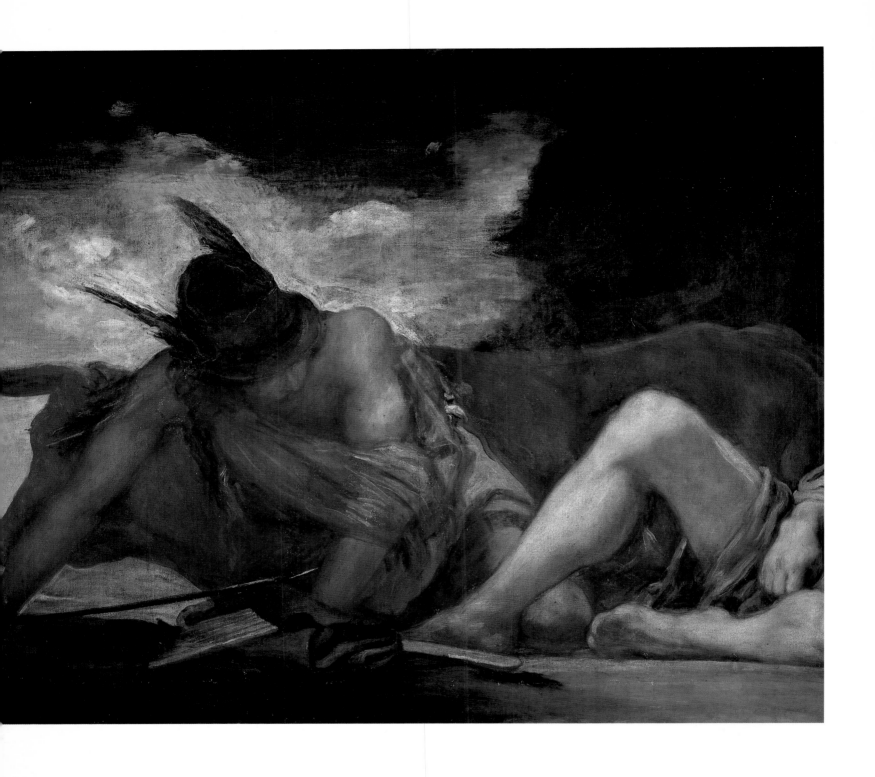

Details of pl. 39.

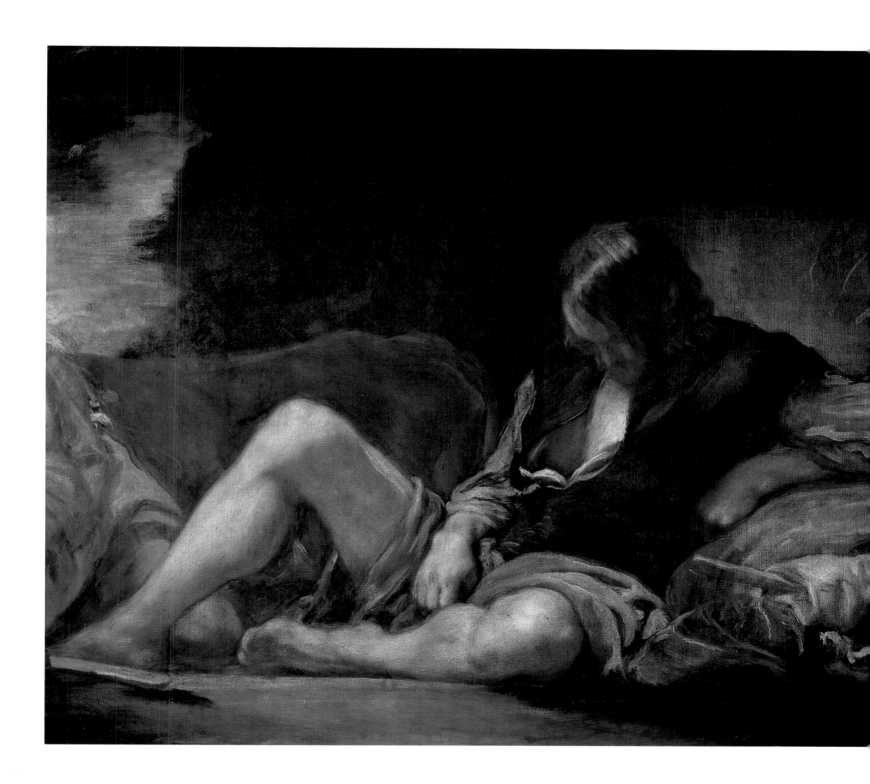

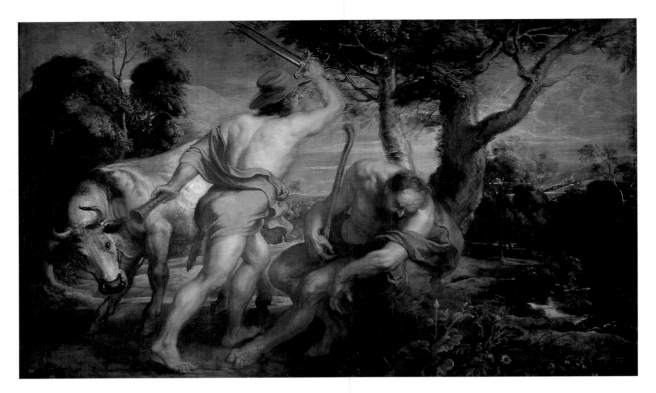

Peter Paul Rubens. *Mercury and Argus.*
Museo del Prado, Madrid.

its original appearance" (1973, pp. 292, 317). This cleaning has recently
been accomplished, revealing an astonishing subtlety of silvered tones and an
almost watercolor-like lightness of technique. Velázquez made the best of the
difficulty posed by the strong light from the window beneath the painting. As
Brown (1986, p. 246) points out, "Argus is highlighted while the rest of the
composition edges from half-shadow toward darkness." He continues, "the
extraordinary freedom of execution was undoubtedly abetted by the original
placement of the picture, but this in itself cannot account for the shortcuts
taken by Velázquez. Rather, and especially to eyes conditioned by the experi-
ence of modern art, he seems to have arrived intuitively at the understanding
of the dual nature of the art of painting, namely, its ability simultaneously to
create form and to express its own essence." As Pantorba states (1955, pp.
203–4), "on this narrow strip of cloth no two human figures with a cow could
be composed with more acumen, or greater equilibrium. The play of the
large masses and luminous areas, in solemn harmony with the darkened cave,
achieves that degree of indefectibility that is the mark of Velázquez. Vigorous
forms are modeled with astonishing simplicity, with effortless élan, as if dash-
ing off a sketch."

Velázquez handled the story in a manner typical of the Spanish Golden
Age, when it treats mythological subjects. He approached it without rever-
ence, "turn[ing] the myth upside down," as Ortega y Gasset says in his
study of Velázquez (1943 [1962, p. 481]) and relating the episode to everyday
reality (the same stance is seen in *The Forge of Vulcan* [no. 11] and *Mars*
[no. 28]). Mercury's winged helmet here becomes a worn soft felt with a stiff

feather on either side, a hat befitting the ruffian who, after lulling the cowherd to sleep with the music of his flute, crawls forward stealthily, shielding the sword that is to deliver the fatal blow. His ragged cape slips from his shoulder, revealing muscles more appropriate to a weight lifter than a messenger from Olympus. The dozing Argus, although inspired by the Roman statue *The Dying Gaul* (Museo Capitolino, Rome), is astonishingly lifelike. His head, of which we see little but fine straight hair, is not without nobility, inviting the viewer's sympathy. This figure, adapted to the restricted space of the canvas, has something of the eurythmy of the figures on classical pediments. Light falls on his legs, drooping hand, and half-bared chest. The cow completes that composition (of which it is the raison d'être), drawing the eye to the left and accentuating Mercury's desire to flee.

The well-known fable from which this episode is taken appears in Ovid's *Metamorphoses* (Book 1). Jupiter, enamored of Io, envelops her in a thick mist to prevent her escape and to enable him to possess her "without vexation" (as Pedro Sánchez de Viana writes in his Spanish version of 1589). Astonished by the sudden darkness, Juno, Jupiter's wife, suspects her husband of a new infidelity; descending from the empyrean to earth, she dispels the cloud. Jupiter has transformed Io into a beautiful heifer; Juno, still suspicious, asks for the animal as a gift, and the adulterer dares not refuse. The goddess leaves the metamorphosed nymph in the care of the herdsman Argus, whose head boasts a hundred eyes, fifty of which sleep while the other fifty keep watch. Jupiter dispatches Mercury, his divine messenger, who arranges a chance meeting with Argus and offers to entertain him with his flute. His sweet music lulls Argus into a deep sleep, closing all one hundred of his eyes. Mercury then cuts off his head and flees with the heifer. A compassionate Juno collects Argus' eyes and places them in the tail of the peacock, her favorite, and thenceforward emblematic, creature.

Velázquez, of course, does not depict the hundred closed eyes. His Argus is a simple, exhausted guardian. Neither did Peter Paul Rubens depict the eyes in his rendition of the same theme, painted for the Torre de la Parada (Museo del Prado, no. 1673), in which the baroque energy of the murderer and the cow contrasts with the heavy sleep of Argus. In Rubens we do not find the silence, the caution of the Velázquez version.

LITERATURE

Mayer 55, Curtis 33, López Rey 62, Pantorba 119, Gudiol 159, Bardi 121

PROVENANCE

Hall of Mirrors, the Alcázar, Madrid, from 1659; recorded in inventories of 1666, 1686, and 1700.

After the Alcázar fire of 1734, taken to the Royal Armory (no. 57).

Palacio Nuevo from 1735; recorded in inventories of 1772 and 1794.

Museo del Prado since 1819.

Prince Felipe Próspero

Oil on canvas
50⅜ × 39 in. (128 × 99 cm.)
Kunsthistorisches Museum, Vienna, no. 319

NOT IN EXHIBITION

Although, as is usual with Velázquez, this portrait is neither dated nor signed, no one has cast doubt on its authenticity, and critics concur in dating it 1659, the year this picture was sent to the emperor Leopold of Austria, along with that of the infanta Margarita dressed in blue (also in the Kunsthistorisches Museum, Vienna). "One of the best gifts in the annals of history," according to Gudiol (1973, pp. 291–92), "such are the qualities of these paintings . . . that it is well nigh impossible to critique them, given the imprecision of critical language. Suffice it to say that they display all of Velázquez's endowments to the utmost degree." In the opinion of Camón Aznar (1964, p. 880), "this is the most ingenuous and candid of all the portraits of children. No one has surpassed Velázquez in the enchantment with which he has imbued these child models." For Pantorba (1955, p. 208), "here it is proved once again that, in portraying children, Philip IV's painter is unrivaled. . . . Nobody has brought those children to life—those children who hardly lived at all—with such powerful intensity." Echoing this note of foreboding, Brown observes (1986, p. 229): "Not even the incomparable execution of the picture can dispel the faint but unshakable atmosphere of gloom which pervades it."

In fact, Felipe Próspero, barely two years old in this portrait, did not live until his fourth birthday. Born in Madrid on November 20, 1657, the prince (infante was a title reserved for younger sons) was the son of Mariana of Austria and Philip IV and heir to his father's throne (Philip's son by Isabella of Bourbon, Baltasar Carlos [pls. 21–23], had died earlier). The prince's birth was greeted with immense jubilation at court, but the child was sickly and weak. His name—commemorating the glory of his forebears and expressing hopes for a bright future—was bestowed on December 13, 1657, in a baptismal ceremony at the Alcázar in Madrid, where the chapel (according to Barrionuevo in his *Avisos*) was heated with six silver braziers and scented by an equal number of incense burners. His birth was celebrated with all manner of festivals, fireworks, cavalcades, and bullfights, and on December 26 preparations were begun for a *comedia grande*, costing 600,000 ducats, to be performed in the gardens of the Buen Retiro; the prince's poor health, however, necessitated postponing the opening, scheduled for May 23, 1658. The play finally opened in June, to such extraordinary acclaim that Philip IV decided to continue presenting it, no longer by invitation but through the sale of seats. These tickets brought in 5,000 reales daily, a welcome sum, given the financial straits of the court (Gállego 1983, pp. 119ff.).

As the boy grew, he was anemic and subject to epileptic seizures, and he

died in 1661. The crown was again without a male heir, until Doña Mariana gave birth to Prince Carlos on November 6, 1661, after the death of Velázquez. He would reign, under his mother's tutelage, until 1700, when he died childless. The Bourbon dynasty then succeeded to the Spanish throne, by virtue of the marriage of the infanta María Teresa to Louis XIV of France.

This portrait is thus later than *Las Meninas* (1656) and *The Weavers* (ca. 1657) and immediately precedes the painting of the infanta Margarita in a pink-and-silver hoop skirt (Museo del Prado, no. 1192), Velázquez's last work, which was completed by his son-in-law, Mazo. It demonstrates the quintessence of the artist's extraordinary technique and refinement of color. The boy has light blond hair, like his sister Margarita (pl. 37), and he wears a skirted dress, red with silver galloons and covered in front by a fine white pinafore; the white collar, or gorget, is adorned with a red bow on the left shoulder. Suspended from the bow is a jet talisman (an amulet against the evil eye) and a fine gold chain that crosses the chest and holds a pendant. A badger's foot (another vain amulet) and a little gold bell hang from the belt. The prince holds a cascabel, also golden, with his left hand, while his right rests, as often in royal portraits, on a small armchair upholstered in crimson velvet. Sitting on the chair is a little white dog "that seems alive and is a portrait of one that Velázquez was very fond of," according to Palomino. A heavy curtain with silky luster hangs on the left; there is another curtain on the right, where a door is open. In front is a stool with a rich golden-tasseled cushion on which the boy's crumpled hat rests like a crown. The plush carpet emphasizes the splendor of the chamber.

The mysterious, almost menacing atmosphere of this painting reminds today's viewer of the fate of this little boy, who resembles his sister Margarita but is sadder and has a less alert expression, as if already weary of life. Its suggestion of space brings *Las Meninas* to mind. This portrait both delights and disturbs us. The chiaroscuro, more pronounced than in other portraits of Velázquez's last years, creates a red-and-white spiral effect on the near-black background. The composition is carefully calculated: The verticals of background and furniture and the horizontals of the floor are broken by the diagonals of the armchair, the prince, and the taboret, thus relieving the oppressive atmosphere. López Rey (1979, p. 176) remarks on the dramatic character of this portrait, "the first in which Velázquez introduced a note of melancholy."

In a portrait of Felipe Próspero inspired by this painting, the little prince appears in the uniform of a captain general, with Vandyke collar, crimson sash, and riding boots. According to Mayer, it might have been begun by Velázquez in 1660 and finished by Mazo. After showing up in various British collections, it passed to the Collection Contini-Bonacossi, Florence. Pantorba (1955) alludes to a portrait of a child in his crib that Stirling (1848) identified as Felipe Próspero (then in the collection of the marquis of Landsdowne) and that Curtis later cited, but that cannot rightly be attributed to Velázquez. I wonder whether this last picture might represent the dead prince rather than the sleeping prince.

LITERATURE

Mayer 304, Curtis 147, López Rey 334, Pantorba 121, Gudiol 158, Bardi 122

PROVENANCE

Sent by Philip IV in 1659 to his nephew Leopold I.

Graz Castle, treasury room, until 1765.

Imperial Palace, Vienna, until 1816.

Imperial Gallery of the Belvedere Palace, Vienna.

Kunsthistorisches Museum, Vienna.

BIBLIOGRAPHY

Ainaud de Lasarte 1946
Ainaud de Lasarte, Juan. "Pinturas de procedencia sevillana." *Archivo español de arte* 18 (1946), pp. 54–62.

Alciati *Emblemata*
Alciati, Andrea. *Emblemata*. Augsburg, 1531. Spanish ed., *Los Emblemas de Alciato traducidos en rhimas españolas*. Translated by Bernardino Daza Pinciano. Lyons, 1549.

Allende-Salazar 1925
Allende-Salazar, Juan, ed. *Velázquez: Des Meisters Gemälde*, by Walter Gensel. Berlin and Leipzig, 1925.

Andres 1976
Andres, Glenn M. *The Villa Medici in Rome*. New York and London, 1976.

Angulo Iñiguez 1948
Angulo Iñiguez, Diego. "Las Hilanderas." *Archivo español de arte* 21 (1948), pp. 1–19.

Angulo Iñiguez 1952
Angulo Iñiguez, Diego. "Las Hilanderas. Sobre la iconografía de Aracne." *Archivo español de arte* 25 (1952), pp. 67–84.

Armstrong 1896
Armstrong, Walter. *Velázquez: A Study of His Life and Art*. London, 1896.

Azcárate 1988
Azcárate, José Maria de. *Guía del museo de la Real Academia de Bellas Artes de San Fernando*. Madrid, 1988.

Bardi 1969
Bardi, P. M. *Tout l'oeuvre peint de Velázquez*. Introduction by Yves Bottineau. Paris, 1969.

Barrionuevo *Avisos*
Barrionuevo, Jerónimo de. *Avisos (1654–58)*. Edited by A. Paz y Melia. Biblioteca de autores españoles, vols. 221, 222. Madrid, 1968–69.

Baxandall 1957
Baxandall, David. "A Dated Velázquez Bodegón." *Burlington Magazine* 99 (1957), pp. 156–57.

Beruete 1898
Beruete, Aureliano de. *Velázquez*. Paris, 1898. English translation by Hugh E. Poynter. London, 1906.

Borenius 1931
Borenius, Tancred. "Velázquez's Portrait of Góngora." *Burlington Magazine* 59 (1931), pp. 153–54.

Boschini 1660
Boschini, Marco. *La carta del navegar pitoresco*. Venice, 1660. Edited by Anna Palucchini. Venice and Rome, 1966.

Brown 1978
Brown, Jonathan. *Images and Ideas in Seventeenth-Century Spanish Painting*. Princeton, 1978.

Brown 1986
Brown, Jonathan. *Velázquez: Painter and Courtier*. New Haven and London, 1986.

Brown and Elliott 1980
Brown, Jonathan, and J. H. Elliott. *A Palace for a King: The Buen Retiro and the Court of Philip IV*. New Haven and London, 1980.

Bürger 1865. *See* Stirling-Maxwell 1865.

Camón Aznar 1964
Camón Aznar, José. *Velázquez*. 2 vols. Madrid, 1964.

Camón Aznar 1978
Camón Aznar, José. *La pintura española del siglo XVII*. Summa Artis 25. Madrid, 1978.

Carducho 1633
Carducho, Vicente. *Diálogos de la pintura*. Madrid, 1633. Edited by Francisco Calvo Serraller. Madrid, 1977.

Ceán Bermúdez 1800
Ceán Bermúdez, Juan Agustín. *Diccionario histórico de los más ilustres profesores de las bellas artes en España*. 6 vols. Madrid, 1800. Reprint. Madrid, 1965.

Chaunu 1966
Chaunu, Pierre. *La Civilisation de l'europe classique*. Paris, 1966.

Cook 1906
Cook, Herbert. "A Re-discovered Velázquez." *Burlington Magazine* 10 (Dec. 1906), pp. 171–72.

Cossío 1952
Cossío, José Maria de. *Fábulas mitológicas en España*. Madrid, 1952.

Cruzada Villaamil 1885
Cruzada Villaamil, Gregorio. *Anales de la vida y de las obras de Diego de Silva Velázquez*. Madrid, 1885.

Curtis 1883
Curtis, Charles B. *Velázquez and Murillo: A Descriptive and Historical Catalogue.* New York, 1883.

Deleito y Piñuela 1942
Deleito y Piñuela, José. *Sólo Madrid es corte: La capital de dos mundos bajo Felipe IV.* Madrid, 1942.

Deleito y Piñuela 1959
Deleito y Piñuela, José. *La mala vida en la España de Felipe IV.* 3d ed. Madrid, 1959.

Deleito y Piñuela 1964
Deleito y Piñuela, José. *El rey se divierte. Recuerdos de hace tres siglos.* 3d ed. Madrid, 1964.

Deleito y Piñuela 1966
Deleito y Piñuela, José. *El declinar de la monarquía española.* 4th ed. Madrid, 1966.

Díaz Padrón 1985
Díaz Padrón, Matías. In *Splendeurs d'Espagne et les villes belges (1500–1700)* (exh. cat., Palais des Beaux-Arts, September 25–December 22, 1985). Edited by Jean-Marie Duvosquel and Ignace Vandevivere. Brussels, 1985, pp. 427, 429–31.

Díez del Corral 1979
Díez del Corral, Luis. *Velázquez, la monarquía e Italia.* Madrid, 1979.

Domínguez Ortiz 1983
Domínguez Ortiz, Antonio. *Historia de Sevilla en el siglo XVII.* Seville, 1983.

Elliott 1986
Elliott, John H. *The Count-Duke of Olivares: The Statesman in an Age of Decline.* New Haven and London, 1986.

Fahy 1971
Fahy, Everett. "[Juan de Pareja by Diego Velázquez.] A History of the Portrait and Its Painter." *The Metropolitan Museum of Art Bulletin* n.s. 29 (1971), pp. 453–75.

Félibien des Avaux 1666–88
Félibien des Avaux, André. *Entretiens sur les vies et sur les ouvrages des plus excellens peintres anciens et modernes.* Paris, 1666–88.

Fernández Alvarez 1983
Fernández Alvarez, Manuel. *La sociedad española en el siglo de oro.* Madrid, 1983.

Ford 1851
Ford, Richard. "The Life of Diego Rodríguez de Silva y Velázquez." In *Penny Cyclopaedia of the Society for the Diffusion of Useful Knowledge.* London, 1851.

Gállego 1965
Gállego, Julián. "Baltasar Carlos, Príncipe de Aragón." *Heraldo de Aragón* (July–Sept. 1965). Reprinted in *Temas de cultura aragonesa.* Saragossa, 1979.

Gállego 1968
Gállego, Julián. *Vision et symboles dans la peinture espagnole du siècle d'or.* Paris, 1968.

Gállego 1972
Gállego, Julián. *Visión y símbolos en la pintura española del siglo de oro.* Madrid, 1972.

Gállego 1974
Gállego, Julián. *Velázquez en Sevilla.* Seville, 1974.

Gállego 1976
Gállego, Julián. *El pintor, de artesano a artista.* Granada, 1976.

Gállego 1983
Gállego, Julián. *Diego Velázquez.* Barcelona, 1983.

Gállego 1984
Gállego, Julián. *El cuadro dentro del cuadro.* Madrid, 1984.

Gassier and Wilson 1971
Gassier, Pierre and Juliet Wilson. *The Life and Complete Work of Francisco Goya, with a Catalogue Raisonné of the Paintings, Drawings, and Engravings.* New York, 1971.

Gaya Nuño 1958
Gaya Nuño, Juan Antonio. *La pintura española fuera de España: Historia y catálogo.* Madrid, 1958.

Gérard 1976
Gérard, Véronique. "Les Problèmes artistiques de l'Alcázar de Madrid (1537–1700)." *Mélanges de la Casa de Velázquez* 12 (1976), pp. 307–22.

Gerstenberg 1957
Gerstenberg, Kurt. *Diego Velázquez.* Munich and Berlin, 1957.

Gerstenberg 1960
Gerstenberg, Kurt. "Velázquez als Humanist." In *Varia Velazqueña.* Vol. 1, *Estudios sobre Velázquez y su obra*, pp. 207–16. Madrid, 1960.

Gudiol 1960
Gudiol, José. "Algunas réplicas en la obra de Velázquez." In *Varia Velazqueña.* Vol. 1, *Estudios sobre Velázquez y su obra*, pp. 414–19. Madrid, 1960.

Gudiol 1973
Gudiol, José. *Velázquez, 1599–1660: Historia de su vida, catálogo de su obra, estudio de la evolución de su técnica.* Barcelona, 1973.

Harris 1940
Harris, Enriqueta. *The Prado: Treasure House of the Spanish Royal Collections.* London and New York, 1940.

Harris 1951
Harris, Enriqueta. "Spanish Painting from Morales to Goya in The National Gallery of Scotland." *Burlington Magazine* 93 (1951), pp. 310–17.

Harris 1981
Harris, Enriqueta. "Velázquez and the Villa Medici." *Burlington Magazine* 123 (Sept. 1981), pp. 537–41.

Harris 1982
Harris, Enriqueta. *Velázquez.* Oxford, 1982.

Haskell 1980
Haskell, Francis. *Patrons and Painters: A Study in the Relations Between Italian Art and Society in the Age of the Baroque.* 2d ed. New Haven and London, 1980.

Hispanic Society of America 1954
Hispanic Society of America. *A History of the Hispanic Society of America, Museum and Library, 1904–1954; With a Survey of the Collections.* New York, 1954.

Hume 1928
Hume, Martin. *The Court of Philip IV: Spain in Decadence.* 2d ed. London, 1928.

Jacobus de Voragine
Jacobus de Voragine. *The Golden Legend.* Translated and adapted from the Latin by G. Ryan and H. Ripperger. 1941. Reprint. New York, 1969.

Jordan 1974
Jordan, William B. *The Meadows Museum: A Visitor's Guide to the Collection.* Dallas, 1974.

Jordan 1981
Jordan, William B. "Velázquez's *Portrait of Don Pedro de Barberana.*" *Apollo* 114 (1981), pp. 378–79.

Justi 1903
Justi, Carl. *Diego Velázquez und sein Jahrhundert.* Bonn, 1888. 2d ed. Bonn, 1903.

Justi 1953
Justi, Carl. *Velázquez y su siglo.* Translated by Pedro Marrades. Madrid, 1953.

Kamen 1971
Kamen, Henry. *The Iron Century: Social Change in Europe, 1550–1660.* London, 1971.

Kemenov 1977
Kemenov, Vladimir S. *Velázquez in Soviet Museums: Analysis and Interpretations of the Paintings in the Context of His Oeuvre.* Translated by Roger Keys. Leningrad, 1977.

Kubler and Soria 1959
Kubler, George, and Martín Soria. *Art and Architecture in Spain and Portugal and their American Dominions, 1500–1800.* Baltimore, 1959.

Lafuente Ferrari 1943
Lafuente Ferrari, Enrique. *Velázquez: Complete Edition.* London, 1943.

Lafuente Ferrari 1960
Lafuente Ferrari, Enrique. "Velázquez y los retratos del Conde-duque de Olivares." *Goya* 37–38 (1960), pp. 64–74.

Lefort 1888
Lefort, Paul. *Velázquez.* Paris, 1888.

Liedtke and Moffitt 1981
Liedtke, Walter A., and John F. Moffitt. "Velázquez, Olivares, and the baroque equestrian portrait." *Burlington Magazine* 123 (Sept. 1981), pp. 529–37.

Loga 1913
Loga, Valerian von. "Zur Zeitbestimmung einiger Werke des Velázquez." *Jahrbuch der Königlich Preussischen Kunstsammlungen* 34 (1913), pp. 281–91.

Longhi 1927
Longhi, Roberto. "Un San Tomaso del Velázquez e le congiunture italo-spagnole tra il '5 e il '600." *Vita artistica* 2 (1927), pp. 4–11.

López Rey 1963
López Rey, José. *Velázquez: A Catalogue Raisonné of His Oeuvre, with an Introductory Study.* London, 1963.

López Rey 1968
López Rey, José. *Velázquez' Work and World.* London, 1968.

López Rey 1972
López Rey, José. "An Unpublished Velázquez: *A Knight of Calatrava.*" *Gazette des Beaux-Arts*, 6th ser., 80 (1972), pp. 61–70.

López Rey 1974
López Rey, José. Review of *Velázquez*, by José Gudiol. *La Chronique des Arts*, pp. 30–31. Supplement to *Gazette des Beaux-Arts*, 6th ser., 83 (Jan., 1974).

López Rey 1979
López Rey, José. *Velázquez: The Artist as a Maker. With a Catalogue Raisonné of His Extant Works.* Lausanne and Paris, 1979.

Lozano 1927
Lozano, Eduardo. "Observaciones sobre algunos cuadros de Velázquez del Museo del Prado." *Arte español* 8 (1927), pp. 203–208, 236–39.

Lynch 1981
Lynch, John. *Spain Under the Habsburgs.* 2d ed. 2 vols. Oxford, 1981.

MacLaren 1952
MacLaren, Neil. *The Spanish School.* National Gallery Catalogue. London, 1952.

Madrazo 1850
Madrazo, Pedro de. *Catálogo de los cuadros del Real Museo de pintura y escultura de S. M.* Madrid, 1850.

Madrazo 1872
Madrazo, Pedro de. *Catálogo descriptivo e histórico de los cuadros del Museo del Prado de Madrid.* Madrid, 1872.

Madrid 1985
Madrid. Museo del Prado. *Catálogo de las pinturas.* Introduction by Alfonso E. Pérez Sánchez. Madrid, 1985.

Marañón 1952
Marañón, Gregorio. *El Conde-Duque de Olivares. La pasión de mandar.* 3d ed. Madrid, 1952.

Maravall 1960
Maravall, José A. *Velázquez y el espíritu de la modernidad.* Madrid, 1960.

Maravall 1983
Maravall, José A. *La cultura del barroco: Análisis de una estructura histórica.* 3d ed. Madrid, 1983. English ed., *Culture of the Baroque: Analysis of a Historical Structure.* Translated by Terry Cochran. Minneapolis, 1986.

Martínez de Espinar 1664
Martínez de Espinar, Alonso. *Arte de ballestería y montería*. Madrid, 1664.

Mateos 1634
Mateos, Juan. *Origen y dignidad de la caza*. Madrid, 1634.

Mayer 1927
Mayer, August L. "Three Studies." *Burlington Magazine* 50 (1927), pp. 332–37.

Mayer 1936
Mayer, August L. *Velázquez: A Catalogue Raisonné of the Pictures and Drawings*. London, 1936.

Mélida 1905
Mélida, José Ramón. "Los Velázquez de la Casa de Villahermosa." *Revista de archivos, bibliotecas y museos* 9 (1905), pp. 89–98.

Mélida 1906
Mélida, José Ramón. "Un recibo de Velázquez." *Revista de archivos, bibliotecas y museos* 10 (1906), pp. 173–98.

Menéndez Pelayo 1947
Menéndez Pelayo, Marcelino. *Historia de las ideas estéticas en España*. Vol. 2, *Siglos XVI y XVII*. Santander, 1947.

Millé y Giménez 1932
Millé y Giménez, Juan and Isabel Millé y Giménez, eds. *Obras completas de don Luis de Góngora y Argote*. Madrid, 1932.

Moffitt 1982
Moffitt, John F. "Velázquez, Fools, Calabacillas and Ripa." *Pantheon* 40 (1982), pp. 304–309.

Moragas 1964
Moragas, Jerónimo de. "Los bufones de Velázquez." *Medicina e historia* 1 (Nov.–Dec. 1964), pp. 1–15.

Moreno Villa 1920
Moreno Villa, José. *Velázquez*. Madrid, 1920.

Moreno Villa 1939
Moreno Villa, José. *Locos, enanos, negros y niños palaciegos: Gente de placer que tuvieron los Austrias en la Corte española desde 1536 a 1700*. Mexico City, 1939.

Ortega y Gasset 1943
Ortega y Gasset, José. "Introducción a Velázquez." In *Papeles sobre Velázquez y Goya*. Madrid, 1950. Reprinted in *Obras Completas de José Ortega y Gasset*, vol. 8. Madrid, 1962, pp. 457–87.

Pacheco *Arte*
Pacheco, Francisco. *Arte de la pintura, su antigüedad y grandezas*. Seville, 1649. New ed. from 1638 ms., edited by Francisco J. Sánchez Cantón. 2 vols. Madrid, 1956.

Pacheco *Libro de retratos*
Pacheco, Francisco. *Libro de descripción de verdaderos retratos de ilustres y memorables varones*. Seville, 1599. Facsimile ed. by José Maria Asensio. Seville, 1868.

Palomino 1724
Palomino de Castro y Velasco, Acisclo Antonio. *El museo pictórico y escala óptica*. Vol. 3, *El Parnaso español pintoresco laureado*, Madrid, 1724.

Pantorba 1955
Pantorba, Bernardino de. *La vida y la obra de Velázquez: Estudio biográfico y crítico*. Madrid, 1955.

Passavant 1833
Passavant, Johann D. *Kunstreise durch England und Belgium*. Frankfurt am Main, 1833.

Pellicer de Ossau y Tovar 1631
Pellicer de Ossau y Tovar, José. *Anfiteatro de Felipe el Grande*. Madrid, 1631.

Pérez 1634
Pérez, Antonio. *Authentica fides Pauli super prima et secunda Corinthiorum controversiis catholicis agitata pariterque discussa*. Barcelona, 1634.

Picón 1947
Picón, Jacinto Octavio. *Vida y obras de Don Diego Velázquez*. 4th ed. Buenos Aires, 1947.

Pita Andrade 1952
Pita Andrade, José Manuel. "Los cuadros de Velázquez y Mazo que poseyó el séptimo Marqués del Carpio." *Archivo español de arte* 25 (1952), pp. 223–36.

Pita Andrade 1960
Pita Andrade, José Manuel. "Noticias en torno a Velázquez en el archivo de la Casa de Alba." In *Varia Velazqueña*. Vol. 1, *Estudios sobre Velázquez y su obra*, pp. 400–413. Madrid, 1960.

Pluvinel 1625
Pluvinel, Antoine de. *L'Instruction du Roy en l'exercice de monter à cheval*. Paris, 1625.

Ponz 1772–94
Ponz, Antonio. *Viage de España*. 18 vols. Madrid, 1772–94.

Ripa 1603
Ripa, Cesare. *Iconologia*. Ed. Venice, 1669.

Rodríguez Villa 1913
Rodríguez Villa, Antonio. *Etiquetas de la Casa de Austria*. Madrid, 1913.

Rousseau 1971
Rousseau, Theodore. "Juan de Pareja by Diego Velázquez. An Appreciation of the Portrait." *The Metropolitan Museum of Art Bulletin* n.s. 29 (1971), pp. 449–51.

Salinger 1956
Salinger, Margaretta. "Notes on the Cover: Don Gaspar de Guzmán, Count-Duke of Olivares, by Velázquez (1599–1660)." *The Metropolitan Museum of Art Bulletin* n.s. 14, no. 5 (1956), inside cover.

Sánchez Cantón 1942
Sánchez Cantón, Francisco J. "Como vivía Velázquez. Inventario descubierto por D. F. Rodríguez Marín." *Archivo español de arte* 15 (1942), pp. 69–91.

Sánchez Cantón 1944
Sánchez Cantón, Francisco J. Review of *Velázquez*, by Enrique Lafuente Ferrari. *Archivo español de arte* 17 (1944), pp. 135–36.

Sánchez Cantón 1945
Sánchez Cantón, Francisco J. "New Facts about Velázquez." *Burlington Magazine* 87 (1945), pp. 289–92.

Santos 1657
Santos, Francisco de los. *Descripción breve del monasterio de San Lorenzo el Real de El Escorial.* Madrid, 1657.

Soehner 1963
Soehner, Halldor. *Spanische Meister.* Vol. 1 of *Gemäldekataloge.* Munich. Alte Pinakothek. Munich, 1963.

Soria 1954
Soria, Martín. " 'Las Lanzas' y los retratos ecuestres de Velázquez." *Archivo español de arte* 27 (1954), pp. 93–108.

Soria 1960
Soria, Martín S. "Velázquez y Tristán." In *Varia Velazqueña.* Vol. 1, *Estudios sobre Velázquez y su obra*, pp. 456–62. Madrid, 1960.

Steinberg 1965
Steinberg, Leo. Review of *Velázquez: A Catalogue Raisonné of His Oeuvre, with an Introductory Study*, by José López Rey. *Art Bulletin* 47 (1965), pp. 274–94.

Stirling-Maxwell 1848
Stirling-Maxwell, William. *Annals of the Artists of Spain.* 4 vols. London, 1848.

Stirling-Maxwell 1855
Stirling-Maxwell, William. *Velázquez and His Works.* London, 1855.

Stirling-Maxwell 1865
Stirling-Maxwell, William. *Velázquez et ses oeuvres; Avec des notes et un catalogue des tableaux de Velázquez par W. Bürger* [*Théophile Thoré*]. Paris, 1865.

Suida 1949
Suida, William E. *A Catalogue of Paintings in the John and Mable Ringling Museum of Art.* Sarasota, 1949.

Tolnay 1949
Tolnay, Charles de. "Velázquez' *Las Hilanderas* and *Las Meninas.* An Interpretation." *Gazette des Beaux-Arts*, 6th ser., 35 (1949), pp. 21–38.

Trapier 1948
Trapier, Elizabeth du Gué. *Velázquez.* New York, 1948.

Varia Velazqueña
Varia Velazqueña: Homenaje a Velázquez en el III centenario de su muerte, 1660–1960, edited by Antonio Gallego y Burín. 2 vols. Madrid, 1960.

Velázquez y lo Velazqueño
Velázquez y lo Velazqueño: Catálogo de la exposición homenaje a Diego de Silva Velázquez en el III centenario de su muerte, 1660–1960. 2d ed. Madrid, 1961.

Viardot 1860
Viardot, Louis. *Les musées d'Espagne: Guide et mémento de l'artiste et du voyager, suivis de notices biographiques sur les principaux peintres de l'Espagne.* 3d ed. Paris, 1860.

Waterhouse 1951
Waterhouse, Ellis K. *An Exhibition of Spanish Paintings from El Greco to Goya.* The National Gallery of Scotland. Edinburgh, 1951.

Wehle 1954
Wehle, Harry Brandeis. *Art Treasures of the Prado Museum.* New York, 1954.

INDEX

PHOTOGRAPH CREDITS

Photographs for all works from Spanish museums and collections have been supplied by Oronoz, S.A., Madrid. Photographs for all other works have been supplied by their owners except for the following:

Bridgeman/Art Resource: pp. 26, 27

National Trust/Art Resource: p. 179

Nimatallah/Art Resource: pp. 171, 242, 256 (top)

Scala/Art Resource: pp. 47, 48, 80, 134, 143 (top), 254